AMULETS

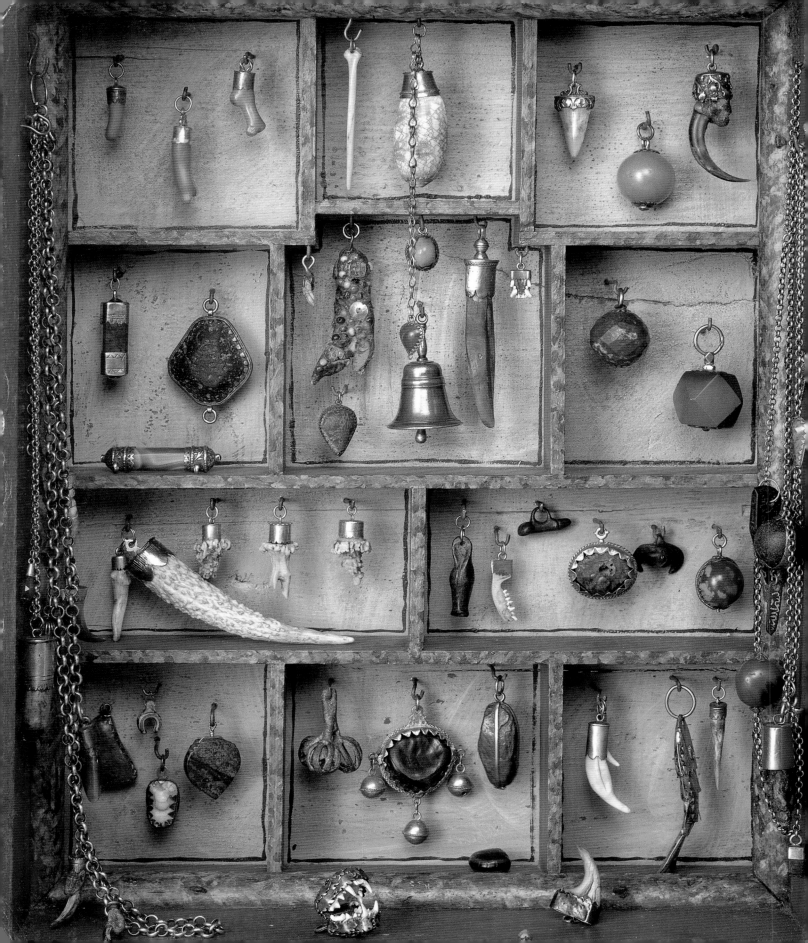

AMULETS

SACRED CHARMS
OF POWER
AND PROTECTION

Sheila Paine

INNER TRADITIONS
ROCHESTER, VERMONT

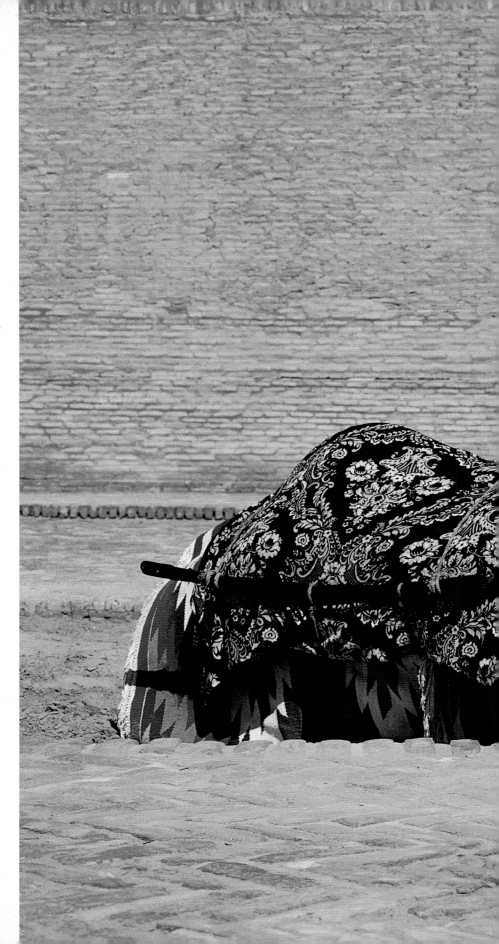

Inner Traditions
One Park Street
Rochester, Vermont 05767
www.InnerTraditions.com

First published in the United Kingdom in 2004
by Thames & Hudson Ltd, London

Library of Congress Cataloging-in-Publication Data

Paine, Sheila.
 Amulets ; sacred charms of power and
protection / Sheila Paine.
 p. cm.
 Includes bibliographical references and index.
 ISBN 1-59477-025-5
 1. Amulets. I. Title.
 BF1561.P34 2004

 2004042091

Printed and bound in China by C&C Offset

10 9 8 7 6 5 4 3 2 1

Text design and layout by Thames & Hudson

PAGE 1 *Triangle with feathers and cloves,
Uzbekistan.*
PAGE 2 *18th-century apothecary's cabinet filled
with amulets dating from antiquity to the 19th
century, France.*
RIGHT *Amuletic halter on tourist camel, Khiva,
Uzbekistan.*
PAGE 6 *Mirrored triangles, hung from a tree in a
Hindu cemetery, Thano Bula Khan, southern
Pakistan; (above) silver and cornelian necklace,
incorporating containers for Koranic verses,
Yemen; (below) Turkmen child's* kurta *with
jewelry, cowries and buttons, Afghanistan.*
PAGE 7 *Camel-hanging with hair, tassels, cotton
reels, embroidered solar patterns, and bells and tin
lids that rattle, Tajikistan; house amulet made of
an old tin lid, depicting Shiva, India.*

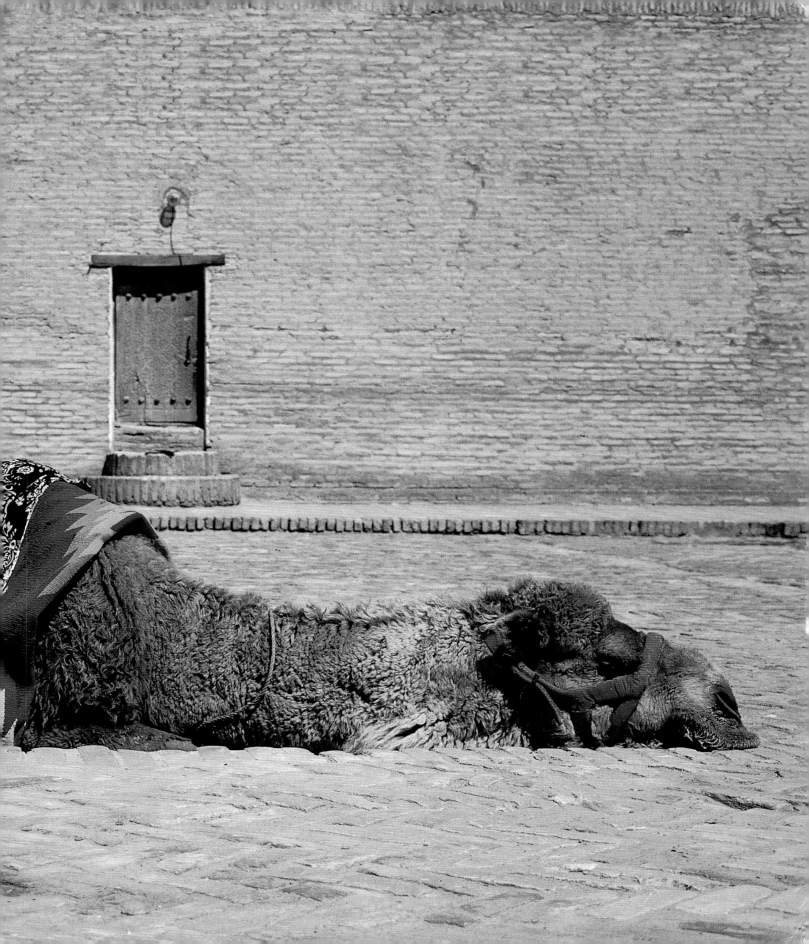

Contents

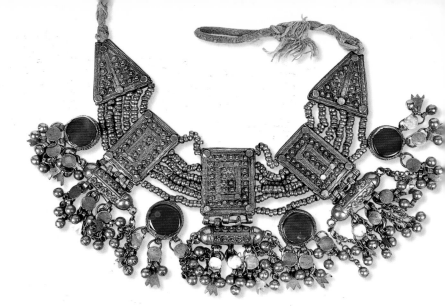

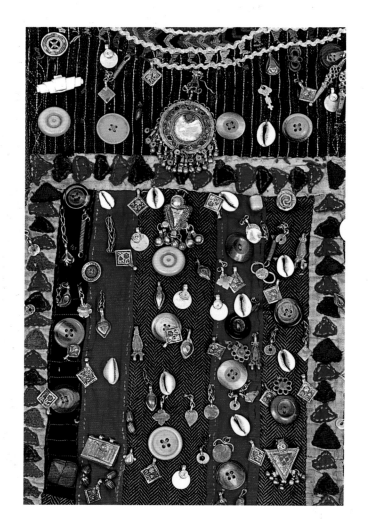

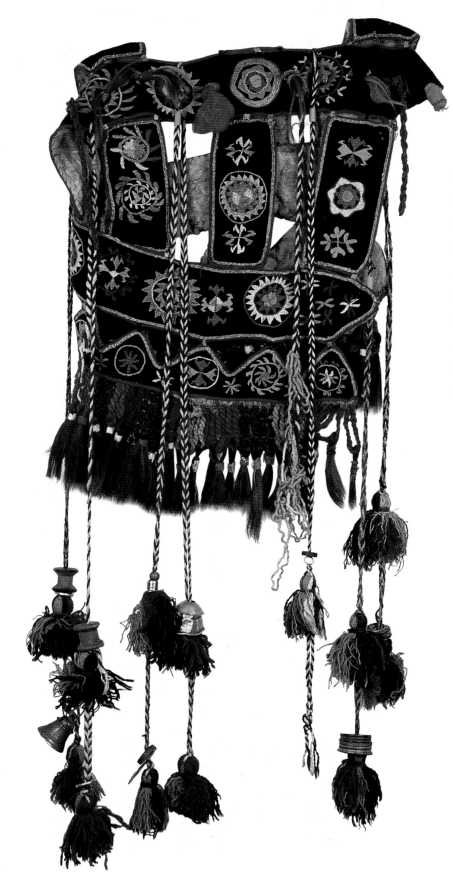

Introduction:
Mr Routledge and the lions

Complete outfit of a professional thief, Nassaraw Province, Abuja, Nigeria.

THIS PAGE, LEFT TO RIGHT *Two amulets to allow the wearer to escape after capture; a belt to protect him from knives; a twisted circle to enable escape after capture; leather bracelets to stick to the load; a circle with a pouch to make pursuers take the wrong road; a bracelet to turn the wearer into a cat.*

OPPOSITE, TOP TO BOTTOM *Red cord to make the wearer invisible; one side of an inscribed charm to save him from injury by other thieves (the other side is for him to get plenty of money); handcuffs; a nut to make him invisible; a bag with a written charm to be burnt and inhaled so that the thief can see where money is; a leather rectangle to prevent anyone from speaking to him; a hyena's tail; two belts against arrows.*

*I*n 1908 Mr Scoresby Routledge took it upon himself to live among what he called 'the prehistoric people of British East Africa', the Kikuyu. He wandered around in the bush in khaki shorts and sola topee, diligently recording the people's activities in his notebooks, oblivious to his surroundings. Watching him, the Kikuyu decided urgent measures were needed to save him from being eaten by lions. They made him an amulet. This consisted of a number of powders blessed by the medicine man with incantations of 'bad beasts do not harm me' and tied in a little package of rags. The usual obscure ritual was amended slightly, at Mr Routledge's request, to ensure that he had a chance to shoot the lion before it ran away. As instructed by the medicine man, Mr Routledge carried the small roll of white rags in his pocket at all times. It protected him most successfully, and not one lion even so much as took a nip at him.

Similar success was recorded in the 1920s in the case of an Albanian who visited London for a month. Presuming the country to be much the same as home, he took his usual precaution of wearing a piece of meteorite as an amulet round his neck, to protect him from gunfire. In the entire month not once was he shot at.

Such tales of the power of amulets are legion, but there are also some sorry stories of failure. Many a small fishing boat, watchful eyes painted on its bows and a tortoiseshell cat on board, has foundered at sea; many a

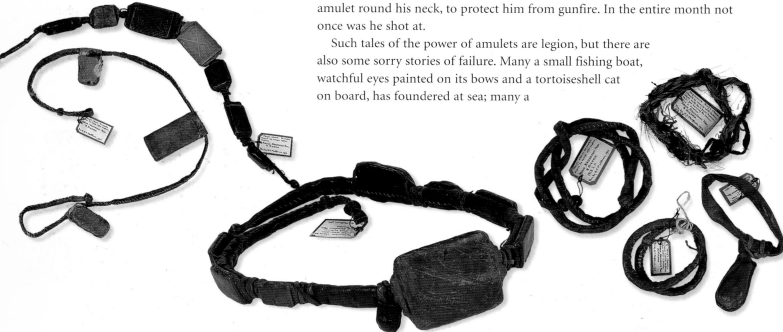

mangy donkey, red tassels and blue beads on its reins, has had to be despatched prematurely to the knacker's yard; many a soldier, a crucifix or bear's tooth hung round his neck, has been slain on the battlefield; and many a sickly infant, a sparkly embroidered triangle pinned to its bonnet, has died of diarrhoea.

Mr Routledge, Albanians, fishermen and soldiers are not alone in carrying amulets. The practice is common with taxi drivers, astronauts, even thieves and burglars, who in more innocent days relied on them as their stock-in-trade.

A professional thief in colonial Nigeria, who managed to escape capture by the British Commissioner, dropped his bag of amulets in his hurried departure. It contained twenty-seven amulets, together with a chisel and two razors which might be presumed to be of merely practical use. The Commissioner took the bag along to the local *mallam* for analysis, suspecting that he had probably sold the contents to the thief in the first place. They included a nut to make him invisible and a number of leather-covered charms, some to enable him to escape, some to make his pursuers take the wrong road, others to prevent anyone talking to him if they saw him in a house. A cord of bark twisted up with hair from a hyena's tail would turn him into a hyena, while an antelope horn wound round with fur would turn him into a cat, should anyone hear him. A belt of cotton would prevent arrows hitting their mark and several written charms, mostly to be burnt and inhaled, would enable him to find lots of money, even if it was hidden. For a couple of bits of twisted leather and one of cotton, the *mallam* was unable to give an explanation.

Though the bag was recorded as containing twenty-seven amulets, many were described as charms or talismans. What then is an amulet? And what a charm? And a talisman? A fetish?

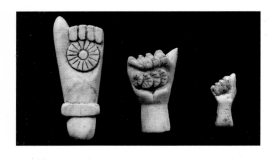

ABOVE *Three alabaster hands. The one in the centre is an amulet, protecting from financial problems, whereas the one on the left is a talisman, used to cause financial problems to others. Both are from La Paz, Bolivia. The amulet on the right was found in an ancient cemetery in Peru.*

BELOW *Wooden fertility doll covered in yellow beads, wearing and holding leather amulets. The doll is held by young Namji women to ensure fertility, Cameroon.*

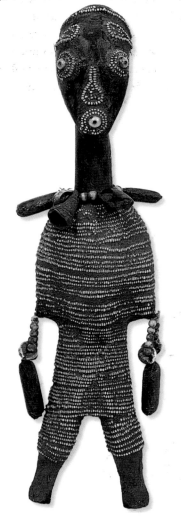

An amulet is a device, the purpose of which is to protect, but by magical and not physical means – a lump of meteorite worn against gunfire is an amulet, a bullet-proof vest is not.

A charm is something believed to bring good luck, health and happiness. In so doing it might also be expected to protect from bad luck, sickness and misery, but protection is not its primary function.

A talisman is something thought to be imbued with some magical property. It can both protect, and radiate power, and is often used in ritual.

In all three cases most are real objects, but they can be an act, such as, in the case of an amulet, wearing clothes inside out as protection; in the case of a charm, saying 'white rabbits' on the first of the month for luck; or in that of a talisman, taking a piece of holy bread round seven churches to cure a sick child. There is always some overlap in the meaning of the three words and they are often used indiscriminately.

A fetish is somewhat different. The origin of the fetish was as a West African amulet but the word now describes an object believed to contain a spirit. Fetishes are found in Polynesia, Australasia, West Africa, North and South America and the Arctic. Once magical rites have been performed over it, anything can become a fetish, especially if it is something unknown or not understood, but most fetishes take the form of a doll or statue. The spirit they contain is usually fed. The North American Pueblo Zunis give them cornmeal and water, and hide them away in secret corners or use them for hunting, while the people of Cameroon feed them once a week on whatever is going, and hang them over doors to protect the house. Each fetish has a different function, so that an African, for example, would carry several in a bag round his neck to cover every eventuality. In its positive aspect the fetish is an amulet, but even when it is destructive – as a doll to stick pins in, for example – it usually has some device, like a piece of mirror or red thread, to ensure it retains its amuletic protective function.

An amulet protects us from what? Who or what does it protect? Who protects us? With what? Where in the world? When? Why? The simple answers could be:

From what? From witches, hobgoblins and the little folk, from evil spirits that dwell in dark woods, at crossroads or in water, and, in particular, from the evil eye. Who or what does it protect? The vulnerable or precious, such as hunters, babies, cows, houses and tractors. Who protects us? God, Allah, ancestors, benign spirits of the natural world. With what? With a complexity of materials and objects that range from such things as misshapen stones, cloves, rattling nutshells and moles' paws, to blue glass beads and mirrors that express ideas of reflection and confronting an eye with an eye.

Where in the world? Amulets are almost universal, their form and substance varying, as in the Islamic world where silver hands of Fatima and blue beads predominate, while in Europe it is red threads and crucifixes, in America weaving patterns and birds, and in the Far East inscribed paper. They can be a declaration of faith – a crucifix on a necklace, a paper

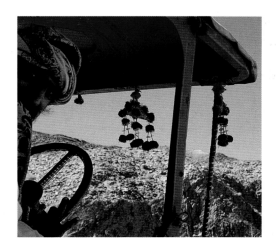

ABOVE *Tractor amulets in situ in a tractor on the road to Buleida, Makran, southern Pakistan.*

BELOW RIGHT *Tractor amulet with large sequins and bright pompoms, as shown above.*

OVERLEAF *Horse protected by pompoms in Kabul market, Afghanistan.*

inscription from the Koran, or a crystal of New Age conviction – or they can be but one manifestation of a complex system of animist beliefs that encompass ancient concepts of power and hierarchy, of ancestors and sorcery, of spirits that dwell in the natural world: in trees, stones, springs and wells, in snakes, toads, panthers and owls. In Africa they are intrinsic to everyday life and the world of witchcraft they protect from is far more potent than, say, the influence of the evil eye in Indo-European culture. African amulets have, as a result, a brooding presence, a destructive capturing of the potency of nature. Their dried animal skins, scales, feathers and claws, their scrapings of bark and grindings of leaves, have a chthonic strength that a blue bead or a bit of red embroidery could never match.

When? Amulets are not just something from the distant past. When astronaut Edward White went to the moon, he took in the right-hand pocket of his space suit a St Christopher medallion, a gold cross and a Star of David. Now a new amulet dangles from the rear-view mirror of many a taxi and car, flashing in the sun. It is a CD, some freebie of Björk or a forgotten Elvis, the glint of the disc believed to distract the evil eye as well as deflecting the rays of the speed cameras. And the newest of all is a circular silver pendant, available by mail order and priced at £196 ($320), which protects the wearer from the electromagnetic fields of his or her cell phone.

Why? Why does anyone believe in amulets, when such faith flies in the face of logic?

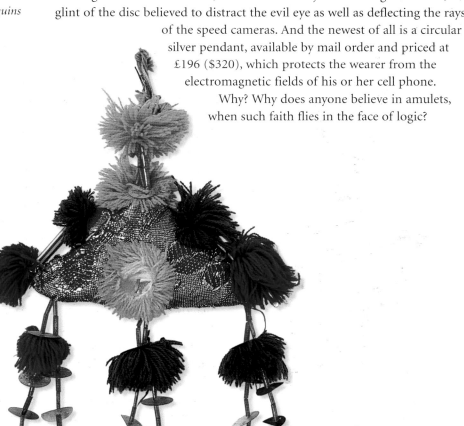

Plague & pestilence

As the worst epidemic of the plague since it first appeared in the sixth century swept across Europe and reached the canton of Basel in 1329, the good burghers of Switzerland looked for a scapegoat and picked on the innocent Jews. They had deliberately poisoned the wells. The entire Jewish population of the city was rounded up on an island in the Rhine and burnt to death. Still the plague raged, unfavourable star configurations now being blamed, and the atmosphere of terror continued. Amulets were deemed the only protection. Pieces of paper printed with pictures of saints were folded into small packets around scraps of red ribbon and tiny cuttings of plants, then wrapped in a piece of fabric and worn. 'Plague cushions', they were called, and such amulets were used all over Europe.

BELOW, LEFT AND RIGHT *Plague cushions: drawings of saints wrapped round a double cross, with a piece of red cloth and sprigs of juniper and pimpernel, 17th century, canton of Lucerne, Switzerland.*

OPPOSITE *Cross of Caravaca, against the plague, 17th century, Spain.*

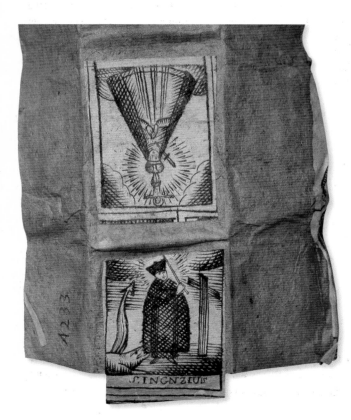

In the Great Plague that scythed through Europe and hit London in 1665, the disease was believed to be caused by the wrath of God and spread by the bad odours emanating from the sick. On still days, church bells were rung and shots fired to drive off the disease by moving the air. Birds were kept in rooms to sing and create draughts. But strong-smelling amulets, pomanders of cloves and spices, were the best protection, while in Catholic Europe the holy plague healer St Roch of Montpellier, who had helped victims of the Italian epidemic in the fourteenth century, was featured on amulets, together with St Sebastian, whose torture by arrows was akin to the pain suffered by victims of the plague.

It is particularly in such a climate of deadly pestilence caused by forces unknown and not understood – as in the case of AIDS in Africa today – that the power of amulets thrives. Illness, until well into the nineteenth century, was believed to be the work of evil spirits, demons, witches, the evil eye, magic, angry gods or ancestors. In the face of such supernatural forces a magical defence acquired its own rationality, though the power of such defence and the dangers it confronted were – and in many cases still are – conceived differently in different parts of the world.

There is, above all, a widespread belief that all things in the natural world have a spirit and a power that links them, including man, together. An amulet is part of such a system of natural and magical force. The invisible aura of an unusual stone, the perfume of a pungent plant, the tortured shape of a root, the soaring power of an eagle, all such phenomena can be used to redress the imbalance of evil influences.

The world is also conceived in many cultures as a three-layered abode: the upper inhabited by birds and spirits (and encroached by horns and hair), the lower the domain of water animals and creepy-crawlies, the middle a complex animal habitat in which humans play merely a part. All must be kept in harmony.

Within this earthly and celestial world, concepts of the symbolism of astrology, of numbers and colours, of alchemy and magic, of wind, sun and moon are all harnessed into the power of amulets. And into this world intruded, usually with considerable distaste, the established religions of Islam, Christianity, Judaism, Buddhism, Taoism, Shinto and Hinduism. In place of the gods of Babylon and Egypt, and the fetishes of the animists, came inscriptions from the Koran, holy texts of the Orient, footprints of Vishnu, and images of Christ, Madonna and the saints.

ABOVE *Pre-Columbian figure from c. AD 1300, Peru.*

BELOW *Two poisonous snakes made of polished stone inset with white gypsum and probably once gemstones, c. 2000 BC, Ferghana Valley, Uzbekistan.*

The story of amulets is a continuous one from prehistoric times to the present day. Texts from Sumer show that the evil eye was known from about the fourth or third millennium BC, while amulets survive in huge numbers from Ancient Egypt. A Chinese jade amulet of a boar-dragon from the Hongshan culture of about 3600 to 3000 BC is drilled with a hole to wear as a pendant and is similar to objects six thousand years old. They were used as ritual offerings to deities and spirits for protection, while later ones of the Eastern Zhou dynasty, such as the emperor's amuletic pendant of around 400 BC made of white jade hung on red strings as stipulated in the Book of Rites, were also a sign of status. From 2000 BC stone amulets have been discovered in the Ferghana valley and nearby Bactria in north-western Afghanistan, one in the form of a double snake, and one a ceremonial camel; a chain of gold amulets from the Hallstatt period of the early Iron Age was found at Prozor in Croatia; the nomads of the steppes buried cowrie amulets in their tombs at Pazyryk in about 400 BC. Later nomadic amulets of cowries, and also of animals, figures and hands, were found in the kurgan burials of Crimea dating from between the first century BC and the second century AD. In Ancient Greece and Rome the evil eye was still feared and confronted by amulets, of which Pliny the Elder was the first to write. A pre-Columbian amuletic figure of clay from Peru wears gold earrings, while its future conquerors in medieval Europe could read recipes for amulets, published in *Le Grand et le Petit Albert*, attributed to the thirteenth-century alchemist and philosopher Albert le Grand, and later in *Le Dragon Rouge*, first published in 1522.

Exotica such as powdered armadillo, pulverized pikes' teeth or peacock semen were prescribed to be swallowed, but an alternative was to enclose such magical ingredients in the form of something to be worn, or strategically placed. This amulet could be worn on the body, hung on an animal, placed at a threshold, used whenever disaster or pestilence threatened people's lives, and wherever something precious needed protection (a horse or a newborn baby, for example).

RIGHT *Notice of illnesses the witch doctor can cure, usually with amulets, Babungo, Cameroon.*

BELOW *Sign erected by the local chief to try to persuade people that AIDS is not caused by witchcraft, Babungo, Cameroon.*

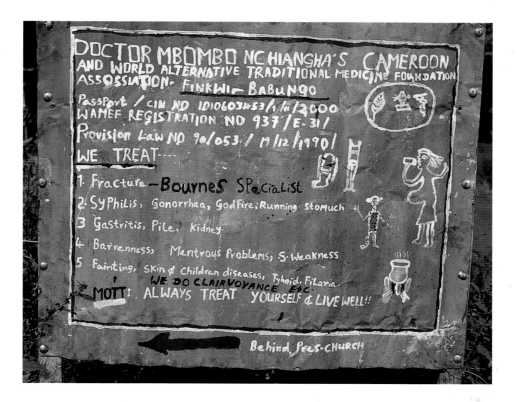

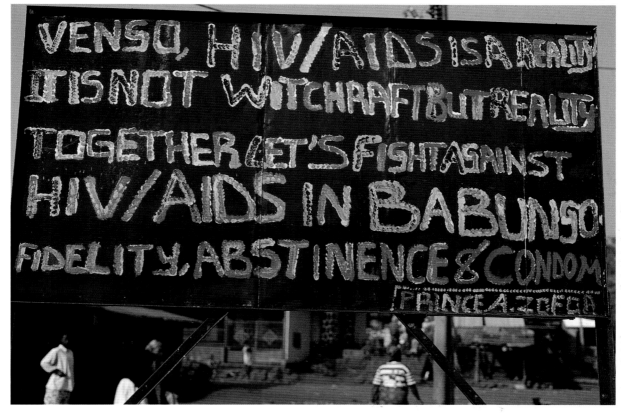

Babies & brides

ABOVE AND BELOW *Baby and little girl at Easter, Olymbos, Karpathos island, Greece. In the matriarchal society of Olymbos, eldest daughters wear amulets and the family wealth in gold coins.*

J. Theodore Bent, Victorian explorer and ethnographer, remarks that the witches of the Cyclades, who haunt the caves and rocks on the mountainsides, are old men and women, past a hundred, whose favourite food is unbaptized babies. As he follows Mrs Gamp, the midwife of Ios, on her delivery calls, he notes that an amulet is put on the baby as soon as it is born.

Small babies are particularly vulnerable to evil and illness. High infant mortality rates – the causes of which are not understood – are confronted by a plethora of beads, stones and bags of herbs hung round the child's neck, when a good meal and a wash would be more effective. The witches of Albania were known to be particularly fond of the blood of babies. Perhaps two would survive of the eight to twelve born, and would be kept in a cradle under a thick coverlet hung with amulets, so that, having no air or light, they 'looked like bleached celery'.

Babies are welcomed into the human race in various ways – in Bulgaria by tying red thread round their wrists, in the Golden Triangle by neck rings put on a few days after birth and kept on night and day. These hold the soul in the body, ensuring the humanity of the child, and protect it from ill. Similar bronze torques were worn by little girls in Palestine to keep away the evil eye. The Rev. A. W. Hands was given one in 1887 by the grandfather of the girl who wore it. He didn't believe in it himself, the grandfather said, but the women liked it.

Boys are very precious and therefore at great risk of the envy and attack of the evil eye. In Albania, for example, they are dressed as girls to confuse the jinn, who will then not bother with them. Among the minority tribes of southern China, evil spirits are held at bay by the children's hats which fool them into thinking the child is a flower or an owl, or, in the case of a boy, even a tiger or a dragon.

Turkmen babies are considered unclean when they are born and are dressed in a loose shift for forty days. It is then given to a dog who will carry it off, dragging it along the ground and leaving behind any evil that might have come from the child. The shift is worn again, the hem left rough and unstitched to free the future reproductive powers of the child and symbolize the continuation of births in the family. As a final precaution the shift is hung with amulets, mainly on the back, making it extremely heavy to wear. Now small Turkmen children prefer track suits.

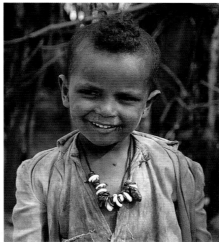
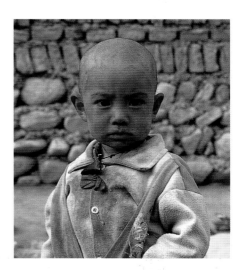

ABOVE, LEFT TO RIGHT *Small children wearing amulets round their neck: Uzbek/Russian boy from Besh Chasma, Uzbekistan; boy from Lalibela, Ethiopia; Uighur boy with herbs in his neck amulet and a red rag, Tashkurgan, south-west China.*

BELOW *Children's owl caps, south-west China. Bai children are dressed in caps to fool evil spirits into thinking they are only animals, birds or flowers.*

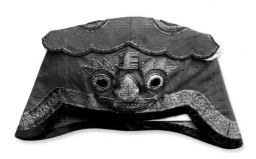

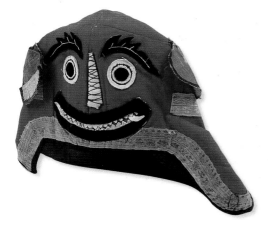

Specific childhood illnesses are often targeted, especially teething problems – usually confronted by coral – and whooping cough, against which, for example in Egypt, a folded strip of palm-leaf, inscribed with a charm, is put round the child's neck.

A menstruating girl is the next most vulnerable person in the life-cycle. Most amulets are worn to guard her fertility, but among the Hausa of northern Nigeria an amulet of leather pouches, enclosing incantations written on paper, was worn round the waist to prevent conception during pre-marital sex.

There are many beliefs concerning menstruating girls and women and the contamination they can cause. In many places they are not allowed contact with an amulet and must keep away from processes deemed magical, such as the dyeing of indigo.

The next vulnerable stage for a girl is that of being a bride. Then she is in the transient state of a rite of passage, neither a young girl nor yet a married woman, and is dressed at her most beautiful. Coveted by the evil eye, she is therefore veiled and adorned with amuletic jewelry to save her. The European bridal veil comes from this tradition, as do pearl headdresses: the sheen of pearls reflects the evil eye and frightens it away, the reflection of light being anathema to it. In the Nasaud area of northern Romania bridal headdresses are still hand-made of pearls and mirrors for this specific purpose.

The custom of decorating the bride's hands and feet with henna also acts as a talismanic protection, as the extremities are one part of the body through which demons are known to enter.

Childbirth is the most dangerous stage of all for a woman, and protective amulets are most commonly placed under her pillow or mattress. These can consist of a Koranic inscription, or a collection of the most powerful forces, such as garlic and gunpowder, sometimes wrapped in crocheted pink acrylic. Latvian women in labour beat themselves with birch branches to drive out evil spirits. A woman's vulnerability in childbirth is matched for a man by leaving home to go fishing or hunting or, worse, to go to war.

19

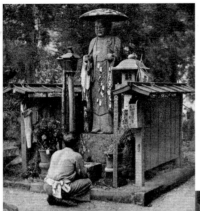

RIGHT *Bai temple bag with tasselled triangles, containing a drawing of a child protector (far right), Yunnan, south-west China.*

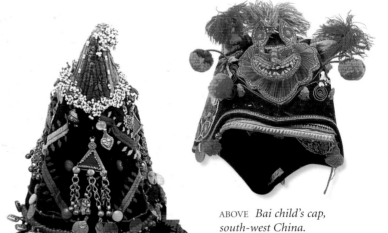

ABOVE AND RIGHT *Jizo, protector of the spirits of children who have died, Japan. Bereaved mothers place clothes and stones on and below the statues.*

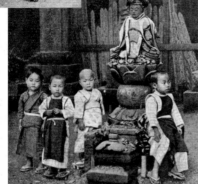

ABOVE *Bai child's cap, south-west China.*

ABOVE AND RIGHT *Front and back of a baby's helmet from the Palas valley, Indus Kohistan, northern Pakistan. The amulets, buttons, beads and talismanic trinkets are bought by men in Pattan bazaar, two days' walk away on the Karakorum highway, as the women are confined to their homes. The back of the helmet forms a shawl to wrap round the baby and protect it from evil spirits and the cold winds of the Himalaya.*

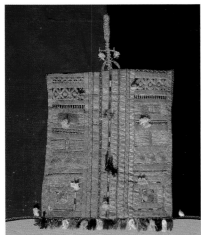

LEFT *Goldwork, tassels and pompoms on a bridal shawl, worn on the seventh day of marriage, El Djem, Tunisia.*

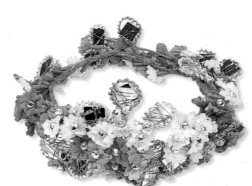

LEFT *Bridal headdress with mirrors and flowers of crêpe paper and tinfoil, Nasaud, Romania.*

BELOW *Tekke child's* kurta *with coins, triangles and jewels, Turkmenistan.*

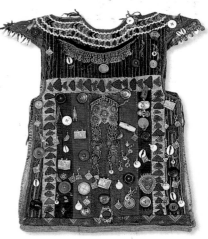

LEFT *Turkmen child's* kurta *(reverse shown below) with jewelry, cowries and buttons, Afghanistan.*

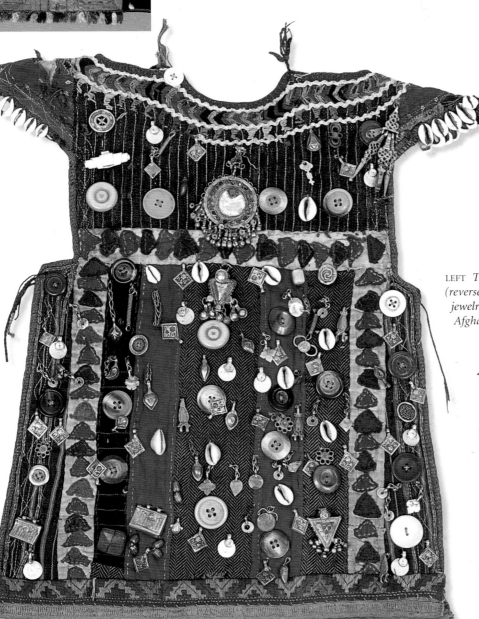

21

Travellers & hunters

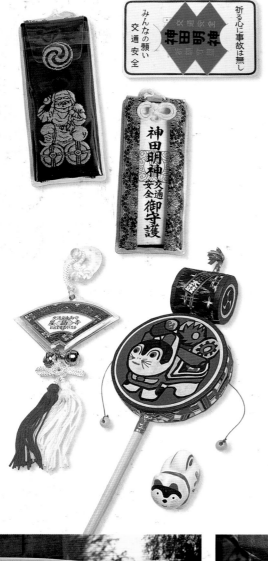

Leaving home is recognized as being a potentially dangerous business, with the chance of stumbling across the vampires and demons that lurk at crossroads, or the simple possibility of being run over. The Japanese traveller in the past employed myriad devices to ensure his safety once he left the vigil of the local deities of home. He scattered bits of raw beans before him (known as effective for demon-clearing), ate pickled dried plum, wrote the character for 'tiger' on the palm of his hand and resorted to many other well-tried magical defences. Still today the majority of Japanese amulets are to protect against traffic accidents.

In Cameroon as well, where a five-seater jalopy pre-dating seatbelts never departs with fewer than nine people, and sometimes even eleven, traffic accidents come high on the list of dangers against which amulets are carried.

Everywhere, the best way to protect from traffic accidents is to hang amulets in the car, usually on the rear-view mirror: crosses, crucifixes, CDs, garlic, red and gold silk scarves, fish, fluffy toys, a one-dollar note, all can be seen at one kerbside in Korça in Albania.

Danger lurks too at the entrance to villages, as in Thailand, Greece and Algeria, where effigies, food, and rags from a diseased person's clothes are usually placed. The passer-by who touches the food or walks over the rags will find the sickness or offending jinn transferred to him.

Not only can the traveller pick up the vagrant diseases of the village, but in Ghana a string of amulets placed in his path – for example, bones of a tortoise, three tails of bush-tailed porcupine, a wooden cigarette-holder and a small unidentifiable bundle tied up in a rag – will mow him down with

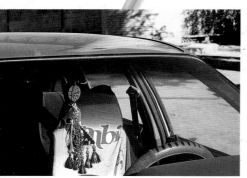

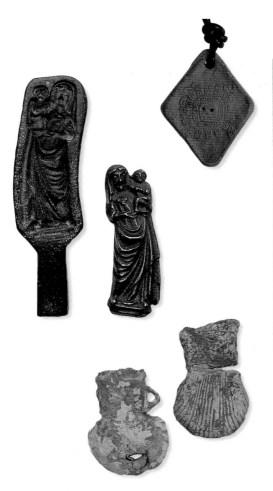

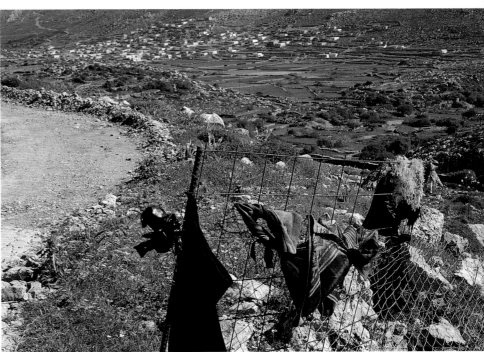

ABOVE, TOP TO BOTTOM *Terracotta copy of sun god's face to protect travellers, made in Peru and sold at Christmas markets in Strasbourg, France; a mould for a pilgrim badge depicting the Madonna and Child, Chirbury Priory, Wales; ampullae for pilgrims to carry, St Davids, Wales.*

ABOVE RIGHT *Old clothes and yellow fishing net hung on a fence at the approach to farmland and the village of Avlona, Karpathos island, Greece.*

RIGHT *Ashanti* suman *causing an enemy traveller to contract venereal disease, Ghana.*

OPPOSITE ABOVE, TOP TO BOTTOM *Protection against traffic accidents: red car sticker with black and gold characters, sold on a card, Kanda shrine, Tokyo; the back (left) and front (right) of a Shinto charm with a Daikoku deity, Kanda shrine, Tokyo; three Japanese amulets for safety in driving and to hedge bets.*

OPPOSITE BELOW, LEFT TO RIGHT *Amulets in a taxi, Uzbekistan; in a bus, Albania; in a taxi, Tunisia; in a car, Uzbekistan.*

venereal disease, presumably removing it from the person responsible for thus ambushing him.

Travellers of a special kind, such as pilgrims, need amulets. Silver ones are made for the pilgrimage of Mari Amman in Tanjore, southern India, while pilgrims of medieval Wales carried small ampullae or models of saints. Traders who ply the ancient salt routes of the Himalaya and the Andes are also protected. In the Himalaya their amulets are effigies in paper of a horse, dispersed in the wind, or prayer flags asking for the protection of Buddha, while the dangers of the high Andean salt routes – bears who will steal the traveller's soul if he pauses where the bear lives, huge insects who live underground and will emerge at night to attack the traveller – are confronted by an esoteric collection

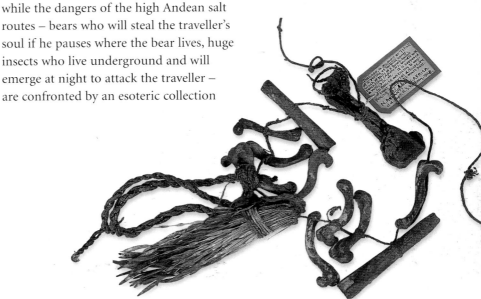

23

of substances, wrapped in a small rag and kept in the pocket. These can include bits of cotton wool, breadcrumbs, salt, coins, mica and wool or silk threads of red, white and yellow.

Like the terrifying mountains, a Finnish forest in the endless gloom of winter could well be thought to harbour supernatural beings, tree spirits and goblins, imaginings born of the long dark nights. Bears that lurk in bracken undergrowth are hunted not just for food but for the mystic power they are believed to hold. Amulets of a bear's skull, its muzzle skin, its paws, bones, dried windpipe and teeth hold this power to protect the hunter. Dating from the Iron Age, amulets of bears' teeth and paws, and bronze replicas of the animal, have been found in graves in Finland and Estonia.

The forest trees yield birch bark, used to fashion amulets for the fisherman. Two pieces are stapled together and carved into a face with cut-out eyes and mouth and incised nose. Such amulets are pinned on a stick and set on a trap of branches where roach and dace spawn: the evil eye is even capable of dragging fish straight out of the water. Other fishermen take a frog and place it in a small box with scraps of linen and fishing net. This they hide under the church to invoke God's protection.

Fishing, like hunting and war, can be a dangerous occupation and boats set sail armed with amulets. Eyes painted on Japanese bows watch for spirits of the river in the torrents ahead, snakes carved on Indian bowsprits are ready to overpower the evils of the deep, while on the fishing boats of Oceania wooden sticks representing ancestors man the fo'c'sle.

Prehistoric stones are also known to protect the hunter and fisherman. In England William Twizel of Newbiggin-by-the-Sea hung a holed black limestone pebble behind his cottage door to protect him as he went to sea. Other fishermen of the village did the same, while those of Great Yarmouth never left port without taking small bone amulets of fish with them, though the purpose of these may have been more to ensure a good catch, on the same basis as the power of a slain bear can be used against a living one in the hunt. As for the bone from sheep's heads, worn by the fishermen of Whitby, they were specifically to protect against drowning. The fishermen called the bone 'Thor's hammer' and so invoked the protection of the god of storm and thunder.

ABOVE *Snake's head on a fishing boat, Gwadar, Makran, southern Pakistan.*

RIGHT *Fishing amulet, Chukotka, Siberia, Russia.*

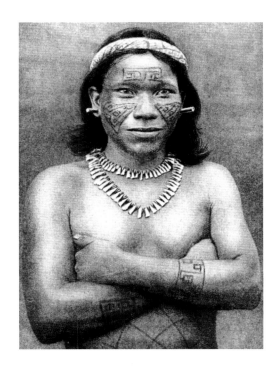

ABOVE *Amazonian tribesman, tattooed to denote his rank, and wearing a peccary tusk necklace to show his skill as a hunter, Brazil.*

BELOW, LEFT TO RIGHT *Hunting amulet of mammoth bone, with a face looking up to the sun and animals painted on the bone base, Chukotka, Siberia, Russia; hunting amulet in the form of a bear, Chukotka, Siberia, Russia; Baule hunter's hat stitched with leather amulets, claws, and red and indigo fabric, Ivory Coast.*

Whaling might be considered to be both hunting and fishing, and when the spring ice breaks at the end of the long Arctic winter, the Inuit, Eskimo and Aleut prepare their kayaks and make amulets for the start of the whaling season. Seals and sea-otters are carved in ivory, and male and female faces in wood. They are fixed on the boat to combat evil sea-dwelling spirits, are kept in boxes, or are worn hanging round the neck or from a belt, or stitched to a parka. That such objects are more than just lucky charms is shown by the case of the hunter whose kayak was equipped with an ivory sea-otter, which in 1881 he refused to sell, knowing he would die if he did.

The hunting hats of the Arctic were visors against glare that afforded status and protection, disguising the wearer as a seabird and bringing him the magical protection of the bird spirit. These hats, often topped with long bristles, had bone or ivory amulets attached in the form of human figurines or heads, heads of birds, walruses and sea mammals. The beak of a loon was also worn on the hunter's head, as the migrations of this bird give it some affinity with the whale.

Such beautiful headdresses and carving were believed to please the hunted animal, as were the painted caribou coats of the sub-Arctic, so that the spirit of the animal would help the hunter who had showed him such respect. Hunting amulets, particularly of the North American Indian, thus tend to be very decorative – a bear's chin or loon's head will be encased in ornate beading. Those of the Zuni are made of stones carefully carved into the recognizable shape of the animal, whose power again is transferred to the owner. The Zuni traded such stones for many years with Navajo and Pueblo Indians, who used them for hunting.

In most parts of the world, animal parts form the basis of amulets for hunting and fishing, though in Oceania carvings of ancestors and protective spirits will be fixed to a boat to ensure its safety, or as a trap to lure wild animals into it.

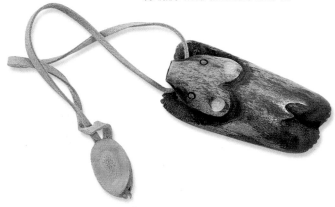

Warriors & weaponry

ABOVE *Ashanti warrior's coat covered with leather amulets, Ghana.*

BELOW *Warrior's tunic hung with leather amulets, Mali.*

*I*f carrying a bear's jaw is expected to protect from the attacking animal, or a carved ivory sea-otter to save a boat from thrashing whales, how much more fragile is the belief that amulets will protect a man in war. A balistically armed foe is valiantly opposed with, in Japan for example, paper charms made especially for soldiers, and sometimes printed in red with the character for Fudo, the war god. Others might be of wood, decorated with black characters and a red seal, and wrapped in paper. These were replicas of an amulet taken successfully into battle in the seventeenth century by the future Governor of Japan. Faith in its power lasted for centuries.

If paper seems flimsy against arrows, it was used against bullets in the 1948 War of Independence of Israel, when printed amulets were published by private individuals in Jerusalem for Jewish members of the forces defending the city.

Bits of cotton seem hardly more effective, but waist cords of cotton were worn for safety by the native allies of the British in East Africa when other natives attacked a British outpost. One assumes this was not normal army issue.

Protection was often afforded by amuletic clothing. The King of Foumban in Cameroon, who died in 1933, set off on war expeditions protected by a rough brown hessian robe sewn with leather amulet pouches and, hanging at the front, an animal penis and testicles covered with leather. He also wore, specifically for war, a quilted cap, each section of which contained an amulet.

In Myanmar and Thailand, cotton shirts covered with magical squares and circles were also expected to ward off bullets, while for many headhunters of south-east Asia – the Nagas of north-east India, the Nias of Indonesia – it was the life-force in the trophy skulls of their slain enemies that protected them as they went again to war.

Carved wooden shields have perhaps a slightly more practical power, though their decoration is assumed to be as protective as the shield itself. Roman legions emblazoned theirs with motifs of the sun or of Minerva as the war goddess, while in the nineteenth century the warriors of the Trobriand Islands in Papua New Guinea depicted on theirs the vagina of a terrifying witch.

As in hunting, where the power of a slain animal is invoked in its claws or teeth to help kill the next one, for the Baule of the Ivory Coast it was the

RIGHT *Shield decorated with an ancestor with staring blue eyes turned towards the enemy, northwest Irian Jaya, Indonesia. Towards the end of the nineteenth century war was banned in the region and the shields were turned into use for ritual.*

FAR RIGHT *Wooden shield depicting a witch's vagina, Trobriand Islands. Only the most courageous warriors could carry this shield, which was sprayed with narcotics by a special 'war magician' to strengthen it and its bearer.*

BELOW *Kenyah shield painted with a red and black human face and adorned with human hair taken from the heads of slain enemies, Borneo.*

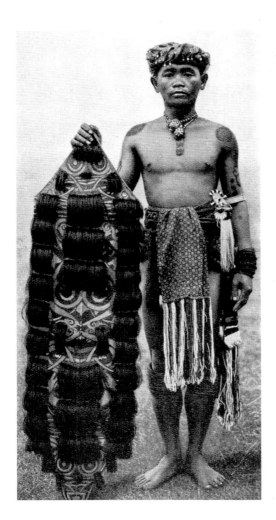

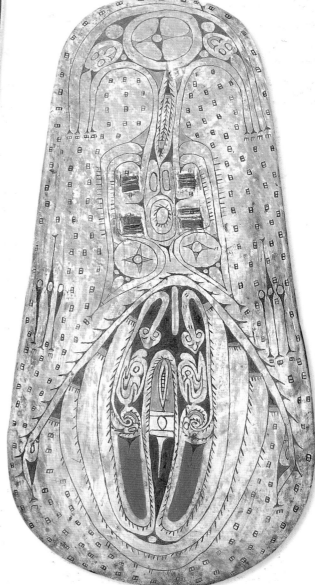

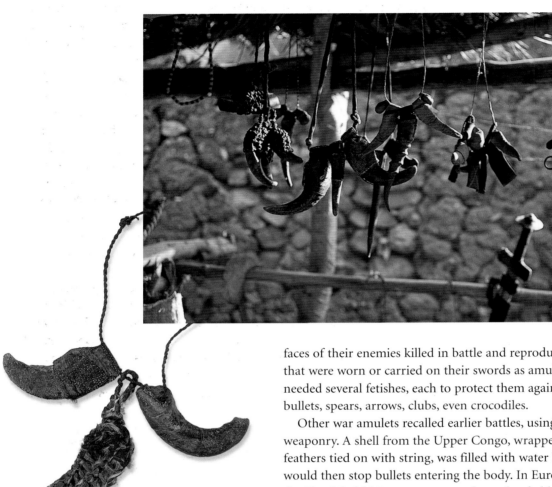

TOP *War amulets being sold by the owner as tribal wars were no longer an everyday event, Roumsiki, Cameroon.*

ABOVE *Amulet to take to war, consisting of three horns, one wrapped with strips of animal fur, similar to those above, Cameroon.*

RIGHT *Gun holster cover with silk embroidery and white beads, Ghazni, Afghanistan.*

faces of their enemies killed in battle and reproduced in small bronze masks that were worn or carried on their swords as amulets. Other African warriors needed several fetishes, each to protect them against a particular danger – bullets, spears, arrows, clubs, even crocodiles.

Other war amulets recalled earlier battles, using surviving pieces of weaponry. A shell from the Upper Congo, wrapped in strips of leaves and feathers tied on with string, was filled with water before going to war, and would then stop bullets entering the body. In Europe amulets of the First World War were commonly made of old bullets and splinters of shells: the French surmounted theirs with the tricolore, and the Italians fashioned bullets into the *fica*, the amulet hand of obscene gesture. For the Jews of Morocco charms were written on a flattened bullet and worn round the neck to make them immune to gunfire.

A thriving trade was carried out in Scarborough during the First World War, recycling German shells as amulets of horseshoes and Maltese crosses.

In North America, Chief Sits-as-a-Woman, of the Gros Ventre tribe of Plains Indians, was the owner of an amulet made from the butt plate of a musket, enclosed in a muslin bag and a rawhide envelope containing fragrant balsam needles. He wore it into battle and survived to sign the treaty of 1855.

For other tribes of the Plains and Woodlands, war charms to stop bullets penetrating the body were in the form of headdresses representing the crest of a woodpecker, or necklaces of fur, feathers and beads, and war-bonnets of feathers symbolizing previous brave exploits of the tribe.

The Sioux of the Ghost religion, which predicted the extermination of the white man and the resurgence of the buffalo herds, wore muslin shirts believed impervious to bullets, hung with rabbits' feet, feather necklaces and feather headdresses with brass bells. The ringing of the bells sounded like the hail of gunfire from the Europeans, perhaps pitting like against like. However, 127 of their warrior dancers were massacred by the United States military and, soon after, at Wounded Knee, their hopes and dreams ended.

No less valiant were the Tibetan soldiers, wearing amulets inscribed with Buddhist scripts, who were massacred at Tuna on 30 March 1904 during a British military expedition to Lhasa. The soldiers simply walked on, contemporary reports stated, believing their amulets would make them invulnerable to bullets, and were mown down.

The battle of amulets against bullets seems inevitably a losing one. In December 2003 a Nigerian witch doctor was shot in the head and killed by a potential customer testing the efficacy of the amulet the witch doctor was trying to sell him. However, sales of inscribed neck pendants of clay or metal have recently escalated in Thailand, following the deaths of many dealers. Criminals will often pay as much as ten million baht – about $370,000 – for an amulet made by a highly revered monk or with a known history of

ABOVE *Cloth of magical figures in squares, from the tent of King Theodore of Abyssinia, present-day Ethiopia.*

BELOW *Cloth and metal amulet, and embroidered bag with small string of blue beads, taken from a tribesman after a night attack on Kabul during the Afghan War of 1879–81; the letter (far right) describes the acquisition of the objects.*

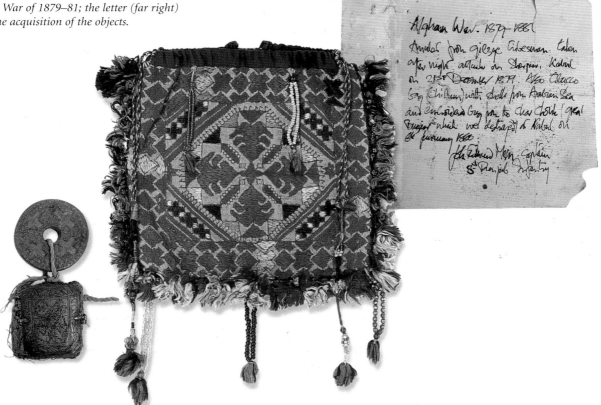

protecting from bullets and car crashes. Such astronomical amounts have even led to amulets being traded for illicit money laundering.

On a more modest, and legal, scale, padlocks are another war amulet, but to be effective, these have to be blown through first and then carried in the top right-hand pocket. In May 2003 five Mai Mai warriors from the Congo, defending themselves against bullets by wearing magic amulets, were killed by Zambian troops. Amulets against bullets and war can still be bought in West Africa. A witch doctor's roadside stall displays the shell of a tortoise: he fills this with a secret powder that protects against guns and arrows, and covers it with white goatskin. The asking price is £15 ($24), but if you seem ready to pay that, he raises it. Other amulets available and used are small cotton bags filled with 'medicine' and sewn with beads, cowries and hair-covered skin, and also pieces of cactus, whose spikes are effective against both bullets and lightning.

In Afghanistan and Pakistan guns themselves are protected by embroidery.

And Dr Bashiruddin Mahmood, a senior director of Pakistan's Atomic Energy Commission – claimed to be working with Osama Bin Laden in Kabul on developing a uranium bomb – believes in spirits and recommends that 'jinn should be tapped as a free source of energy' to fight back against America's arsenal in the war against terrorism. Like a genie in a bottle, the energy of a jinn could only be held in an amulet.

Warriors wearing headdresses of white cockatoo feathers and tasselled cords, breastplates made of fibre cross-belts sewn with disc-like shell sections, necklaces of tusks, and fearsome nose ornaments, western New Guinea.

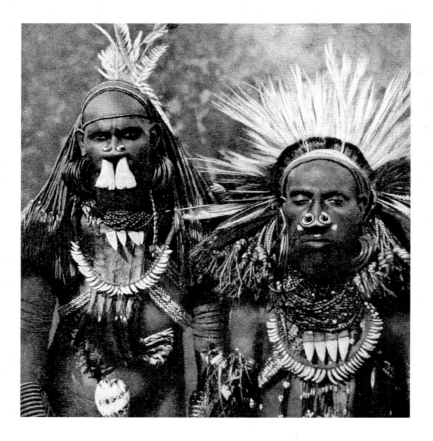

Body & soul

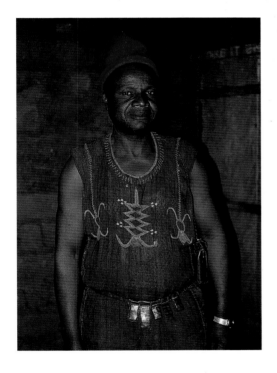

Whoever the person to be protected – soldier, traveller, newly-wed – the most common way for an amulet to be worn on the body is as a pendant round the neck, preferably next to the skin and often concealed. It can be hidden inside clothing, tucked in a turban, hung on a keyring. The top right-hand pocket – or indeed any pocket – is another place to keep an amulet, chosen for its secrecy. There is an almost worldwide shame in the wearing of amulets, though not in hanging them in public, such as on a barn or gate. The most visible personal amulets in the Islamic world are those worn round the necks of children, who are not expected to have any understanding of the disapproval of Allah at the use of the Koran in a magical context and thus in the service of the devil.

The idea that a circle protects from invasion is behind many a necklace of amulets, as well as the neck torques that capture the soul, such as those of Thailand. Amulets forming a belt or hung on one have the same function, as the waist is associated with the life-force. A marabout in Cameroon, for example, wears a belt of amulets that will protect him from sexual disease. He can sit among a group of women and, if one he fancies has some sort of venereal disease, his belt will come loose and warn him to keep away. A girl in Estonia would make numerous belts ready for her married life, and in the

ABOVE *Fulani Muslim marabout wearing a belt to warn against sexual activity, and a waistcoat to protect him from attack, Babungo, Cameroon.*

RIGHT *Garo woman wearing heavy earrings, India. She believes that the devils, waiting to devour her soul after death, will fight over the earrings, thus allowing her to escape.*

FAR RIGHT *Makonde woman wearing lip disc and neck rings, Kenya.*

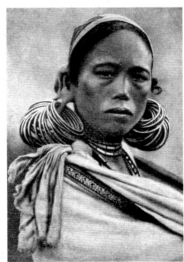 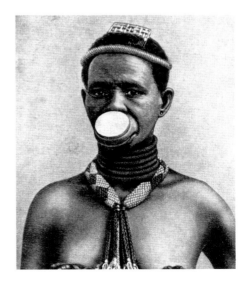

meantime carry them on all her domestic tasks, to protect her from the evil eye and look after the animals and crops she tends.

The wrist is another bodily region for amulets. Bracelets of copper that protect from rheumatism are common – even Prince William has been photographed wearing one – while those made of twisted cord and blue beads are sold in every Greek market.

Amuletic bracelets are worn around the upper arm by men in Eritrea and other parts of Africa, while African women wear theirs as jingling anklets that protect them from the evil spirits of the underworld. The tremendously heavy ankle bracelets that men of Gabon put on their wives both shackle them and scare away these same spirits.

Certain parts of the body need special protection, often associated with ancient beliefs. The ear is not only vulnerable as a body orifice through which spirits can enter, but was also thought to hold the soul. In Albania it was believed that life depended on a worm living in the ear, while in Brazil certain tribes still believe that piercing the ears directly affects intelligence as it is in the ear that this resides. The ears of baby girls in Central Asia and India are pierced in several places when the child is only a few months old, so that she can be protected all her life, as many earrings are amuletic. Kazakh girls and women are buried wearing earrings so snakes cannot enter their ear and attack them. Pinning triangles and various baubles over the ears on children's bonnets is also thought to offer protection. Heavy embroidery on the shoulders and sleeves of clothing, particularly on the shifts of Eastern Europe, fulfils the same function.

The mouth and nose are also vulnerable orifices. It is believed that the soul can escape by the mouth, and evil spirits enter by it. Veiling the mouth prevents this, as does the lip plug of the Lobi women of the northern Ivory Coast. Nasal ornaments of the women of many parts of Africa, and of Papua New Guinea and the Solomon Islands, are also worn to protect from evil spirits and disease, while those of India are usually purely ornamental.

The back is also considered at risk, as evil spirits tend to attack from behind, catching their victim unawares. The thick, long plaits of the women of Central Asia offer a hold for the evil eye to crawl up, and they are always covered with tassels, silver and coral, and pendants of embroidery, while the strip of cloth linking the vestigial sleeves of their cloaks and coats is frequently hung with amulets. Nigerian women wear striking buttock covers that protect against evil spirits, while at the same time attracting the attention of men.

BELOW *Extremely heavy brass ankle bracelet placed on Bakota women by their husbands, ostensibly to protect them from evil spirits of the underworld, but also to prevent them from running away, Mekambo district, Gabon.*

LEFT *Rashaida woman's face mask with silver, red fabric and triangles, Sudan.*

RIGHT *Strip of fabric, hung with coins and red appliqué triangular amulets, used to link the vestigial sleeves of a Tekke woman's cloak, similar to that shown below right, Turkmenistan.*

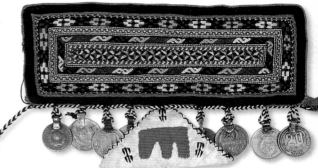

BELOW *Back view of a Tekke bride wearing a cloak known as a* chyrpy *over her head, Turkmenistan.*

BELOW *Woman's tie-dye face mask, Sana'a, Yemen.*

ABOVE *Tasselled cover for a woman's long hair, Tajikistan.*

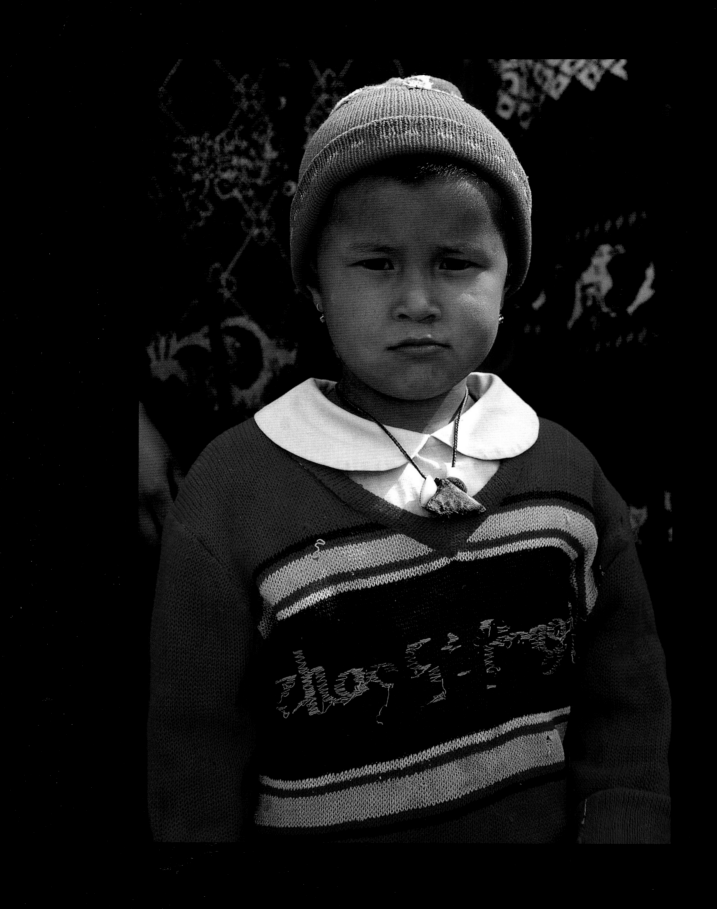

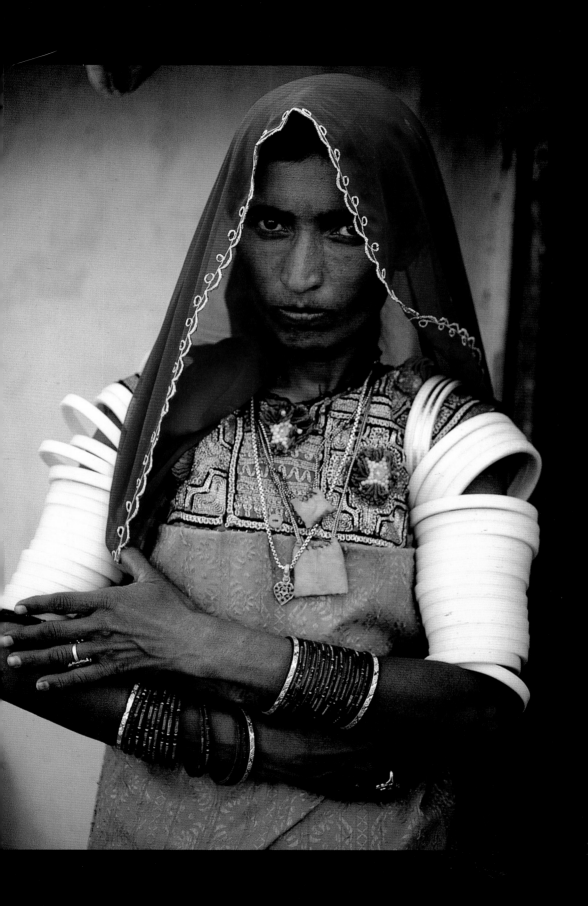

It is particularly in the decoration of clothing that the body is protected. Embroidery on costume more often than not plays an amuletic role by its positioning, colour and motifs. Seams, hems, wrists and neck edges, where spirits are most likely to slip under clothes and cause disease, are stitched in multicoloured thread. The breast area is covered with embroidery, in Siberia with red triangles, while in Baluchistan slits to facilitate breastfeeding are decorated with coloured triangles that protect the mother's milk, the source of life for the baby. The genital area also carries a focal point of embroidery, as in the dresses of the Sayyid community of Kutch in north-west India.

PRECEDING PAGES *(left) Small girl wearing a neck pendant, Kunya Urgench, Turkmenistan; (right) Rabari woman wearing neck pendants, Kutch, India.*

RIGHT *Woman's shift for consummation of marriage, the back stained with blood. The small black patterns are the same as tattoo motifs, El Djem, Tunisia.*

BELOW, LEFT TO RIGHT *Embroidery round the pocket of a coat, Aleppo, Syria; embroidery round the pocket of a coat, Beit Saber, Syria; triangles decorating the slits for breastfeeding on Baluchi clothing, Afghanistan (ornate embroidery also covers the genital area); typical dress of the Sayyid community, with a five-leafed pattern embroidered over the stomach, Kutch, India.*

OPPOSITE, CLOCKWISE FROM TOP LEFT *Dress front decoration hung with silver and cornelian amulets, Karakalpakstan; Geija courting apron with red silk embroidery and batik spirals, Guizhou, south-west China; woman's dress appliquéd over the breasts with fabric triangles, silver thread and green floss tassels, Sa'da, Yemen; Sarakatsani ritual apron with solar motif, northern Greece; Berber breast pendant of floss silk in solar colours, beads, bead triangles and cowries, to be buttoned onto a marriage gown, Siwa oasis, Egypt.*

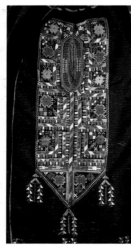

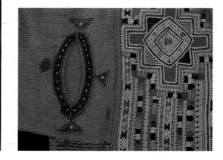

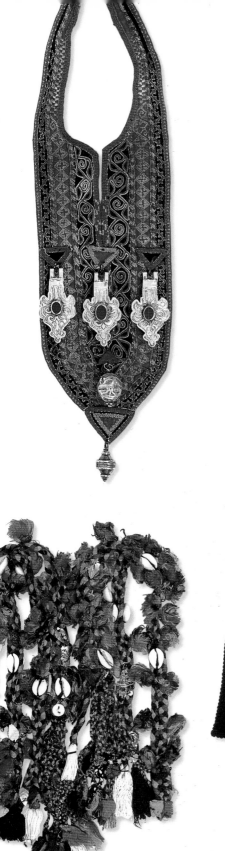

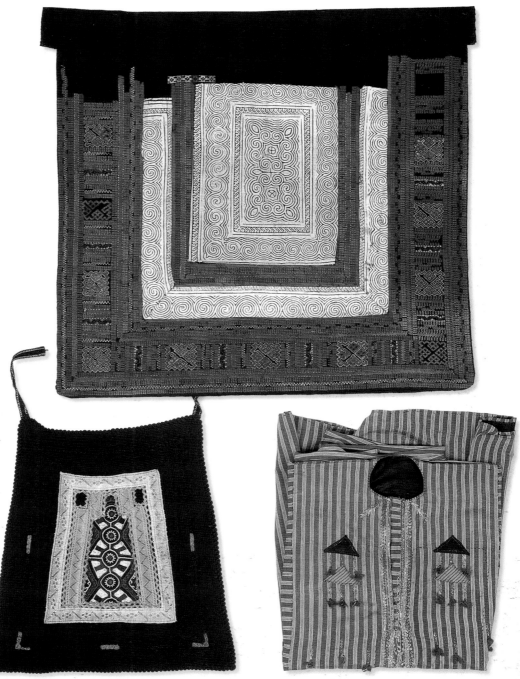

Embroidered aprons play a potent amuletic role in many parts of the world, in particular east and central Europe, protecting the body rather than the dress. The deep pockets of the dresses of Baluchi women are for this purpose, and are sometimes closed by stitching, indicating that they play no practical role. Just the decoration round a pocket is often considered sufficient to protect the money and keys it holds.

ABOVE RIGHT *Maori couple wearing* lei tiki *pendants and* moko *tattoos.*

OPPOSITE, CLOCKWISE FROM TOP LEFT *Masai wood and leather amulet to stop goats wandering, Kenya; bunches of dried flowers and herbs tied with red rag and fixed to a stable door, Orlat, Romania; camel-hanging with hair, tassels, cotton reels, embroidered solar patterns, and bells and tin lids that rattle, Tajikistan; horse protected by red hair tassels and beads, Kashgar, western China; four wooden cattle amulets, Afghanistan.*

PAGES 40–41 *Hennaed donkey, Turbat, southern Pakistan.*

Decorating the body itself, as with henna or by tattooing and scarification, may also have an amuletic function, though the *moko* of the Maoris and the body-marking of Polynesians have a much deeper significance. Tattooing was frowned upon by Christian missionaries and forbidden by Islam, though it is still common, particularly on women, in the Muslim world. Patterns of tattooing are often duplicated in embroidery, as on the molas of the Kuna Blas of Panama, and the shifts of Tunisia.

Animals, as a source of wealth, merit the same protection as humans. Donkeys and horses, from Sicily and Corfu to Afghanistan and China, wear necklaces of blue beads, and red tassels tucked into their harnesses. The horses that pulled the carriages of Naples a hundred years ago wore trappings of bright polished brass, vaunting bells, horns, wolfskin, wolves' teeth, boars' tusks, bright ribbons, pheasants' tails, pictures of saints and angels – a 'powerful battery of resisting charms, so that an evil glance must be fully absorbed, baffled or exhausted before it can fix itself upon the animal'.

Cows, led from door to door in Naples to be milked, and so frequently exposed to the evil eye, were protected by a metal star. Today, in the mountain valleys of the western Himalaya, a carved wooden amulet hangs on the cow's neck, that exactly matches the pattern embroidered on the babies' bonnets of the region. In Japan, it is a rectangle of wood, inscribed with characters, that protects from evil; in Africa a lump of wood or bone that shows the animal the way home and prevents it being led astray by demons.

Animals of traction – and their mechanized replacement, the tractor – are also often hung with amulets. In Eritrea, camels gathered for market in a dry river bed sit patiently chewing, blue beads hung around their halters.

As animals are protected, so too are crops – usually by a scarecrow – and also farm buildings such as stalls, stables, barns and pens. In western China, where pigs are their main source of income, the women hang their old tie-

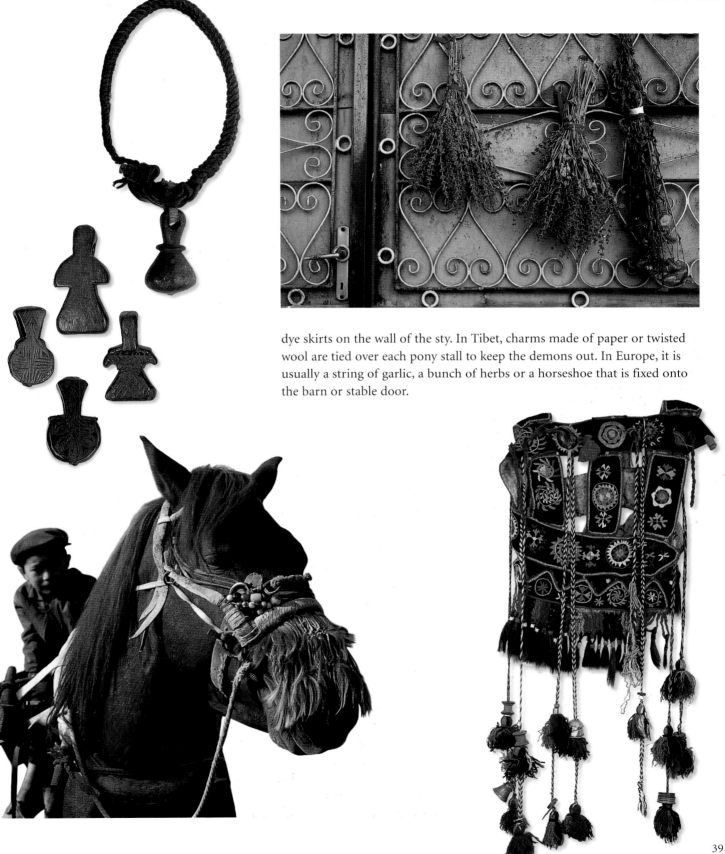

dye skirts on the wall of the sty. In Tibet, charms made of paper or twisted wool are tied over each pony stall to keep the demons out. In Europe, it is usually a string of garlic, a bunch of herbs or a horseshoe that is fixed onto the barn or stable door.

39

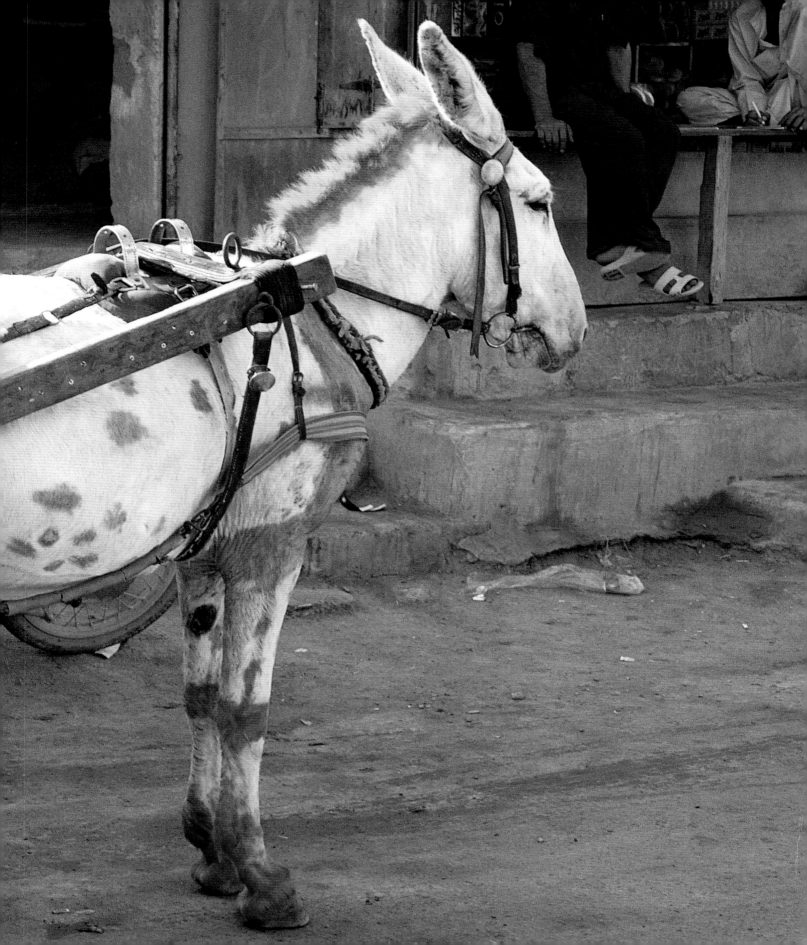

House & home

Albania's pyramid investment scams of 1997 were followed by fierce rioting. Believing the government to be responsible, protesters destroyed schools, hospitals, hotels, museums, shops, every building thought to belong to the State. In the old fortress town of Gjirokaster, rebuilding is slowly beginning and on all the rough concrete slabs that will be new floors and roofs dangles a woolly toy – a lamb or teddy – or a lolling, legless doll. These are amulets to protect the new building from the evil eye that surely was responsible for all the pent-up anger that destroyed the old one.

Toys with a touch of red – a ribbon, say – are believed to be the most powerful, though a doll missing an arm or a leg, or better still its head, is especially prized. On the walls and over the doors of houses are also animal skins, horns and horseshoes, which were there long before the rioting.

The protection of buildings is common in most parts of the world, particularly those under construction. Topping-out ceremonies, celebrating the roof being put on a new building, are still held in Europe, while in southern India an earthenware pot painted with a horned devil is placed upside down at the threshold of a house being built. Gargoyles guard the

ABOVE *Pink and yellow fluffy toy and plastic fish on the balcony of a house under construction, Gjirokaster, Albania.*

RIGHT *Horns on a house gable in a Carpathian village, Ukraine.*

OPPOSITE TOP LEFT *Embroidered yurt amulet, Mazar-i-Sharif, Afghanistan.*

OPPOSITE TOP RIGHT *Door hanging of the Chodgui people, with tassels, rags and plastic gew-gaws, Turkmenistan.*

OPPOSITE BELOW, LEFT AND RIGHT *The beckoning Japanese cat, originally to ward against demons, now to repel competition and attract custom, as in this shop window in Paris, France (left).*

cathedral of Notre Dame in Paris and the college buildings of Oxford; devils' faces carved in wood, and iron motifs of the sun, protect the churches of Norway; the obscene sheela-na-gig opens her legs and vagina over the doors of the churches of Ireland.

Shops use amulets to attract custom and repel competition. The beckoning cat of Japan sits not only in windows there, but also in those of Japanese shops and restaurants in Paris, London and Toronto. In Naples, the macaroni dealers, the apothecaries, the butchers and cobblers were protected by horns and angels. In Bukhara, in Uzbekistan, a textile shop in the old capmakers' bazaar – a cluster of domed stalls where the silk roads crossed – has a wasps' nest by the door, while in India and Central Asia, embroidered triangles and bands hang across entrance-ways.

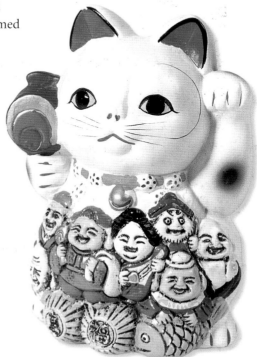

For houses it is the vulnerable points of entry – gates, doors, windows, chimneys, gables – that usually carry an amulet, of which

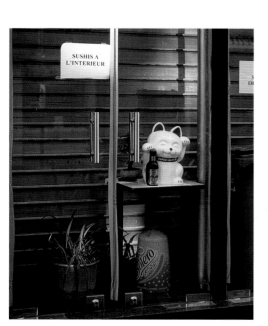

horns and horseshoes are favourites. Even the apex of a tent or the opening of a yurt will be decorated.

White hawthorn or white paint, patterning in brick, heads carved in stone (a device of Celtic origin), crosses, floral designs, all have the talismanic power to protect not only the house itself but its inhabitants. Indoors, it is the places that retain some aura of the sacred – thresholds, hearths, holy corners, the beam facing the entrance, the bedroom door – that are protected,

ABOVE *Flowers round windows, Vlcnov village, Moravia.*

RIGHT *Madonna and white painting on house, Ciçmany, Slovakia.*

OPPOSITE ABOVE *White paint round windows in a Carpathian village, Ukraine.*

OPPOSITE BELOW *Paintings and white rags on a house façade in a Carpathian village, Ukraine.*

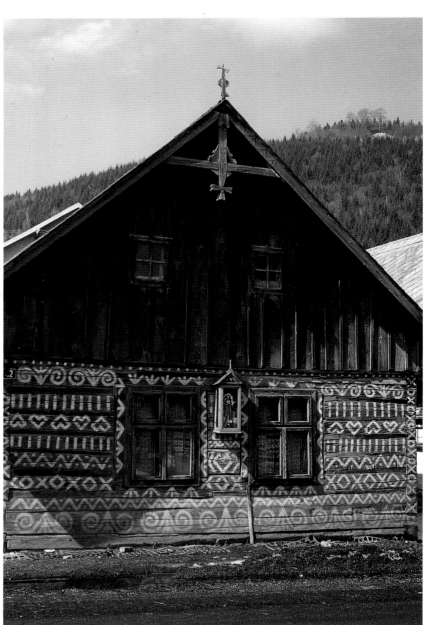

RIGHT *White paint round windows, Rada, Yemen.*

BELOW *White paint under a window, Babungo, Cameroon.*

BELOW RIGHT *Painting and amulets round a doorway in a Khuri village, Rajasthan, India.*

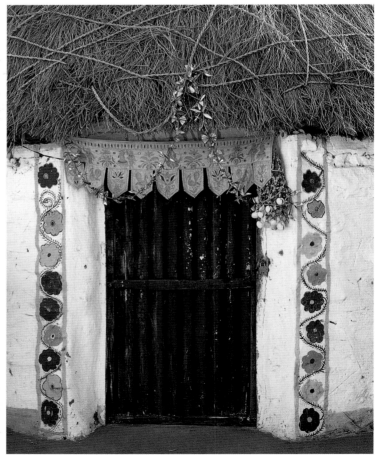

BELOW RIGHT *House protector for Guyan festival, Japan.*

FAR RIGHT *Embroidered cloth protecting the hearth, Ciçmany, Slovakia.*

BELOW *Embroidered cloth round the main support of a house, symbolizing the man of the household who is usually away working in Philadelphia, Olymbos, Karpathos island, Greece.*

often with textiles. Thresholds are raised to keep out the evil eye; embroidered cloths are draped around icons, ceramic plates and window frames.

Spirits are known to frequent frontier spaces that hold special powers: the fences and gates of Europe, even the overlapping logs that form the corners of wooden houses, are marginal areas between the chaos of the supernatural and the order of human space. The neat patterning of a wattle fence defines such order; the spikes on a picket enclosure hold back such chaos. The compounds of Africa are set at each corner with an unusually patterned leaf, or a stick of dead palm and an amulet stuck in the ground with an egg on top, to keep out evil people and the vampires who come disguised as animals.

These are the homes of the living, but supernatural beings also have their dwelling places. Crossroads are one of the most potent. In these magic and unclean places witches meet, while evil spirits, jinn and goblins who lead the innocent traveller astray live there. In Russia, those who have committed suicide and the unidentified are buried there, along with icons. In Zanzibar, while the spirits who dwell in caves or ruins or trees are given offerings of 'potsherds, rags and other valueless trifles', the spirits of the crossroads receive only offerings that are 'very worthless – a handful of grass will do, though I have seen unripe fruit, a piece of tobacco, a stick of muhogo and other odd things'. In Cameroon, men place herbal charms at crossroads to stop women 'wandering about', that is, being led by the spirits there into indulging in adulterous affairs. They also take the mentally ill there, dress them in masks and make them dance in all four directions. The illness will leave them by one of the roads. In Romania, wooden shrines sheltering a crucifix are erected at crossroads to save the wanderer from taking the wrong path.

As crossroads are a place of confusion, so too are large markets. Witches hide there during the day, absorbing the power of trading, and are aroused at night, so people in Cameroon scoop a little earth from each corner of the marketplace and take it home to protect them while witches are on the prowl.

If witches flourish in disturbing settings, they also haunt calm, quiet places such as lakes, wells and springs, the seashore, trees, mountains and islands, caves and stones and graveyards, especially by moonlight. Horns, apples, crosses protect gravestones; rags bedeck trees. Holy shrines too are the abode of evil spirits, as also are latrines. Midnight in the latrine is very dangerous in Cameroon, as is the early morning. Witches and vipers there wear women out, then turn into animals and make love to them. In Russia, it is the bathhouse at midnight that is feared. Protective amulets are taken off with clothing – the cross from the neck, the belt from the waist – leaving the bather vulnerable in an environment seething with magic.

OPPOSITE TOP *Intricately constructed fencing in Fono village, with thorns and an amulet to keep evil spirits out, Eritrea.*

OPPOSITE CENTRE AND BELOW *Neatly spiked and woven fencing from various villages, now in folk museums in Bucharest and Sibiu, Romania.*

RIGHT *Apples on a gravestone, Kolomiya, Ukraine.*

BELOW *Crucifix with religious paintings in the centre of a crossroads, Gura Râului, Romania.*

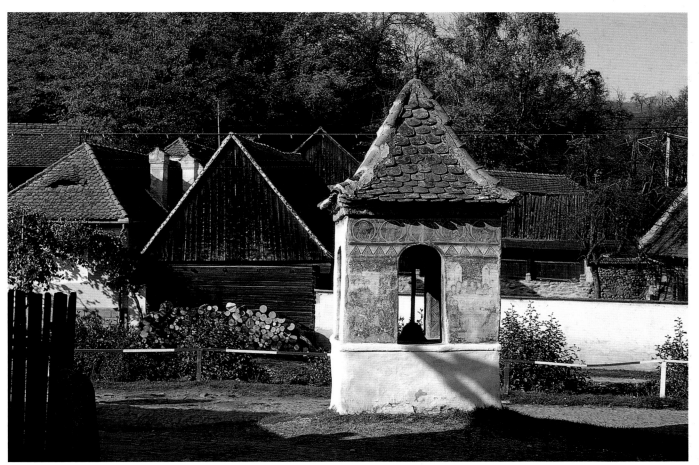

Trade & profit

The fears of the gullible, not only of the night and all its demons, are catered for by commerce and, as in all trade, fashions come and go. Lionel Bonnemère, French collector of amulets in the late nineteenth century, records the trends in Paris at that time. By 1887 lucky pigs hanging on rings were no longer considered *le dernier cri* and by 1896 it was four-leaf clovers that were all the rage. Tradesmen around the Sacré Cœur sold small metal statuettes of St Antony of Padua in a case convenient to carry in the pocket. One hundred and twenty francs, a huge sum in those days, would buy a selection of amulets mostly made in Vienna. By May 1900 it was the tortoise with movable head and feet that was the height of fashion.

In the same year, however, Bonnemère was shocked to find versions of the four-leaf clover on sale everywhere that were overtly pornographic, and even marketed as postcards. He notes that the first of the four leaves shows just a man's feet together with a woman's: 'and this is only the first meeting'. On the second leaf the man is going off with the 'tart' he has just picked up. On the third the man and woman are lying down together, with their shoes still on. 'This must,' declares Bonnemère huffily, 'be taking place in the countryside.' The fourth leaf is a graphic depiction of love-making. Below this, in gold letters, is the French word '*Porte-Bonheur*'.

'I cannot understand,' continues Bonnemère, 'why the police have not stopped the sale of this disgracefully lewd card. Although the motto is in French, the descriptions are in several languages, and I can only presume it was published abroad, as it is hardly a custom of ours to give information in anything other than French. I would not be at all surprised if this piece of depraved smut were not, in short, of German or Austrian origin.'

Austria was a source of many amulets in the nineteenth century and the firm of Sachse in Vienna produced objects specially for the Far East and African markets. They dealt in metal charms stamped with Hindu deities for India and Indonesia, and others in thin brass with Arabic inscriptions for Muslim India and the Middle East, while for the West African native trade they imitated the coral *mano in fica* of Italy in red glass.

The glass of Bohemia was another material of traded amulets. Versions of canine teeth, three-fingered hands, rings and discs made of glass, often opaque and decorated with coloured dots, were widely sold in West and Central Africa. In Islamic North Africa, and also in the Middle East, amuletic

necklaces of cornelian pendants, shaped like arrowheads and strung on red cords, were made in Mecca and traded everywhere. Amulets were considered important enough to be shipped on. One example of a charm of blue and white beads, worn by babies against the evil eye, is believed to have been made in Birmingham for Venice, from where it was sent on to Fes in Morocco.

Amulet making is an established industry in Lebanon and Egypt, producing especially hands, eyes, scarabs and Koran containers. Egyptian scarabs were already found in medieval Scandinavia and Russia. Jewish amulets have been traded since the sixteenth century, and generally keep to the same format, requesting divine assistance for the bearer. The Muslim Hausa people of West Africa dealt in charms containing Koranic verses and 'medicines', selling them to the non-Muslim Ashanti who had great faith in them.

J. B. Millot of Nancy made amulets of balsam, while silver-gilt medallions, inset with pink and blue beads and 'worthless pearls' from the rivers of Saxony, were traded in profusion around Switzerland and Germany at the end of the nineteenth century.

The church was often involved in the amulet market. Amulets were sold throughout Europe at pilgrimage churches and at Ascension-tide fairs. Even missionaries would make money for the church by disposing, through church missionary societies and bazaars, of amulets removed from their owners in the hope of weaning them from pagan beliefs. One – a bracelet of brass and iron – acquired by an M. W. Bailey from a starving Wanyika tribesman in the great East Africa famine of 1899 was sold in the very same year at a missionary bazaar in Oxford. The tribesman had parted with it most reluctantly, Bailey noted.

Today religious establishments are still among the main traders in amulets. In Japan, Shinto shrines and Buddhist temples sell pieces of paper inscribed in red, or small paper bags enclosing a few grains of rice. These cover most eventualities – flood, fire, lightning, earthquake, disease and accidents – or bring good luck in exams. In most of the Orthodox world – Greece, Albania, Romania, for example – on 15 August, the Day of the Assumption of Mary, churches and monasteries sell bracelets and crosses of twisted black thread decorated with blue beads or tiny blue Madonnas. And in Ethiopia, Coptic priests, resplendent in gold brocade, sell little paper twists of the holy soil of Lalibela to the waiting lepers.

Herbalists, healers, even chemists are thriving dealers, as are market stallholders, and entire markets such as the Nang Kuak in Bangkok, named after a local goddess. Throughout Latin America market stalls and shops sell local medicinal herbs that have been used for centuries. Eggs are sold, not for scrambling but for cleansing: as a natural, pure object they are drawn over the body, absorbing all the evil inside. Besides such everyday objects, exotic imports are also available: Chinese medicine, black magic potions, red glass squatting Buddhas, perfumed candles, soaps, incense, even an ASTRAL EXTRACT AGAINST EVERYTHING, its packet decorated with the sun, moon and a shooting star.

OPPOSITE *Amulet with Shinto, Buddhist and Taoist symbols, the five auspicious Chinese colours and bales of rice, for safety in driving, but also for success in fishing and other aspects of life, Japan.*

BELOW *Priest and amulet dealer, Lalibela, Ethiopia.*

OVERLEAF *Stall dealing in amulets, Jodhpur market, Rajasthan, India.*

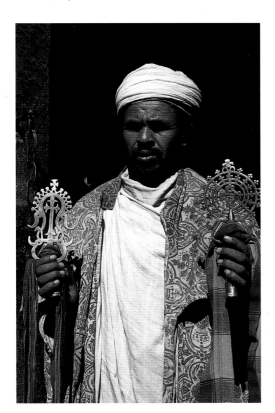

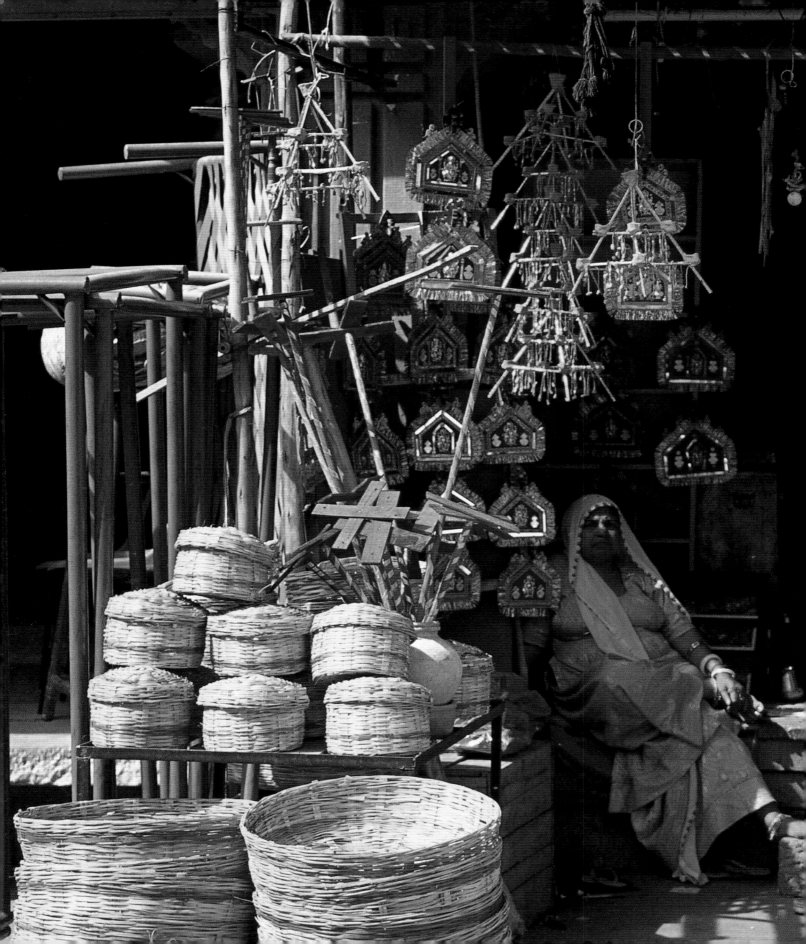

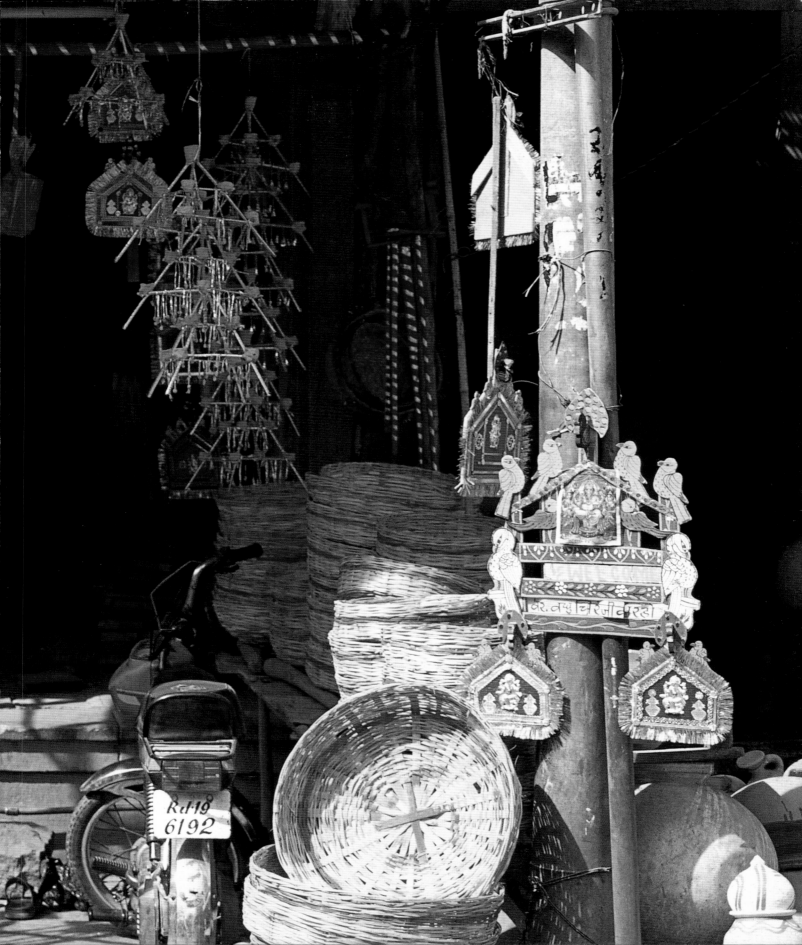

In Mexico, Brazil and the Caribbean, commercial amulets are a fusion of African gods and Christian saints. Kitsch and sparkly, they blend garlic, crosses, hearts, lucky elephants and rice and seeds painted gold, often sealed in horseshoes of red plastic.

In contrast, the amulets of the nearby Indian tribes of Bolivia, Peru and Amazonia call on local spirits rather than saints for protection, and use feathers, white clay, bark, wood, shells, raffia, and red cloth, and in Bolivia also soft alabaster. When Louis Girault went to the village of Curva in the La Paz district in 1957, he found a thriving industry of amulet making that had been using the same materials, techniques, and designs of hands, houses and cattle since at least 1904. Distributed over most of South America by the Kallawaya tribe – dealers in empiric medicine and magic – some were for the public in general, and others destined for specific customers such as widowers or the newly married. Amulets for those still single were forbidden to the married.

Some market values are established. In Brittany in the 1880s owners of stones soaked in holy water would only part with them for five francs, while 'the wife of the postman Dupuy who comes to Crampoisic rents hers out for 0,25 centimes'.

Today's prices can be very high. A rational Japanese motorist will take his car to a Shinto shrine to have it blessed and equipped with an amulet. This will be a piece of paper inscribed with the name of the shrine, enclosed in a brocade pouch with bells, red and white tassels, and a knot. The price varies according to the prestige of the shrine, but is never less than the equivalent of $50, though more substantial donations are encouraged.

ABOVE *Plastic horseshoe containing red seeds, wheat, a coin and pictures of saints, Mexico.*

BELOW *Herd of goats and llama figurines, made of soapstone before 1919, La Paz, Bolivia.*

BELOW RIGHT *Women selling food and amulets outside their adobe home, Bolivia.*

OPPOSITE *Berber amulet dealer and his goods for sale, Marrakech, Morocco.*

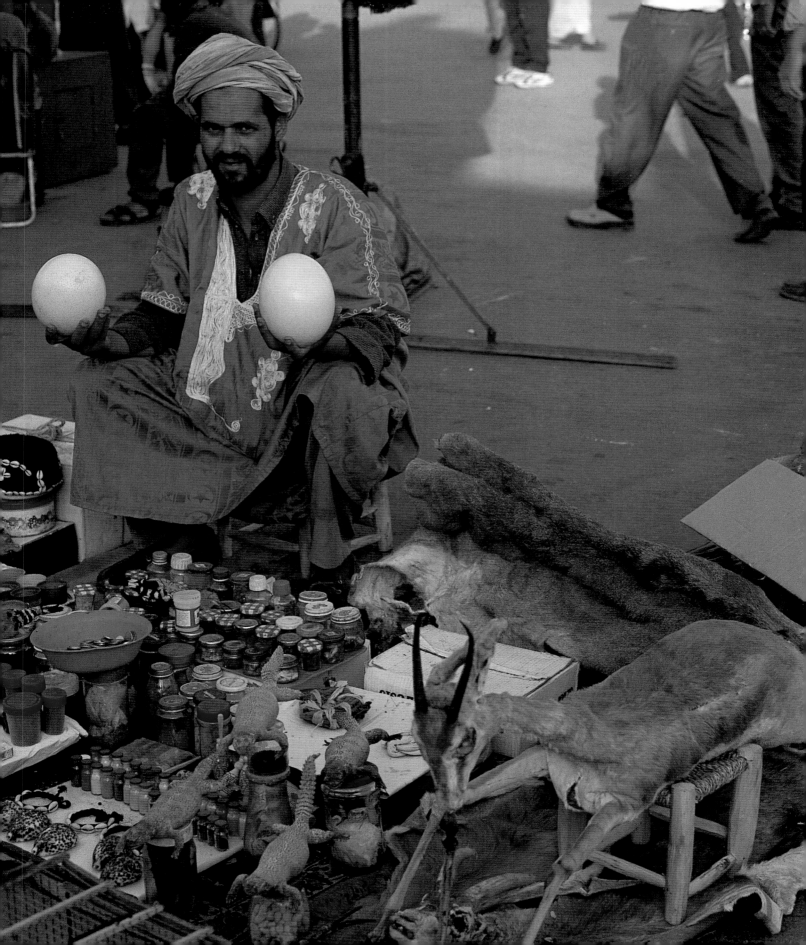

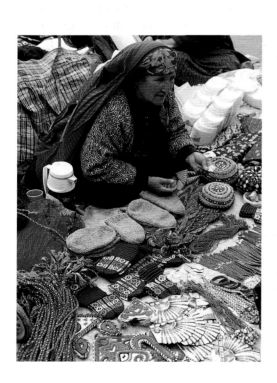

The oldest Maori symbol, the *tiki*, worn as a pendant by men and women, used to be made by a carver and handed down in the family. Now they are more often made professionally and cost between 800 and 1,500 New Zealand dollars.

The witch doctors of Cameroon have a fixed tariff, depending on the quality of the amulet. The simplest cost two roosters, worth £3-4 each, then a small goat, £7-8, will secure the next grade, a large goat, £20, the next, while a small version of the best amulet will cost a sheep or ram, £12-15, and a large version a big sheep, £30-40, considerably more than anyone's monthly income.

Alberto Denti di Pirajno comments on Berbers who will give everything for amulets, from a gold piece to all their jewelry: 'She had spent so much on amulets which were to have worked miracles but had done nothing whatever for the child. She had spent so much, and she was so poor. She put out a hand to rock the cradle – her arm was devoid of bracelets, without even a miserable mugyas of horn.'

ABOVE *Maori* tiki *pendant, New Zealand.*

RIGHT *Amulets from Shinto shrines and Buddhist temples, Japan.*

BELOW *Amulet dealer at the Sunday market, Ashkabad, Turkmenistan.*

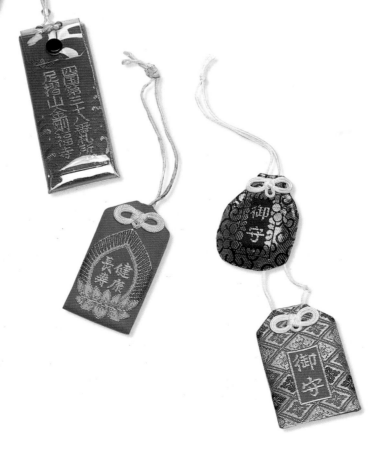

Made to measure

*C*ommercially traded amulets do not have the force of those made individually. A horseshoe picked up off the ground, a stolen potato or, most especially, an amulet created for its owner alone are infinitely more powerful, and not easily traded. The bespoke amulet is believed to capture universal forces for the protection of its owner. Designs personal to the customer are particularly potent: French amulets will feature the owner's initials and various elements associated with his or her astrological sign, while the decoration of each of the beautiful locks made to protect the storehouses of the Dogon of Mali is inspired by the personality and characteristics of its owner.

Dr E. H. Hunt, working in Hyderabad in 1921, discovered that his laundrywoman was threatened by a 'black magic' doll. To protect her he made her an amulet. 'It consisted of a large garnet in a small tin which at one time had protected a V. P. K. film. Sewn round the tin was a small Union Jack, in silk. The garnet was chosen for the stone in case she opened it up to see what was inside. She would have the satisfaction of finding something she had never seen before and which would look red, and sparkle at her.' She was given instructions on how to use it and told they were of the highest importance. She was not to tell a soul she had it, and she was to make sure she placed the amulet in her clothing with the Union Jack the right way up, as it was the flag of the British Empire. 'Whenever she felt the evil influences coming over her she was to shake herself gently. There would be a rattle from inside the box and the Devils would hear this even before she did. They would be frightened and would have no power to harm her.'

It is unusual for an administrator of the British Empire to turn into an amateur amulet maker. Usually the local population were divested of their amulets by various brushes with colonial law. They were confiscated on suspicion of being used in cases of human sacrifice, or in rituals of secret societies. They were acquired during court cases, or by police on patrol; they were removed from convicts. One was even taken from Lord Kitchener's desk in Khartoum.

Basket containing a black magic doll intended to cause the death of Dr Hunt's laundrywoman, together with seven betel nuts, seven pan leaves, seven dried dates, some rice and a piece of ink-stained cloth representing a shroud; by the side of the basket is the amulet made for the laundrywoman by Dr Hunt, Hyderabad, India.

An amulet can be taken over and become very personal, as in the case of Somerset Maugham, who took the Moroccan amulet his father had acquired, and used it as his symbol. He had it engraved on the windows of his house, the Villa Mauresque in Cap Ferrat, which he named after the amulet. He used it on almost all his personal possessions, from his notepaper and cigarette cases to the radiator grille of his cars, and had it embossed on the cover of all his books. He considered it very effective in warding off the evil eye, evidenced by the fact that the one book on which it was printed upside down – one of his earliest novels, *The Hero* – met with no success. What the spiked arch and inverted double cross design of the amulet is supposed to represent is unclear.

Taking over a family amulet is one thing, but when amulets fall into the wrong hands, they can lose their powers of magic.

This happens, for example, in the case of a vaguely anthropomorphic monster, the *tulipek* of the Ammassalik peoples of the east coast of Greenland, which once it is sold to tourists becomes worthless.

People will usually refuse to sell or part with an amulet, whether traded or personal. African women wearing medicines sealed in small sheep's horns hanging from a belt would reluctantly sell the belt but could never be persuaded to part with the horns. An Angolan woman, for example, absolutely refused to sell her fertility charm of a gourd filled with perfumed powder and decorated with iron beads to a curious ethnologist, who was obliged to have a copy made.

The metal necklaces worn by Yemeni Jewish housewives, holding twenty-one miniature pendants representing domestic utensils, are highly prized and rarely sold.

In the Nicobar islands life-size wooden figures stand outside the huts, while smaller versions that hang in the huts as amulets are 'so highly esteemed that no reasonable offer would serve to secure a specimen'.

Money, however, does talk. While the spirit of a Zuni fetish would be offended if it were sold at a low price, he would not object to the fetish he inhabits being traded, if the price offered were high.

If hand-made amulets are sold in markets, they too can be surprisingly expensive, as in the case of a wolf's toe recently offered for sale in Samarkand. Crudely stitched onto a snippet of red plastic, embellished with a black 'eye' bead, this digit of fur and nail cost as much as several good dinners, and was by far the most expensive item in the collection of hairgrips, potions, acrylic socks and pungent shampoos the old Uzbek woman was selling. Its price, of course, reflects the rarity of wolves in the oases of Central Asia, let alone in the modern-day city of Samarkand: no doubt some hapless cur is still limping along the turquoise alleyways of the Shah-i-Zindah. Such an amulet would have been made by a medicine man.

TOP *W. Somerset Maugham's personal amulet, used on all his books and possessions, the original brought by his father from Morocco.*

ABOVE RIGHT *Wolf's toe stitched onto red plastic with black 'eye' beads, sold in Samarkand market, Uzbekistan.*

ABOVE *Witch doctor's confection of crosses made of cord with beads, cowrie, amber and shell, probably made for a precious animal, Morocco.*

RIGHT *Seated female house guardian wearing a palm leaf necklet, Nicobar islands.*

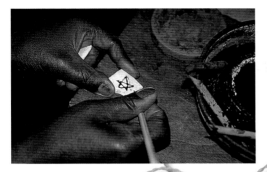

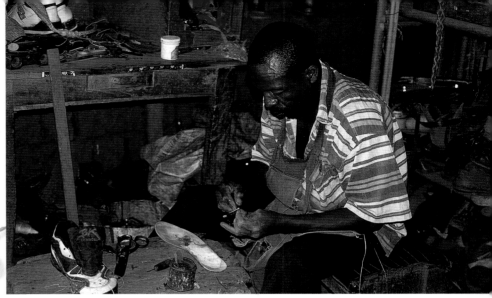

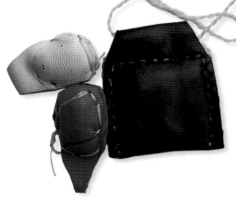

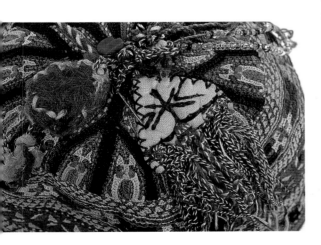

Though Bohemian glassmakers and Tunisian silversmiths may have been historical amulet makers and tradesmen, the truly professional makers fall into two distinct categories, for both of whom this work is something of a sideline. The one bases his power in magic – like the creator of the red plastic and wolf toe confection – and the other in religion.

The amulet makers whose field is magic are variously described as medicine men, witch doctors, herbalists, healers. For all of them it is the magical potency of plants, of tree barks, of animal parts, of arcane substances that they harness into an amulet. But, like the holy men whose calling has a higher purpose, their main function is to cure disease and avert disaster by natural means. They will wander the countryside, gathering plants and picking up stones; they will grind their secret ingredients of 'eye of toad' and sell the resulting powder to be soaked in water and drunk. Only as an alternative is it to be stuffed inside the horn of a bullock or the shell of a tortoise or the finest snippet of antelope or calfskin, and then worn as an amulet. Among the most important of their number are blacksmiths.

The amulet makers of religious persuasion are the guardians of Shinto shrines and Buddhist temples, the monks of impoverished monasteries, the holy men of Islam, who supply folded pieces of inscribed paper. For the mullahs and the marabouts these will often consist of some vaguely Arabic script or general scribbling, enclosed in some sort of casing – leather from the market shoemaker, silver from the smith, textile from the women. These men will make amulets but only at a high price and as a mark of respect to their standing: their main function remains that of the revered holy man of the village.

A third category of amulet makers are the amateurs. These are usually mothers, married at fourteen, illiterate, uncomprehending, whose babies have died inexplicably one after another. They tie a red or white cord round the wrist of the first, hang a shell or predator's tooth round the neck of the second, then lovingly twine cloves and broken needles onto the bonnet of the third, before they themselves die of puerperal fever with the next.

Only the darkest forces of evil could be responsible.

Witches and the taxman

The village streets of the regions of central Romania settled by Saxons presented a defensive phalanx of alternating walls and high wooden gates to invading Mongol, Hun and Turk. The houses lie sideways to the road, divided from each other by their farmyards, which are hidden behind a barrier of gates – a huge wooden one for horse and cart and cattle, and a smaller one for people. The house walls are blank, not a chink of a gap between them and the concealing gates. The totally enclosed space of the yard is the hub and heart of the household.

Parasciva Rāchita lives in such a house in the village of Gura Râului, where the local river has its source, and her neighbour is a witch – a man, for such creatures are not always women. The story began when the axe she used to cut down trees, a very precious object, was stolen. In such cases the identity of the thief can be revealed by two possible procedures. One involves fasting and burning candles, while kneeling down reading the Book of Psalms. In Mrs Rāchita's case this gave no results, proving that the thief was a witch in cahoots with the devil.

The second procedure requires a new wooden tub and seven virgins: those aged seven to ten years are easiest to find. These girls must fetch water from the river on a Saturday evening while the church bells are ringing. It is of the utmost importance that the river is flowing downstream from left to right. A gold object – a ring, say – a cross and a sprig of *busuioc* (sweet basil) are put into the tub and the water added. The girls then gather round the tub in a darkened room until the whole scene of the crime is revealed to them – the thief, the entire episode, and how he worked. This was how Mrs Rāchita's neighbour was identified as a witch.

Whenever he walks past her gate her furniture crackles with his negative force, so she protects herself by burning a circle of incense in her courtyard. One day he pushed a little dog under the high wooden gate of her yard and everyone in the family who touched it was ill. He also put his hand under her gate and scooped up some earth so as to have something of hers and thus have power over her. She knows this because she saw the marks of his fingernails in the mud. She has consulted the monks in the local monastery but they have told her there is nothing she can do as he is in direct contact with the devil. Like everyone else, she protects her horse from evil spirits with a red tassel on his whip, so she now carries this with her at all times for

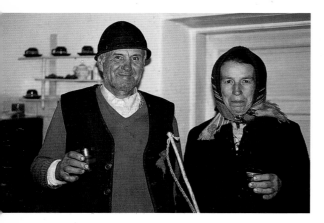

ABOVE *Victim of a witch, Parasciva Rāchita tries to protect herself with her horse's red tassel, Gura Râului, Romania (she and her husband are farmers and produce their own raki).*

OPPOSITE LEFT *Aboriginal magician wearing a headdress representing the sacred emu in order to make emus abundant for the hunters of his tribe, Australia.*

OPPOSITE RIGHT *Aboriginal men adorned with white down, acting the part of women searching at the roots of a wattle tree in order to conjure up ants and ant eggs to eat and gain a food supply by magic, Australia.*

her own protection, but is afraid it will not be strong enough to keep the witch away from her yard.

Witches are most active at night, particularly by the full moon, and are at their most powerful between midnight and one in the morning. Without knowing they are doing it – though their neighbours see – they walk around at night and have a habit of going to the nearest river and bathing there. Witches generally have unkempt hair and six toes. They are usually born from incorrect relationships, such as incest, adultery or three generations of illegitimate progeny. Some, though, are the dead not properly buried, who live on as vampires or as ghosts. They suck people's blood and then vomit it. They also have a strong, direct look that can hurt and, by glancing at a cow being milked, can stop its milk supply.

When engaged in any kind of ritual, they must wear virgin clothes specially bought for the event. These clothes can only be used once and must then be thrown away, the occasion often being marked by the sacrifice of, say, a white mouse or a black cock.

All this Madame Rāchita knows.

Such witches are still active today in Europe, and not just on the more remote fringes. Those operating in the suburbs of Paris earn serious money, which they do not declare to the taxman. In Anglesey in Wales, in December 2001, an elderly woman was murdered. Her heart was cut out of her body and left, presumably still palpitating, on the floor beside it, while a crude cross was fashioned out of two iron bars and left in evidence of the passage of a witch, while in the same year the torso of a boy aged about five was found floating in the River Thames near Tower Hill. He is believed to be the victim of a ritual killing. In Crewe in 1990 it was domestic cats that were being stolen and subjected to ritual slaughter, but in Central and West Africa it is children. Their sexual parts are cut off, both male and female, and they are left to die, or they are beheaded for a certain part of the skull that holds mystic power. Still today.

In January 2002 a conference on witchcraft was held in Cameroon. It was established that witches sell human lives for money. The people offered die early in mysterious circumstances – of which AIDS is undoubtedly one – and go to work in the spiritual world, while the witch enjoys the money in the physical world.

Much of the power of witches, it was stated, is known to be stolen from witch doctors. They attend as alleged customers and watch what preparations are used in the amulet so that they can prepare antidotes. If necessary, they take the witch doctor's medicine, vomit it out and then work out an antidote.

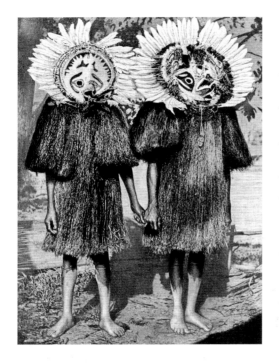

A serious suggestion was made to the conference delegates that the power of witches – their ability to change into the wind and blow down the roofs of houses, or to control bees and lightning for their own ends – should be tamed and used in the same way that whites have used their witchcraft. That is, to make cruise missiles out of the lightning they control, and employ the bees as soldiers for infantry and an airforce.

The witches of the Islamic world are the jinn, creatures of fire who live between the angels of light and men of clay. They can live for centuries, and occasionally enter a human or animal, but are normally invisible. They can be particularly dangerous during human sexual intercourse when, if the man forgets to call on Allah, they intervene and are responsible for a boy who is 'effete'.

In South East Asia, witches are usually the spirits of benign ancestors who, disturbed at seeing the younger generation failing to observe traditions and fulfil their duties, grow angry. They retaliate by causing failed harvests and deadly epidemics. Terrifying masks can be employed to drive them away, as they can too in Africa.

ABOVE *Costumes and fish-like masks framed in white feathers bring mythical power to dances and initiation ceremonies, Papua New Guinea.*

RIGHT *Ritual mask of terrifying aspect, like those that frighten away evil spirits or mislead wanderers at crossroads, Bandjoun, Cameroon.*

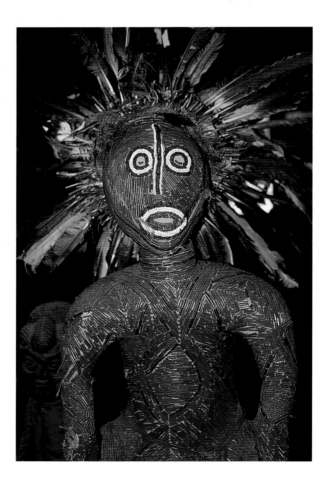

The owl and the pussycat

*J*ust as the colonies of France were known as France d'Outremer, so Portuguese colonial territories were always considered an integral part of Portugal: 'Aquí é Portugal' was set in stone in the municipal pavements of Angola and Mozambique. The battle for independence from European colonial powers was everywhere fraught, but in Angola particularly so. Jonas Savimbi, revolutionary leader of UNITA – Union for Total Independence of Angola – committed appalling atrocities against his enemies but always managed to escape. It was well known that he could turn into an owl and fly anywhere in the world.

Turning into an owl is a skill possessed by most witches and especially wizards, generally the male of the species. The owl is an ancient symbol of witchcraft, a manifestation of the devil, but also a companion of the goddess Athene. Amulets in the form of an owl exist from the late second century BC and are still sold on the streets of Athens.

The owl is, of course, a bird of the night, a bird of ill omen, and so an obvious choice for witches and wizards looking for disguise. In Africa owls sit on trees outside the compound. Exotic medicines are burnt – the fragrant ground bark of the alalee or ber tree – and, if the owl is a wizard, as the smoke rises it will fall out of the tree.

In Egypt a murex shell, a precious mollusc that is a source of purple dye, is hung over doors specifically to keep away owls, the whorl of the shell resembling the eye of the owl. 'Wise' women in Cairo used to sell them.

In Russia, amuletic necklaces are patterned like owls' eyes, as are ritual belts and shoulder bands in West Africa. In Kazakhstan girls would wear an amulet of owls' claws set in silver, pinned either to their cap or on their camisole over the right breast.

TOP *Two owls, believed to protect at night, Chukotka, Siberia, Russia.*

ABOVE *Owl, sacred to Athene, Athens, Greece.*

RIGHT *Amuletic necklace of beads and fur, Lake Baikal region, Russia.*

FAR RIGHT *Kuba ritual belt of red cloth, cowrie shells, beadwork and fur, for the aristocracy, Zaire.*

RIGHT *Tiger painted on a bus, Agordat, Eritrea (the qualities of a tiger are not always met by local bus services).*

BELOW *Egyptian blue china cat with red eyes, an amulet known from Ancient Egypt.*

BOTTOM *Cats sold in a Hispanic chemist's shop, red for luck in love and black against evil spirits, most effective when used at night, Los Angeles, United States.*

Though animal parts are favoured for amulets, some animals themselves have talismanic powers, of which the cat is one of the most common. The favourite familiar of the witch is the demon in the form of a black cat. In some countries this animal of darkness itself embodies the witch and brings bad luck; in others it is considered lucky. A black cat can be sacrificed to protect a new building, or to cure disease. Edith Durham recounts being called to the sickbed of a man in Bosnia, to find that ten days before, in the heat of summer, a black cat had been split open and placed across the man's stomach.

The cat representing the goddess Bastet was an amulet of Ancient Egypt and modern copies are still made. However, the most common cat amulets are those of Japan. They are mostly associated with tigers – the cat is known as the 'hand-fed tiger' – and are therefore feared by evil spirits. They protect in particular ships and shops, as the beckoning cat.

Black cats can foretell the weather and so are associated with thunder and storm, but a tortoiseshell cat, with its strong resemblance to a tiger, is a favoured ship's passenger. Tigers, in China as well as Japan, protect travellers – as the tiger roams and returns, so will the traveller – and amuletic pictures of the animal are hung in the absent man's house. Tigers also decorate buses and lorries in places as far apart as Pakistan, Eritrea and Morocco.

The tiger and the owl are the animals most often chosen for the hats to fool evil spirits and protect small boys of the minority peoples of south-west China (see p. 19).

Dogs, too, are protective amulets in Japan, guarding children in particular. For the snow festival of Yokote, a small town in the north, children, with the help of their parents, build igloo-type huts. They sit inside them, eating rice cakes and playing games, secure from evil spirits: a toy guard dog is posted outside each one to chase them away.

The goat is another animal with amuletic powers. Sacred to the Zoroastrians, it protects women in particular, and a goat's skull is often placed over the entrance to a house, or on a high pole where it protects from a passing evil eye.

Horse amulets are sold at Shinto shrines in Japan, while the horse also features on Islamic amulets, as well as on graves, as, according to varying tradition, Mohammed went from Mecca to Medina, or to heaven, on a horse. Of the animal protectors commonly displayed on Tibetan prayer flags, the most favoured is the 'wind horse'. The horse, for the Mari people of Russia, is also a symbol of the sun and was worn as an amulet from the ninth century onwards. In many parts of the world a horseshoe nailed above or by a door combines the symbolism of the horse with the power of iron.

When animals are used as amulets it is more often in the form of a tooth or claw, a bone or feather. Necklaces hung with a pig's tooth were found in Neolithic graves and in Bronze Age ones in France, the sacrifice of a pig or wild boar being a rite of early Aryan religions. Small pigs as amulets, still popular in France in the nineteenth century, became associated with Christianity, though they are also found on the necklaces of Madagascar.

ABOVE *Copy of an amulet of the 9th to 13th century, Mari province, Russia. The two horses personify the sun in Mari mythology and the ducks' webbed feet symbolize maternity.*

RIGHT *Goat's skull and trellis of seeds at the entrance to a traditional house in the old city, Bukhara, Uzbekistan.*

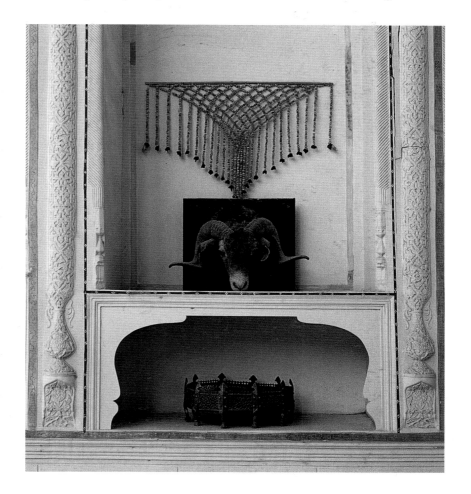

An eye for an eye

ABOVE *Bus amulet depicting the Assumption, with a cross on the back and a blue glass eye attached by a safety pin, Albania.*

BELOW *The imperfections in the embroidery on the bodice of this woman's shift are intended to avert the evil eye, Saraqib, Syria.*

Though Saleema laboured over the embroidery on her shift, sitting on the floor of the family home in the small town of Saraqib in northern Syria, it was not the best she could do. There were imperfections – a stitch missed, a faulty colour. She was well satisfied. Wearing the shift, she would be protected from the envious glance of the evil eye, attracted as it is to beauty and perfection.

The evil eye is the most powerful of superstitions throughout the Indo-European and Semitic worlds, and its power is based on jealousy. Witches, revolutionaries masquerading as owls, and demons lying in wait at crossroads, all pale into insignificance beside the fear the evil eye provokes.

The eye itself, be it the quirkiness of eyebrows that meet in the middle, deep-set eyes, the mysterious eye of the camera and, most particularly, blue eyes in a land of brown-eyed people or vice versa, is but one aspect of the source of evil. Another is the remark that praises, the casual comment of an admirer, that alerts the eye, placing the bonny baby and the beautiful bride in jeopardy. Such praise, remarked Pliny the Elder, even killed cattle.

The evil eye is known from the fourth or third millennium BC and was also recorded among the Ancient Greeks and Romans. It is still powerful and deeply feared throughout the Mediterranean world: the Greek word for amulet, *khalitikhi*, means eye, the Italian *jettatura*, the eye that throws or casts spells. It flourishes under Islam, the proviso 'inshallah', which greets almost every remark, deflecting any certainty of success that might provoke retaliation.

Italian babies are still protected by coral pendants and red vests, but the strongest amulets against the evil eye confront like with like. They are the eye itself – frequently symbolized as a blue bead – and the mirror from which the evil eye flees in horror or lingers in self-admiration.

The blue 'eye' bead stares back at the unseen evil eye throughout the Turkic world, from Central Asia to the Middle East and the Mediterranean. Large versions of it hang above doorways in Uzbekistan and at the entrance to the brand-new Hall of Independence in Ashkabad. Babies in Kosovo wear it pinned to their clothes, camels in Jordan and donkeys in Corfu have it hanging from their harness, roadside stalls in Istanbul sell nothing else.

ABOVE *Eye on the balcony of an office building, Bukhara, Uzbekistan.*

RIGHT *Roadside stall selling blue 'eye' beads, Istanbul, Turkey.*

BELOW *Rayed sun and eye over the door of a small church, Ioannina, Greece.*

OPPOSITE BELOW RIGHT *Bright triangular amulet hung with blue 'eye' beads and stuffed with secret substances, made by a wise woman of the village to protect the author on her travels, Olymbos, Karpathos island, Greece.*

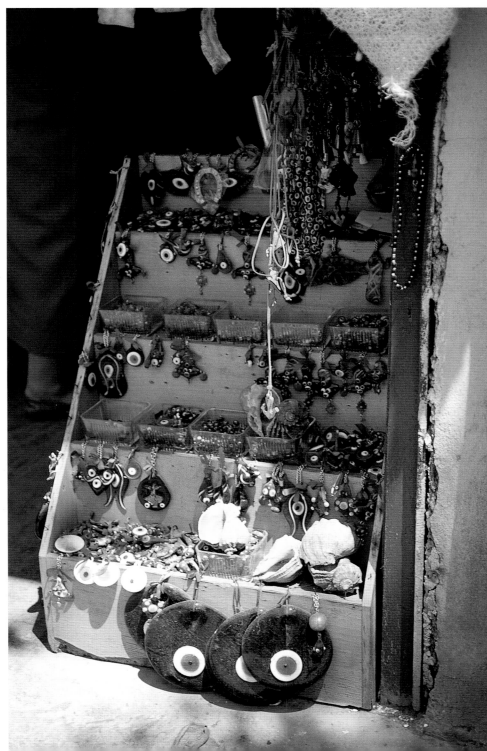

It usually consists of a single bead of blue glass set with a disc of yellow outlined in white and centred by a blue or black dot. Others are of rings of opaque white, green and brown, or of agate. The eye can also be stylized as a dot within a circle.

Confronting the evil eye with an eye was known to the Ancient Egyptians. The eye of Horus, *wedjat*, was one of the most powerful of all amulets during the Old Kingdom and its elongated shape, incorporating a curved line, survives in the oculi painted on boats. These 'eyes' decorate the prow of boats, particularly in much of the Orient, the East African coast and the Mediterranean, where they were known to the Phoenicians, Ancient Greeks, Etruscans and Romans. Here the oculi watch directly for the evil eye and demons of the deep, while in the Orient they symbolize too the protective deity of the boat, and play a more spiritual role.

The cloak, *akhnif*, of the Berber shepherds of the Aït Ouaouzguite in Morocco is emblazoned across the back with a dominant red 'eye' believed to protect the wearer from the evil eye, as do the stylized patterns of sun and lizard brocaded into the weaving of the cloak.

To avert the evil eye, the Berbers also cover their mouths with their hands when passing a stranger, though holding the corner of a veil or a handkerchief over the face is a more usual defence.

ABOVE *Modern replica of the ancient amulet of the eye of Horus, Egypt.*

RIGHT *Aït Ouaouzguite shepherd's cloak, known as an* akhnif, *showing a red 'eye' with brocaded patterning and loose threads, Morocco.*

FAR RIGHT *Eye pattern protecting a neck purse, Sahara, Morocco.*

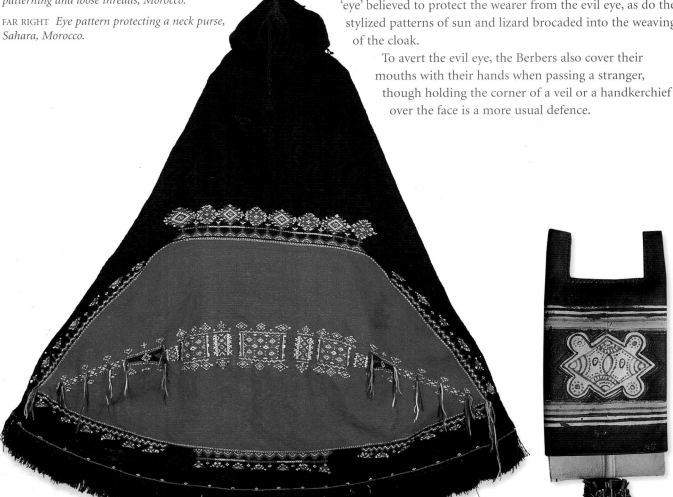

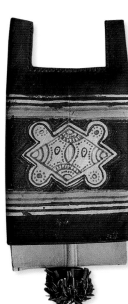

If the eye pitted against the evil eye is believed the most potent of forces, how much more so is the evil eye's own reflection?

Mirrors have an element of mystery: they show the true image of both human and demon, and yet reverse it. The soul can escape through them, and they are thus covered at death, or during a storm, or even for the vulnerable forty days after marriage. In Tetouan, Morocco, an embroidered cloth was hung for that period over the mirror facing the marital bed; in China bronze mirrors were placed in the wedding chamber.

If reflection can chase away evil, it can also act as a diversion. Though the eye or demon might flee, it might also stay to admire its own image, thus diverting its attention from the object that first aroused its envy, be it bride, child, animal or building. Pieces of mirror are inserted into clothing, into the gables of houses, into fetishes and masks.

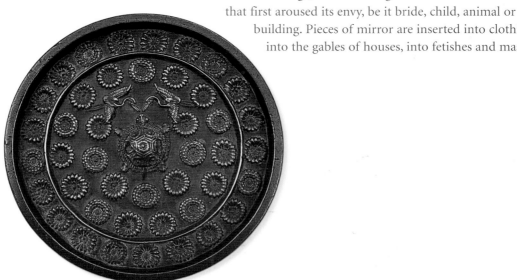

TOP *Mirrored triangles, hung from a tree in a Hindu cemetery, Thano Bula Khan, southern Pakistan.*

ABOVE *Back of a bronze mirror featuring cranes, symbols of longevity, China.*

RIGHT *Cloth hung over a mirror opposite the marital bed for forty days after the marriage, Tetouan, Morocco.*

Captured magic

The substance and form of amulets are governed by symbolism. Every material used has some inherent quality that empowers the amulet itself. Most are of universal application, while others may be specific to certain cultures. The universal outweighs by far the specific.

The universal encompasses belief in the power of whatever is rare or strange (the misshapen stone, the meteorite), or whatever holds something of the night (the owl, the storm), or whatever embodies strength (the jagged tooth of a predator, the claw of a bird of prey), or whatever links with the ethereal (feathers and hair), or whatever recalls the basic sexuality of humankind (cowries and spikes), or whatever reeks with an exaggerated pungency (incense, cloves, garlic), or whatever communes with the netherworld (the snake, the toad), or whatever vibrates with resonance (church bells and tomtom drums), or whatever sparkles with an aura of desirability (sequins, coins and buttons), or whatever can twist and confuse the enemy (tangled threads and knotted rags), or whatever confronts it with its own image (mirrors and blue beads).

The specific merely fixes on a local species whose claws, bones, feathers and teeth represent the universal, such as the chameleon, the mole, the bustard; or in the sphere of botany and geology, on local tree bark, leaves, grasses, stones and resins. Rare indeed is the material used as an amulet in a small, well-defined geographical area alone. The odd slug or seahorse is all that can be found.

Apart from the horns of ruminants – bulls, rams and goats – most animal parts used in amulets come from wild animals, harnessing their particular attributes: flight, rapacity, renewal of bodily parts, nocturnal power.

Many amulets consist of some sort of magical substance within a container, though these can also often be empty, as they are in themselves a strong amulet. A container and its contents must be considered an entity for they are not combined arbitrarily. In North and West Africa – and sometimes in Central Asia – leather is used to enclose magic concoctions of plants and herbs, or folded pieces of paper inscribed with sura from the Koran or with illiterate gibberish. Leather cases that hold herbs are rounded, while for scripts they are flat rectangles or squares. They are either made by the medicine man himself, or his amulet is taken to the market shoemaker. Here, away from public gaze but under the watchful eye of the owner in case

OPPOSITE *18th-century apothecary's cabinet filled with amulets dating from antiquity to the 19th century, France.*

a piece of plain paper is substituted for the inscribed one, the leather case will be made. The only alternative would be a covering of rag, associated with poverty and low status.

In the Middle East and along the southern Mediterranean littoral, such 'Arabic' writings will normally be encased in silver containers of cylindrical, rectangular or triangular shape and worn as jewelry. In Central Asia they will be folded into a triangle and enclosed in fabric, usually embroidered and hung with tassels. Similar triangles of fabric, but of shiny brocade decorated with sequins, cover the potent mixture of such objects as small pieces of umbilical cord, fishing net, fulgurite and wax from church candles, worn as amulets on the Greek island of Karpathos. The talismanic scrolls of Coptic Ethiopia are rolled into snakeskin; the paper charms of Japan are tied in red thread and sold on a piece of card, or wrapped in brocaded silk.

Many amulets combine several materials and symbols together, such as the *cimaruta* of Italy – a sprig of rue fashioned out of silver with a separate amulet integrated into each branch. These can include the *fica* hand, miniature keys, a snake, horse, heart, horn or mermaid, coral, the sun and moon, bells and whistles, each with a specific power of protection. In other parts of the world different amulets will be packaged together or strung as necklaces combining beads, red thread, coins and cowrie shells, or, for the

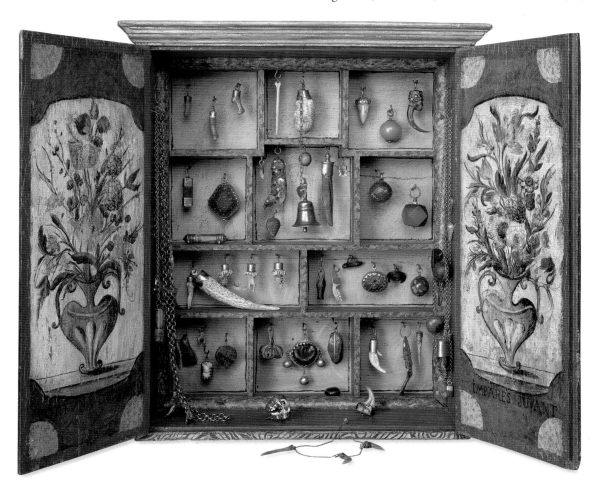

Eskimo, animal or human shapes in walrus ivory or wood, together with anything the person finds powerful – a rock, some animal bones, dried skins, driftwood, birdshot found in migrating geese, iron bells and trade beads.

In Morocco, a clustered pendant of amulets would include miniature guns and daggers to fight the jinn, a candle to see them by, a hand to protect from the evil eye, a goblet to represent water as the source of life, and stars to protect against darkness, while in Russia such a composite amulet would usually be a small bag worn round the neck and containing herbs, roots, embers, bats' wings and snakes' heads.

Among the most complex amulets made of a mix of ingredients are the *mohara* of Madagascar. The basis is a compact paste made of earth or sand, honey and fat, in which a number of symbolic objects are embedded: silver coins to bring fortune, scissor blades to cut up evil spirits, talons of birds of prey to give power, claws pulled out of the paw of a cat on heat, pigeon feathers, statuettes of people, all usually set in a case or the end of a zebu horn.

Many amulets, most particularly those of Mexico and South America, mix the holy with the profane. Having difficulty accepting the submissive figure of Christ on the cross as a powerful force, the local Indians have taken a panoply of minor Christian saints as talismanic and mixed their portraits with horse-shoes, anteater hair, white clay, red beans, exotic gold elephants and shampoo.

Such coexistence of religious protection and natural magic was also evident in the plague amulets of Germany and Austria. Paper printed with images of saints was wrapped around oddly shaped seeds, stones, red rags and so on. The same mixture of objects, usually uneven in number, were strung on silk or red thread to make *Fraisketten*, necklaces to combat fear.

Two diverse aspects of the function of amulets are to attract or repel. The principal role of anything sparkly is to attract the evil eye and so divert it from the wearer. In the same way, the fishermen of the Nanusa islands in the Malay archipelago would place a model of their canoe in the boat itself to attract the spirits of disease, acting like flypaper to protect the men.

Sweeping or washing away evil are also potent symbols. In Africa, in particular, token brooms would rid the house of evil spirits, while in many parts of the world, especially in Japan, amulets thrown into running water, often with incantations, would wash away evil.

The consistency of the materials of amulets over distance and time is evident from a set of objects procured from a witch in Naples – 'a pleasing woman of about forty' – in 1897. The amulets in her possession were: three knotted cords – a black one to cause illness in the head, a red one against pain in the heart, a white one to prevent infidelity. A lemon and a potato stuck with nails. A padlock. A magnet. A horseshoe and a whorl – these often fixed behind the church door, against witchcraft. An old flint and two steels. A small bag of sea sand – the witch must count all the grains before she can enchant the wearer, an impossible task.

Some of these would have been the tools of her trade, some may have been stolen from their owners. All are amulets still found today.

Sex & money

ABOVE *White Hmong (H'mong Kao) boy's cap decorated with a copulating couple and a French Indochina coin of 1938, Laos.*

BELOW *Banjara quilted cotton bag with cowries and a triangle with metal and wool pendants at the opening, India.*

BELOW RIGHT *Detail of a Berber shawl with a cowrie shell, Siwa oasis, Egypt. The colours and patterns are derived from solar mythology.*

A copulating couple, delicately sculpted out of bits of rag, is stitched onto the top of the bonnet of a White Hmong baby from Laos; a collection of carved wooden penises lies on the floor of an African witch doctor's hut; a phallus carved in stone protected Pompeii and also the ancient Roman city of Volubilis in Morocco; many a sheela-na-gig, carved over the doorway of a church of pagan Celtic establishment, holds open her vagina to the entering worshippers. The talismanic power of sex transcends boundaries of culture, religion, decency.

It is, in particular, the cowrie shell that epitomizes the potency of sex, encompassing as it does concepts of fertility and wealth, and depicting as it does the female vulva. It forms the focal point of many a pendant, decorates many a fetish and musical instrument, and covers the costume of many a shaman and dancer. The cowrie shell, like the eye and mirror, confronts like with like, and in its explicit recall of the female, is one of the most common and powerful of amulets.

Cowrie shells come mainly from the Indian Ocean and there are two types, hardly distinguishable one from the other. *Cyprae moneta* from the Maldives and *cyprae annulus* from around Zanzibar were traded both as

RIGHT *Fetish figure with cowries, including one cowrie as the vulva, surrounded by blue beads, Cameroon.*

BELOW *Leather baby carrier edged with cowries, Fono, Eritrea.*

OPPOSITE, TOP TO BOTTOM *Phallus made of bone, Chukotka, Siberia, Russia; Ancient Roman amulet in the shape of a phallus, Italy; fica amulet in coral, Italy; phallic carving near the west gate of the Roman city of Volubilis, Morocco; couple in coitus, made of soapstone before 1919, La Paz, Bolivia; copulating couple marketed by the Kallawaya, La Paz, Bolivia.*

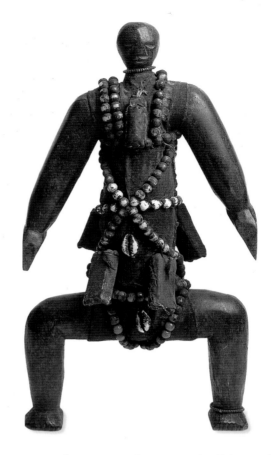

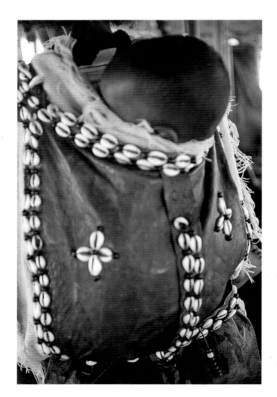

amulets and currency. They were used as money in China probably from around 2000 BC, and later by both Chinese and Indians trading with Egypt. In Africa they superseded payment in salt, meat and strips of cloth, and for centuries were exchanged for gold and slaves.

The exchange rate of the cowrie shell was fixed. In 1911 in Uganda it was set against the value of a cow: one cow was 2,500 cowries, a goat 500, a fowl 25, and cooking pots from two to 200 depending on their size. In earlier days a rough blue bead was used as a guideline, and was considered worth 100 cowries, while a woman was valued at 200. In the 1940s cowries were still currency in African markets, but today they are only a commodity selling for about five American cents each.

The amuletic value of the cowrie is linked to its power as a sexual symbol against the evil eye in particular, its slight resemblance to an eye being a further attribute, but it is also known to ward off demons that might threaten female fertility.

The use of the cowrie as an amulet is evident in the graves of China in the period of the fourteenth to the eleventh century BC, where cowries were set into the mouths of the dead. The cowrie was also a common amulet in Ancient Egypt, often reproduced in faience, gold or silver and worn in a girdle round a woman's waist, emphasizing its role in protecting fertility. In Europe, in graves of the Cro-Magnon era, cowries have been found

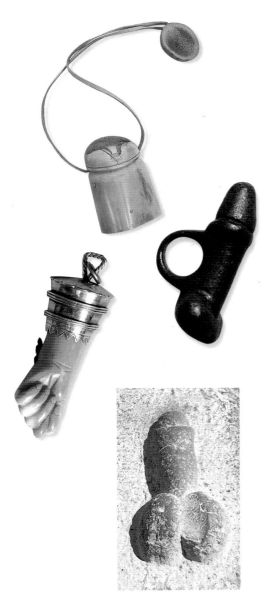

perforated as talismans, and in those of Pazyryk in Siberia of about 400 BC they lie as a single, individual piece in a barrow rich with horse trappings, clothing, felts and gold ornaments. Further west, in the Scythian burial kurgans of the region of southern Russia, where the steppes reach the Sea of Azov, a warrior of about the first century BC was buried holding an iron sword inlaid with fifty-two cowries, and wearing a belt of two rows of cowries held by a gold clasp.

Other shells were commonly used as amulets in various parts of the world, and occasionally as money. In 1854 David Livingstone mentioned that in Central Africa two shell pendants would buy a slave. Valuable shells include abalone, mussel, clam and, most precious, dentalium shells and the wampum of North American Indians. Their origin in the ocean, their pearly lustre like the gleam in an eye, imbued them with some supernatural force: in Japan, the glint on a shell was reputed to scare off cats as well as demons, while in India a shell would crack under the gaze of the evil eye, revealing the eye's presence.

If the connotation of the cowrie with the female vulva is often forgotten, the various guises of the phallus are usually more obvious: overtly phallic shapes carved in bone form hunting amulets in Siberia. The phallus was found in prehistoric caves, and was an amulet of Ancient Egypt and Rome, while necklaces of miniature phalluses were both Pompeian and African. In Rome the phallus was also a favourite amulet to hang on houses and town gates, and to adorn the triumphal chariot of the victorious returning general.

The power of the phallus derives in part from its role as a symbol of a life-force, but also from the obscenity of its depiction. Curiosity, especially that of the evil eye, is aroused by anything obscene and indecent, and is thus diverted from the intended victim. Stones of obvious phallic shape protect ricefields in Japan from locusts and from the evil spirits that infest the crop and emanate from the bodies of fugitives from battle who have hidden in the fields and died there.

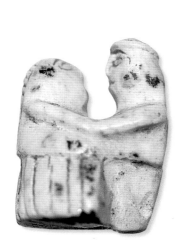

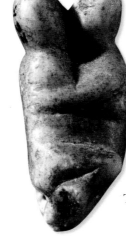

The phallus is often subsumed into less obvious devices: the fig tree, horn, fish, trefoil, fleur-de-lis, pine cone, and in India even the cross. But it is particularly in the form of the fica of Italy that it is perhaps most arresting. This gesture of the closed fist with the thumb raised between the index and second finger has been reproduced since Etruscan times in thousands of amulets of silver and coral.

Lionel Bonnemère may have been shocked (see p. 50), but the depiction of coitus on an amulet was not uncommon, nor confined to nineteenth-century Paris. A version carved in stone, accompanied by a herd of goats, emphasizing its significance in promoting fertility, was an amulet marketed commercially by the Kallawaya in Bolivia. Not only was sex considered a suitable decoration for a Thai baby's bonnet, but a great number of other Thai amulets are explicitly sexual.

RIGHT *'Very rude' male doll made of straw and paper money, pre-1897, placed at field corners and also used by Taoist priests to cure disease, Taiwan.*

BELOW *Beaded cache-sexe, Cameroon.*

OPPOSITE *Cache-sexe on model in Kinni Museum, Yaoundé, Cameroon. The Ndop cloth in the background also has magical qualities.*

Amulets were used to promote, or discourage, the sexual act itself, especially among African people. Incantations written on paper and enclosed in leather pouches were worn round the waist of girls 'indulging in active flirtation' before marriage, to prevent conception. They could also detract from sex itself, as in the case of the Fulani Muslim marabout from Cameroon (see p. 31). The women's beaded *cache-sexes* hung with cowries, and their buttock covers decorated with white beads and prominent tufts of fibre, were ostensibly amulets against evil spirits, but in reality were attention-seeking devices of seduction. The men's penis shields of woven fibre also both protected from evil and attracted the eye of women.

Dwarves with huge phalluses were known amulets in the Graeco-Roman world, and similar 'very rude' figures of men made of straw were placed at field corners in Taiwan, and then used by Taoist priests to cure people of disease. Grotesque figures, in particular hunchbacks, derive from the ithyphallic Egyptian god Bes and are found in many parts of the world, ranging from the Nicobar islands, China and Japan, to the Scythian graves of southern Russia, and westward to Turkey, Italy, France and North America.

While some apotropaic figures are hideously deformed, others are recognizably human, while still others may be representations of ancestors, or have the form of goddesses or dolls.

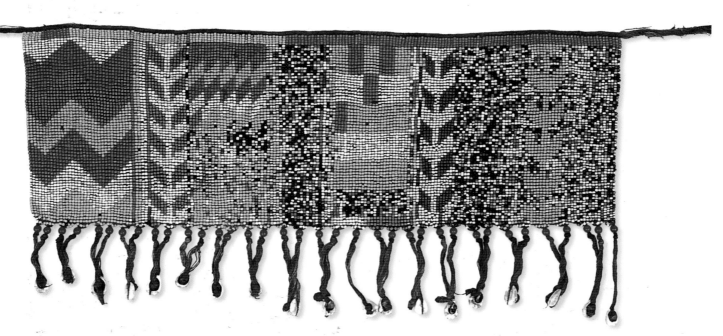

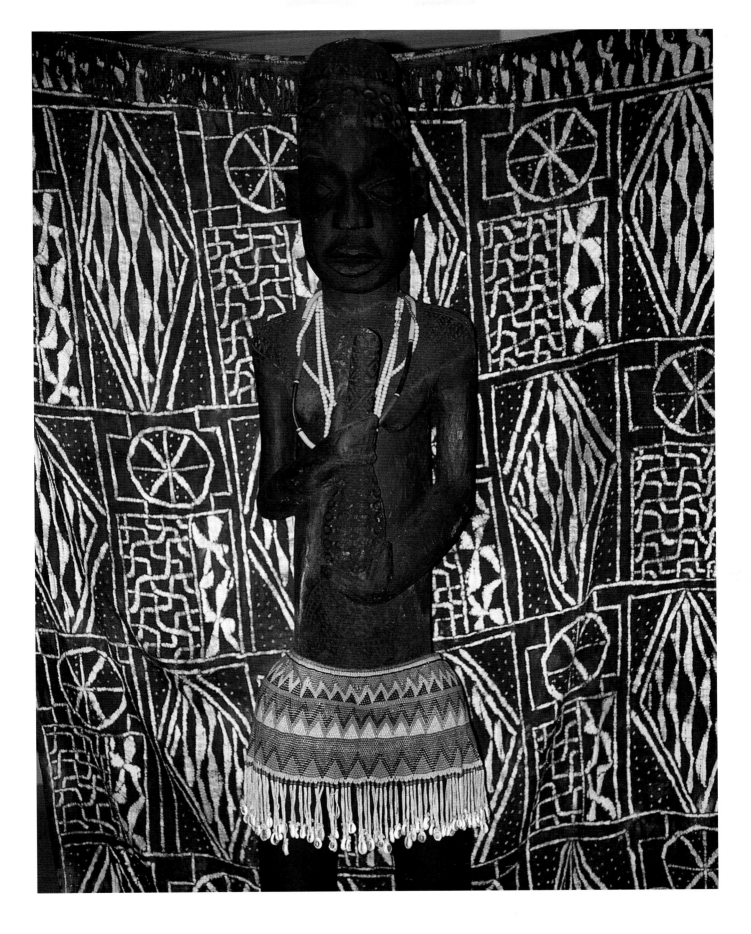

Goddesses & dolls

ABOVE *Goddesses on a ritual towel, Russia.*

BELOW *Goddesses embroidered on a woman's shift, Moknine, Tunisia.*

BELOW RIGHT *Hem of a woman's marriage shift, Attica, Greece.*

OPPOSITE *Goddesses embroidered on a woman's coiffe, Bekalta, Tunisia.*

The Great Goddess, the Earth Mother or Fertility Goddess is manifest in diverse forms from the Palaeolithic era on, particularly in Old Europe, the Near East and Central Asia. She appears on textiles, is carved in stone and wood or wrought in silver, she is flanked by birds or animals, forms one with the tree of life or the sun. Her amuletic function is but one aspect of her powerful influence over millennia.

Isolating the goddess as an amulet, as opposed to a decorative motif – albeit powerful – is not straightforward. Certainly ritual plays a part, so that towels embroidered with goddess figures and hung on trees in the lonely birch groves of Russia are amuletic, as are kilims of Anatolia featuring goddess patterns, which are only used at birth, marriage and death. Other amuletic goddesses are those embroidered above the breasts on the robes of Tunisian women and on the hems of the marriage shifts of Attica in Greece, and those woven on the ikats of Bukhara in Central Asia.

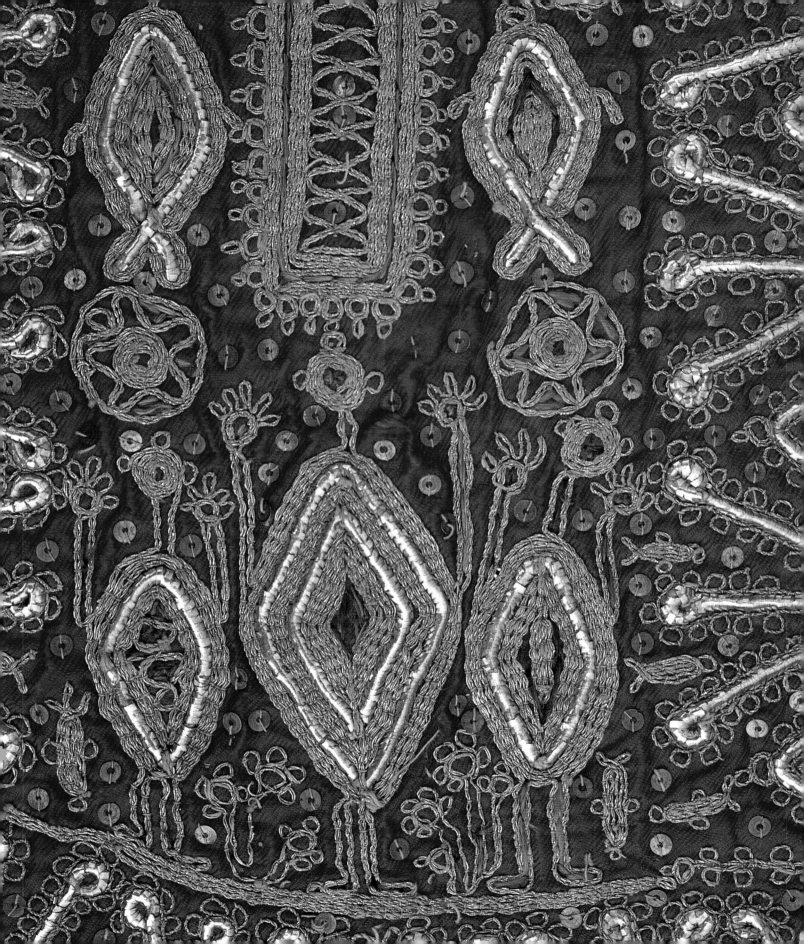

It is in Central Asia, in Turkmenistan, that the goddess is worn as a silver amulet down a woman's back, or as earrings. An older version made of terracotta, hung on the chest in a silver box, has been replaced by a Koranic script.

Pendants of the goddess are also carved in wood and hung round the necks of cattle in Afghanistan; she is tooled in leather and worn by Tuareg men in the Sahara, scratched on a pendant in the Bahariya oasis of the Libyan desert, or chiselled in bone and carried as a hunting amulet in northern Russia.

Versions of the goddess in carved stone were cult objects from the sixth millennium BC in Albania, and also in Ethiopia, where they probably came with the Sabean culture from South Arabia.

The purpose of the Cycladic figurines of the Aegean and Greek mainland, dating from around 3000 BC, is unknown, though they are thought to be talismanic goddesses of fertility. The later Mycenean ones from the fifteenth to fourteenth century BC, found in large numbers in shrines or graves, especially those of children, are interpreted as amulets against the evil eye, or even as nursemaids or toys.

RIGHT *Goddess motif protecting a Tuareg leather neck purse, Morocco.*

BELOW *Silver pendant etched with a goddess figure hung on a sculpture, Bahariya oasis, Egypt.*

RIGHT *Clay model of a figurine, c. 3rd century BC, Altyn-Depe, Turkmenistan.*

CENTRE RIGHT *Carved goddess figure of stone, Eritrea.*

FAR RIGHT *Bone amulet depicting a goddess, Chukotka, Siberia, Russia.*

RIGHT *Clay model of the face of a goddess figurine* c. *6th century* BC, *Erg Kala, Merv, Turkmenistan.*

CENTRE RIGHT *Bashkir metal figure of a goddess in a tree, Russia.*

FAR RIGHT *Zambezi river god amulet worn by Tonga surfers and canoeists to protect against drowning, Zimbabwe.*

BELOW, LEFT TO RIGHT *Tschokwe wooden voodoo doll with leather front and back aprons, decorated with beads and three cowries, Caprivi, Namibia; couple made of wood and glass beads to keep away and punish evil spirits, Majunga Province, Madagascar; wooden guardian doll, covered with red and blue beads and wearing a belt of amulets, Cameroon; Losi medicine-man couple of heavy wood, entwined with twisted leather cording and fur, one with yellow beads and holding a feather, Caprivi, Namibia.*

OVERLEAF *Guardian figurine at chief's palace, Bafut, Cameroon.*

In Ancient Egypt it was specific goddesses and gods that served as amulets. Male and female figures, of more human aspect, still serve as amulets in many parts of the world and are sometimes treated as living beings. Those placed in the fields of Sierra Leone to promote fertility were often beaten, while those the Eskimos wore down their back or sewn into their clothes, needed feeding. For the Ostyaks of the Ob river region in Siberia, peg dolls wrapped in cloths and embodying protective spirits of the clan, kept in a birch-bark satchel and often hung from a sacrificial tree

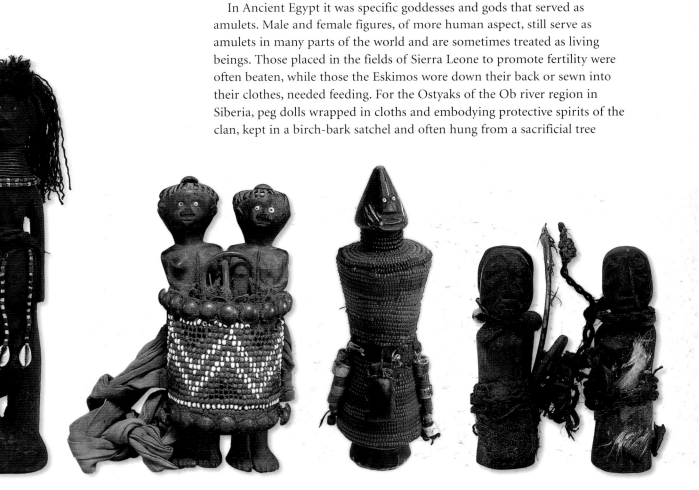

81

in the forest, would be regularly fed, for five years if they represented a man or two for a woman. Other figurines, for example of the Karo Batak in northern Sumatra, are dressed in hats and indigo coats, while those of the Beaju Dayak of Indonesia, who ward off evil powers and represent priests, wear large round hats.

In the Nicobar islands in the Indian Ocean, human figures, carved in wood and placed in the doorway of a hut to keep away evil spirits, were painted in black and red, the men wearing a high hat, and the women a red petticoat. And on Honshu island in Japan, paper amulets in human form were dressed in kimono and obi.

Human figures with hands clasped round the knees formed a Hindu amulet, while the Iroquois of North America wore human-faced effigies as amulets. Eskimo and Aleut necklaces of such figurines represented their spirit helpers, and were inherited from the father, or acquired from shamans. They were painted on kayaks and weapons, or carved on sacred hunting hats.

Many human-shaped amulets personify ancestors, especially in Africa and Oceania. In Africa such figures would not only protect from wizards and invisible dangers, but would also answer questions and advise, and even pass on their qualities to the wearer. In Oceania some wooden ancestor figurines included the skull of the deceased as a visual reminder, a practice later outlawed by the Dutch. Ancestors in this region were strongly protective of their descendants and were often featured on warriors' shields, or they would stand guard over a village and its store of rice.

BELOW, LEFT TO RIGHT *Male house guardian wearing a tall hat: these guardians are kept in the hut to frighten away evil spirits, Nicobar islands; female house guardian in a red petticoat: such female* kareau *warn the male ones when spirits intend mischief, Nicobar islands; Karo Batak figurines dressed in hats and indigo coats, Sumatra.*

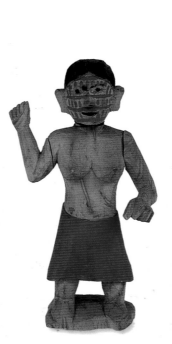

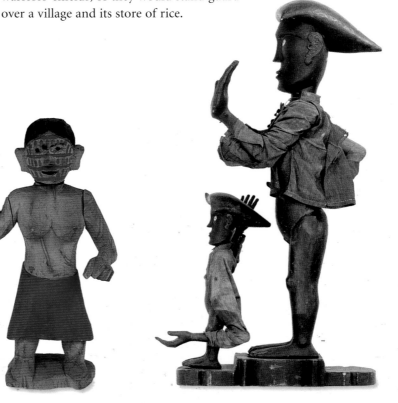

ABOVE *Shaman figure of bone to protect at night, always kept near the hearth of the tent, Chukotka, Siberia, Russia.*

BELOW, LEFT TO RIGHT *Faceless doll made of cloth, Russia; faceless linen doll to protect an Udmurt household, Russia; amulet doll made of wood, Siberia, Russia; doll made of animal bone, bundled with red rags, Russia.*

The mask, which could portray a god or goddess, a human, or a mythological character, is an ancient amulet. Medusa, slain by Perseus, was an amuletic mask in Roman times, the tongue poking out and prominent eyes reproducing the face upon strangulation or sacrifice. This terrifying aspect is still a feature of most amuletic masks. Those in Oceania grimace like Maoris in their war dances, while grotesque masks guard storehouses in Norway, and in the Far East are placed over doorways to frighten spirits.

The doll as an amulet has never been just a toy. Dolls have many associations, of which representing the fertility goddess is one of the most significant. Dolls are hung in fields to promote the crops, as in Syria, and in particular are used in many countries to protect a woman from barrenness. Turkmen women make cradled dolls of rags, like babies, and leave them in holy places, to ensure conception.

Dolls also play a significant part in the traditions of the Arctic and of Russia. The earliest ones, of the Okvik culture of about 2000 BC to AD 100, were in carved ivory and represented a shaman's helping spirit. A small figure of the shaman himself is still placed near the hearth by the people of Chukotka in north-eastern Siberia, to protect the family. Russian dolls were sometimes made of linen and clothed, their faces left blank, otherwise they could be animated by demons and harm children. They guarded the household: if their head was stuffed with linen, they protected the women; if masticated bread, the children; if ash from the hearth, the whole family. If the head was replaced by an egg, they protected the fertility of the family and its land. Other dolls could simply be a pair of crossed sticks, wrapped in bits of rag or thread.

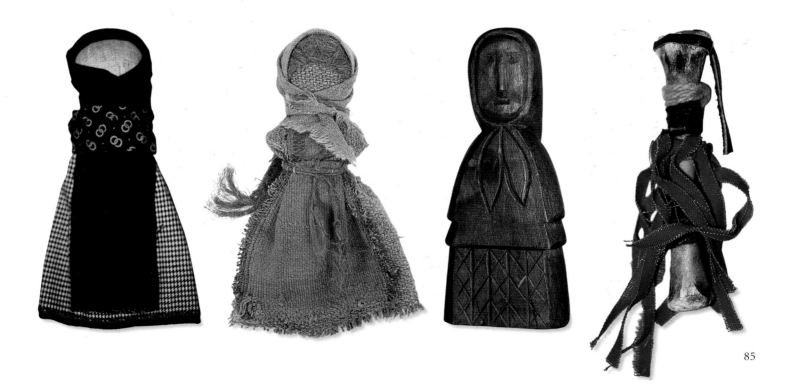

RIGHT *Dolls to protect against the twelve demons of fever, Russia.*

BELOW *Dolls thrown into a river to banish evil from girls, Japan.*

Fevers in Russia were known to be caused by twelve demons in woman's image, and to protect against each stage of fever, twelve dolls wrapped in rags hang by the stove. Their names only feature in exorcism and include Greek words and others of unclear etymology, placing them in the abstract world of Slavonic and Russian demonic beliefs.

Dolls are frequently used in black magic, stuck with pins or nails, burnt or cordoned with barbed wire, in order to injure or even kill the person they represent. They are also believed to be vehicles of evil spirits. The mutilated dolls dangling on buildings under construction in Albania perhaps have the same evil power within them that, confronting like with like, ensures they are amuletic.

In Japan dolls hung from the eaves of houses, or from trees, are expected to bring fine weather. Should that happen, the dolls are soaked in saké and thrown into pure running water. Human figures cut from paper can be substituted. Grass dolls are worn by Japanese children as amulets: during the twenty-sixth year of the reign of Suinin Tenno, in about the year 3 BC, Prince Otowaka made a doll of grass and had it blessed by the Sun Goddess. All human sins were transferred to this doll and banished when it was thrown into a river. When paper was introduced to Japan, paper dolls made for the purification ceremony of the third moon were rubbed over the body, absorbing any evil, and then thrown into running water.

Such paper dolls may represent ancient rain-making magicians, but it is not usually the blessing of rain that demands an amulet. It is rather the fear of thunder and lightning.

Lightning & stones

The trilobite, *Calymene blumenbachii*, curled up like a threatened hedgehog, fits snugly in the clenched hand of an eminent palaeontologist, though he usually keeps it in a small leather pouch in his pocket. He is the latest in a line of famous palaeontologists to inherit this fossil dating from the Palaeozoic period of 570 to 225 million years ago. Its known history goes back to Henry Woodward who sent it in 1917 to Herbert 'Leader' Hawkins, fighting in the trenches. Woodward felt indebted to Hawkins for his professional help and thought the trilobite 'which I possess & love very dearly, would best express my thanks. So I send it & beg you to accept it as a "mascot" from an old friend and never to part with it & so I bid you heartily farewell.'

Fossils were believed to be thrown down to earth by the gods, or to bear the imprint of Satan's claws. They protect whoever finds them and, passed down through generations, never lose their power. They can be worn or kept in a pocket, or, for the people of Finland – where they belong to Ukko, god of the heavens – pressed on boils or rubbed on fishing rods.

As such stones were created by storms, they protected against lightning in particular. Not only fossils, but thunderbolts, flint arrowheads, iron pyrites, nodules of iron dug up in a potato field, Neolithic celts, all have been found embedded in the eaves of houses, buried under the hearth, or set in the walls, specifically against lightning. As in other parts of the world, in Japan iron was thought effective against lightning, and farmers would place their sickle on the roof of their house to keep away the demons of wind, fire and lightning. The association between the number three and lightning was also strong, the angular strike being like a triangle, so that amulets were made of peach seeds that had to be cut into a triangular shape on the ninth day of the ninth month, and carried in a three-cornered bag.

BELOW *Paper replicas of lightning to protect the house, Japan.*

BELOW RIGHT *Trilobite set in a bracelet, England.*

ABOVE *Fulgurite set in silver, with tinkling silver pendants, Eritrea.*

BELOW *Silk amulets, c. 1650, imitating stone celts, prehistoric implements and arrowheads, Catalonia, Spain.*

Thunder and lightning are fearsome elements. When lightning strikes concrete sidewalks in Detroit, or mountain tops in Eritrea, it forms fulgurite, changing rock and sand into glass. Fulgurite set in silver is believed to hold the power of the storm and to protect from it.

Wood from trees struck by lightning destroys demons, while charcoal and pieces of any burnt wood protect against evil. The purifying effect of fire itself burns the evil eye and drives away spirits. For the whalers of the Bering Strait, a medicine woman would light a fire in the centre of their boat to bless it and burn out all evil spirits before it was taken out into open water.

Meteorites are believed to be a part of heaven, and themselves capable of causing thunder and lightning. They are particularly efficacious against gunfire and bullets – common knowledge in Albania. In France, they protect houses from fire and their inhabitants from the evil eye.

'Thunderarrows', often dug up during ploughing, are actually belemnites, fossilized internal bullet-shaped shells of a type of cuttlefish. One, picked up by a Sheffield lady on the sands of Lincolnshire in about 1890, was inscribed with a magic formula in runic script. Such thunderarrows, also called devils' fingers, were widespread ancient amulets in Europe, and were useful to wizards in their rituals of moon divination.

Prehistoric implements were believed to be thunderbolts and therefore magical. They were buried in fields to ensure success of the crops, or kept in granaries to increase the store of rice. In Thailand they were used as a charm against lightning, and to sharpen the artificial spur of fighting cocks, as well as just to sharpen knives. Should a storm rage, the implement was to be buried under the house, or it would jump about and frighten people. Such prehistoric tools were even copied in silk in seventeenth-century Spain to be worn as amulets.

RIGHT *Idol of the god of war, made of pine which must have been struck by lightning, kept in mountain-top sanctuaries, New Mexico, United States.*

BELOW *Statuette of St John representing the god of thunder, placed in houses and venerated as holding the power to keep away thunder and bring rain, Cochabamba, Bolivia.*

BELOW RIGHT *Bridal headdress set with cornelians, Kazakhstan.*

Stones are one of the oldest amulets. The first cult form was the stone ball of the Mousterian period of 150,000–60,000 BC, symbolizing the sun. In Palaeolithic times, stones with natural holes were worn round the neck and believed to hold a magic power, shared by the holed stones used as weights on looms and fishing nets, and as spindle whorls. Such naturally perforated stones, associated with a witch's vagina, are the ones most commonly considered magical. Hung on a cattle byre in Ireland, they kept pixies away from the cows and stopped fairies stealing the milk. Over the stable, they would prevent the devil riding the horses at night.

Holed stones have a particular power to protect houses from witches. The hag-stones of Devon and the witch-stones of northern England were hung over the doors of cottages, the latch-keys looped onto them by a red ribbon or attached by a peg, while in Italy the holed *pietra boccata* decorated the doors of both peasant homes and the shops of Amalfi.

Other stones slightly unusual or misshapen were treasured for their protective powers: one in the form of a swollen foot would keep away gout. Another, shaped like the horns of an ox, or its hooves, increased a Naga man's herd of cattle and ensured they would not wander or be eaten by tigers.

Stones could be incised with special markings or cut in the shape of skulls – particularly effective in Italy against the evil eye. Buddhas, animals and birds were other carved forms.

Magic powers could be assigned to special stones. In Corsica chalcedony would make a man invisible – unless a heretic woman were present – while catochite would endow him with prodigious powers of memory. The owner of such a stone, Jean-Baptiste Leoné of the village of Ochjatana, could recite the names of all the stations from Ajaccio to Bastia and back again.

Unlike such examples, the amuletic power of certain semi-precious stones has some basis in logic – the association of cornelian with blood, and with Zoroastrian fire-worship, making it the most popular amuletic stone in Central Asia; the special refractive qualities of crystal; the slight electrical impulse and scent of amber when rubbed; the iridescence of mother-of-pearl, cat's eye and opal; the striking patterns of jasper and agate; the hardness of obsidian; the spiritual power the Maoris believe jadeite to hold; the colour of turquoise, which links it to the sky and rain-bringing powers, and its tendency to 'age', equating it with life.

Alum is best known as a mordant in dyeing, but its translucency makes it an important amulet in India, the Middle East and Bolivia. In India alum is connected with Lord Shiva and a lingam of it is hung over the main door of a house, wrapped in human hair together with a lemon, to protect from evil. In the Middle East alum is used as it is, usually combined with blue beads and often cut into a triangular shape. It protects babies in particular, the evil eye cracking the alum rather than injuring the child.

The *chiflis* shops, dealers in magic and medicine throughout the Andes and Altiplano, trade in two kinds of alum. The white, sulphate of alumina, when rubbed into the skin calls on the protection of ancestors and local divinities, while the black variety, iron sulphate and actually yellowish-grey in colour, is used in black magic. Mixed with black sulphur and ground glass, it is blown towards the windows, doors and threshold of the intended victim's house.

Of all the semi-precious materials, coral is almost everywhere the most highly esteemed. Its magical powers are drawn from both the vegetable and the mineral world. Its colour is that of blood, the vehicle of life. In Europe it was believed to be the drops of blood from the mythological Medusa, falling into the sea as Perseus killed her. Pieces of coral are hung on doors to protect from evil, lightning and tidal waves; coral is also worn by brides to avoid sterility and to retain their husband's affection. Nevertheless its major role is the protection of children. Coral rattles, coral necklaces, coral pendants, all would ensure painless teething and robust health.

As for the lucky magic accredited to many precious and semi-precious stones in modern New Age thinking, this is somewhat suspect and akin to the 'language of flowers'.

Berber woman's forehead decoration of coral, amber, shell and silver, Morocco.

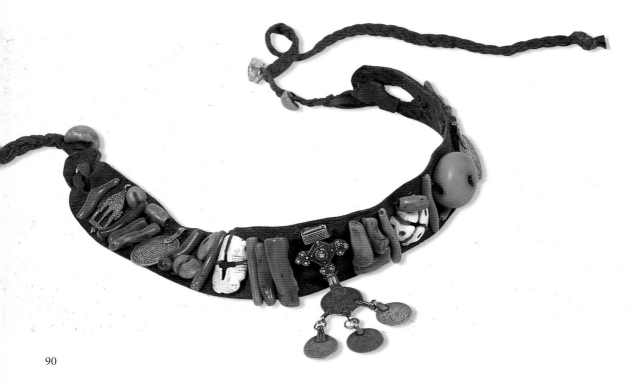

Silver & sparkle

The accepted role of jewelry in the West is as a display of wealth and beauty, only the wedding ring and pendant cross being recognized as symbols rather than as decoration, but in most of the world jewelry is usually amuletic. The protective power of precious and semi-precious stones and that of silver and sparkle, together with local ideas of beauty, determine what is considered jewelry. The healing strength of coral, the prowess shown in a tuft of lion's mane, the cooling tinkle of cheap glass bangles, the association of the purity of silver with Mohammed, all replace the flaunting of wealth of the diamond and ruby parure.

Though it is not uncommon for a bride to be weighed down by kilos of silver, amber, turquoise and coins, amuletic jewelry is normally everyday wear. The Akha women of Thailand work in the fields adorned with so much silver they are sometimes attacked and robbed, while Tibetan women's daily dress is heavy with turquoise. Boxes of gold inlaid with turquoise and enclosing spells and charms and prayers hang from their necks, while the men's are of silver or brass. 'No Tibetan is ever without one of these, no

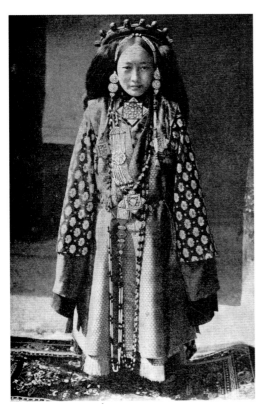

BELOW *Woman wearing amuletic silver jewelry, Tibet.*

BELOW RIGHT *Dancer wearing turquoise jewelry, Leh, northern India.*

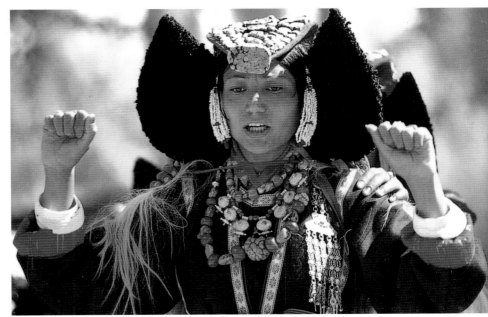

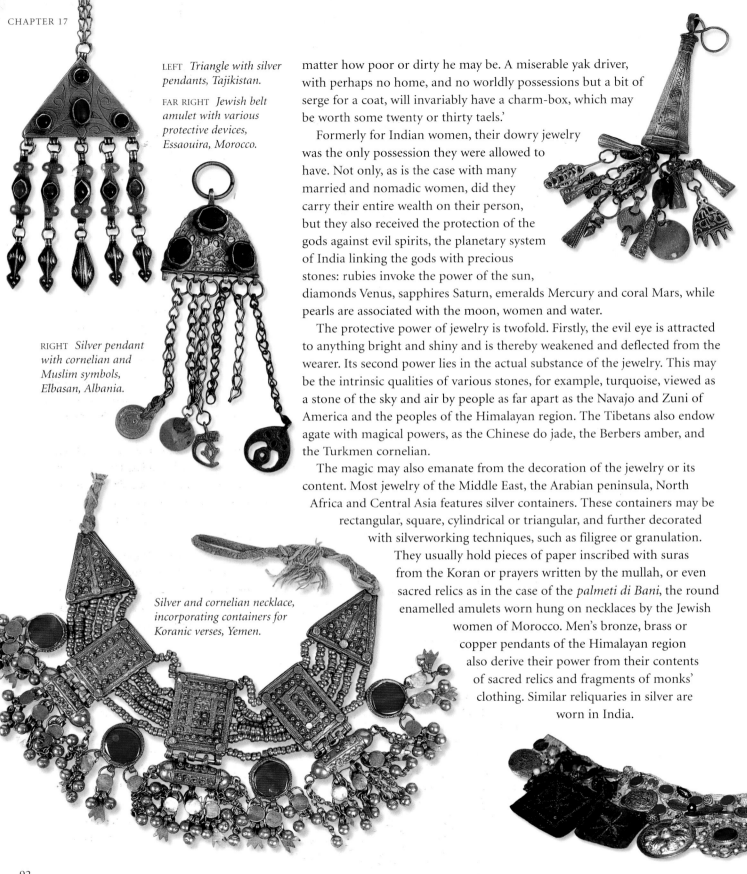

LEFT *Triangle with silver pendants, Tajikistan.*

FAR RIGHT *Jewish belt amulet with various protective devices, Essaouira, Morocco.*

RIGHT *Silver pendant with cornelian and Muslim symbols, Elbasan, Albania.*

Silver and cornelian necklace, incorporating containers for Koranic verses, Yemen.

matter how poor or dirty he may be. A miserable yak driver, with perhaps no home, and no worldly possessions but a bit of serge for a coat, will invariably have a charm-box, which may be worth some twenty or thirty taels.'

Formerly for Indian women, their dowry jewelry was the only possession they were allowed to have. Not only, as is the case with many married and nomadic women, did they carry their entire wealth on their person, but they also received the protection of the gods against evil spirits, the planetary system of India linking the gods with precious stones: rubies invoke the power of the sun, diamonds Venus, sapphires Saturn, emeralds Mercury and coral Mars, while pearls are associated with the moon, women and water.

The protective power of jewelry is twofold. Firstly, the evil eye is attracted to anything bright and shiny and is thereby weakened and deflected from the wearer. Its second power lies in the actual substance of the jewelry. This may be the intrinsic qualities of various stones, for example, turquoise, viewed as a stone of the sky and air by people as far apart as the Navajo and Zuni of America and the peoples of the Himalayan region. The Tibetans also endow agate with magical powers, as the Chinese do jade, the Berbers amber, and the Turkmen cornelian.

The magic may also emanate from the decoration of the jewelry or its content. Most jewelry of the Middle East, the Arabian peninsula, North Africa and Central Asia features silver containers. These containers may be rectangular, square, cylindrical or triangular, and further decorated with silverworking techniques, such as filigree or granulation. They usually hold pieces of paper inscribed with suras from the Koran or prayers written by the mullah, or even sacred relics as in the case of the *palmeti di Bani*, the round enamelled amulets worn hung on necklaces by the Jewish women of Morocco. Men's bronze, brass or copper pendants of the Himalayan region also derive their power from their contents of sacred relics and fragments of monks' clothing. Similar reliquaries in silver are worn in India.

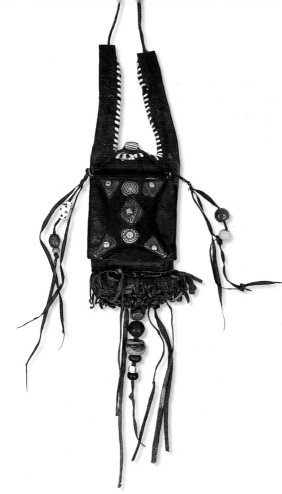

Silver itself is a powerful metal, symbol of purity in the Islamic world, blessed by the Prophet. In the West it is a token of luck: palms are crossed with silver, we should turn the silver in our pocket when we see the new moon, and a man would put a sixpence in his shoe when going out, to protect him.

Brides in Bulgaria are protected by a silver forehead decoration forming a ring, while on the crown of the head they wear silver amulets with Christian motifs such as St George and the dragon. In Norway it was particularly silver brooches that were a powerful weapon against the underworld folk Their power was strengthened by being worn to church.

Charms are very often of silver, as in the composite *cimaruta* of southern Italy, of Etruscan or Phoenician origin, and the small amulets forming part of it – frogs and snakes, dogs and horses, the sun and moon. Silver pendant amulets were also worn or placed on icons in Russia, the Balkans and Greece, and included animals. Similar ones were made as Illyrian jewelry in Albania from about the fourth century AD.

ABOVE, LEFT TO RIGHT *Tuareg neck amulets, Sahara, Morocco: leather neck-purse protected by beads and an amulet of leather and silver; etched leather neck-purse decorated with silver and hung on a necklace of plaited leather and coral; amulet of incised silver and leather.*

RIGHT *Silver dome with chains and tassels to hang from a belt to protect a woman's genital area, Uzbekistan.*

BELOW *Forehead ornament set with cornelians and velvet amulets, Kazakhstan.*

Silver pendants sometimes have phallic form. Those hung on the necklaces of the Oromo women of Ethiopia include phalluses and also the triangle against the evil eye, and the crescent against the power of the waxing moon. Silver phalluses, rings and keys hang from the waist on chains of silvered metal in the archaic costume of the married women of the Padureni region of Romania. In many parts of the world the waist, and therefore the belt, are believed to hold magic powers. Uzbek women hang tassels set in silver from their belts, which also protect their reproductive organs.

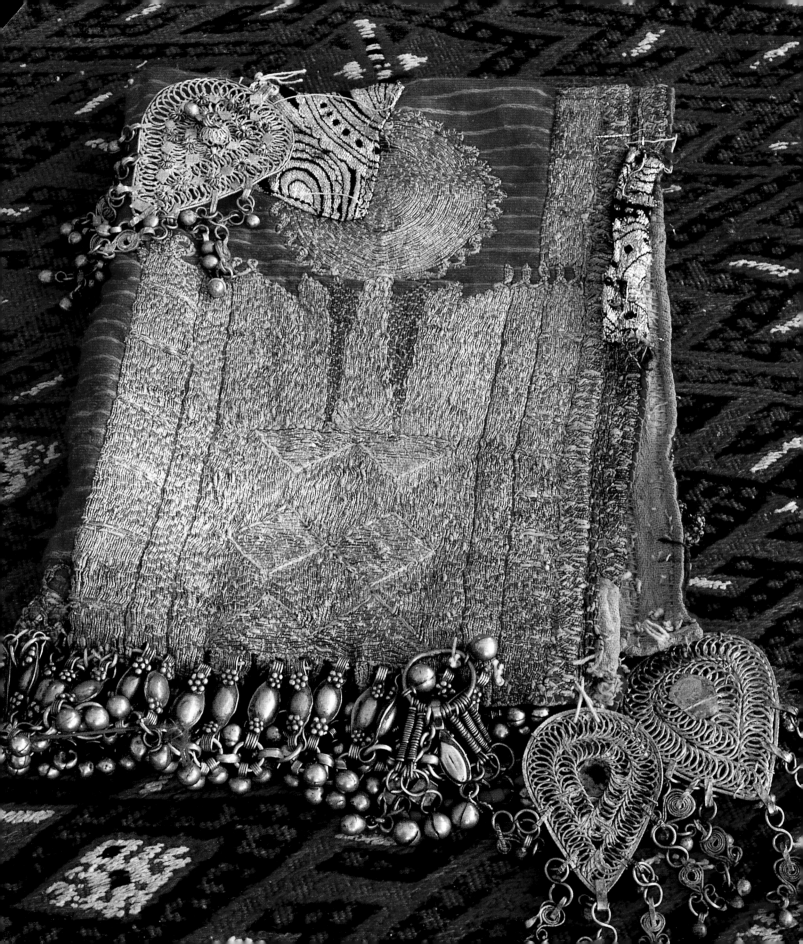

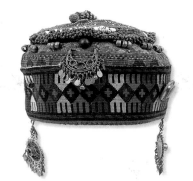

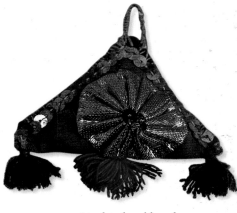

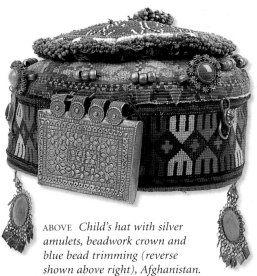

ABOVE *Child's hat with silver amulets, beadwork crown and blue bead trimming (reverse shown above right), Afghanistan.*

OPPOSITE *Child's cap heavy with silver, Yemen.*

BELOW *Woman wearing a silver amulet container, Afghanistan.*

ABOVE *Amulet placed by a bar owner against the blue-eyed Danish tourist who had wrecked his video, Olymbos, Karpathos island, Greece.*

BELOW *Bashkir bib front hung with coins, Russia.*

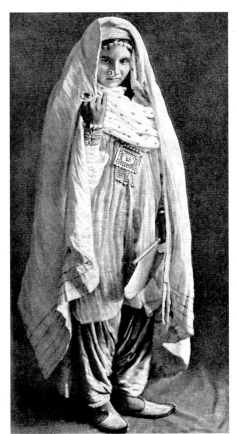

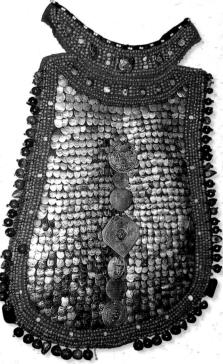

LEFT *Marriage headdress covered in silver and coral, Karakalpakstan.*

95

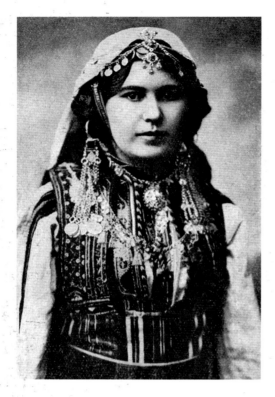

ABOVE *Woman wearing head and neck jewelry, Struga, Macedonia.*

BELOW *Metal popper at the base of the neck opening of a woman's shift, Saraqib, Syria.*

OPPOSITE *Chuvash coin necklace and woman's bib, Russia.*

Gold in amuletic jewelry is much less common than silver, and in some countries is believed imbued with a life of its own, influenced by evil spirits. Brass and particularly bronze, in contrast, are metals frequently found in West Africa and the Far East. Leg and ankle bracelets of bronze, some augmented by defensive spikes, protect men in Nigeria and Burkina Faso against witches and snake bites. They are decorated with horned heads that incarnate the spirit of the animal concerned, while in Sumatra men's bracelets and pendants of bronze depict ancestor figures or a mythical animal, half-elephant and half-snake.

Necklaces hung with small bronze heads were worn by Naga headhunters, symbolizing the life-force acquired by killing, which will protect the whole village. Brass is the metal of the neck rings of the women of Myanmar. Believing the neck to be the source of the soul, these rings will protect the whole tribe. Brass was also of course the shine and sparkle on European horse and carriage, while copper is still believed to protect from rheumatism. The Tuareg wear rings of it for the same purpose.

Jewelry for children is almost exclusively amuletic, from coral necklaces and charms to silver amulets fastened to baby caps. In southern Italy silver keys protected the child from convulsions. In Thailand a silver neck ring is put on the baby and worn at all times to prevent its soul escaping. In the Oltenia region of Romania, one earring was placed in the left ear of a baby boy whose siblings had died. If he grew to adulthood, his survival was attributed to the earring and he continued always to wear it. In the Balkans, coins were tied around a baby's forehead.

The brightness and sparkle that bring fear to the evil eye do not always come from silver jewelry. Flashy CDs in cars, sequins, bits of shisha (the mirror glass of Indian embroidery), old zips, poppers and coins on clothing can have the same effect. Coins are a major feature of much traditional costume of the Balkans, Russia and Eastern Europe, covering headdresses and bib fronts. Of all the coins used as an amulet, the thaler of Maria Theresa, Empress of Austria from 1740 to 1780, is the most popular. Because of its high silver content, it was traded throughout the Middle East, and reached many parts of North Africa, even Chad and Libya, as well as Eastern Europe and Palestine. Many coins are, however, fairly worthless and often replaced by buttons, especially white or of mother-of-pearl.

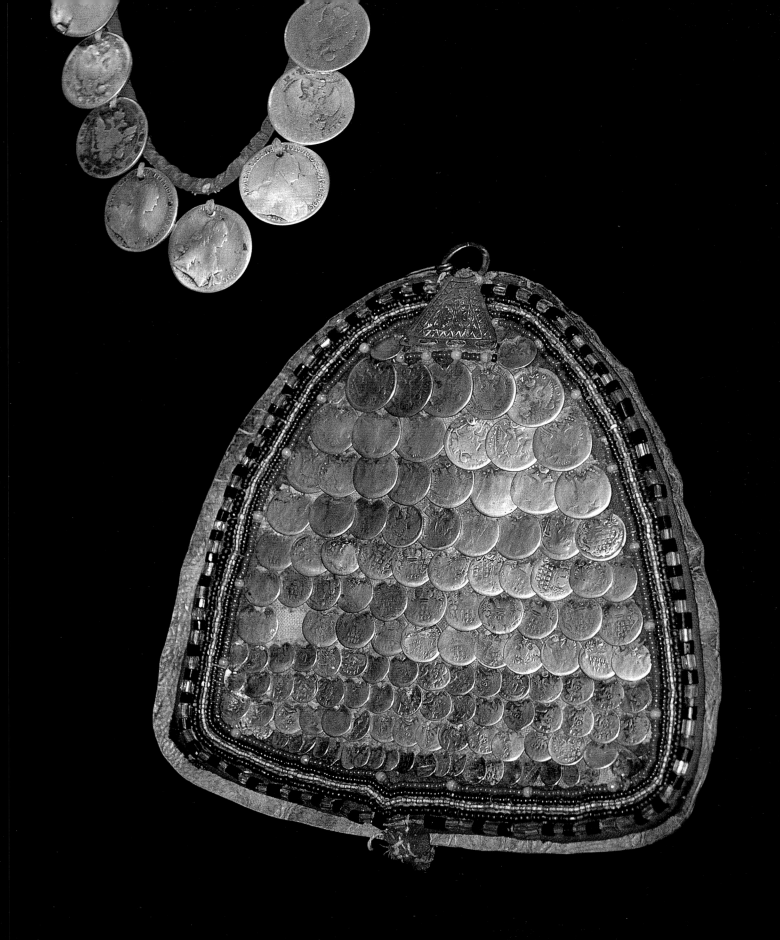

Buttons, beads & blue

The Siwa oasis lies in the Western Desert of Egypt, where trade routes brought salt and slaves across the Sahara. The temple to the sun god Amun, whose oracle Alexander the Great consulted in 331 BC still stands, roofless now and open to the sky. Sun worship remains the leitmotiv of Siwan costume, with its orange and red embroidery of solar symbols. The sunbursts that cover the women's marriage dresses are accentuated with white pearl buttons, now often replaced by buttons of coloured plastic – a dazzling spectacle against the evil eye.

The high valleys of Indus Kohistan in northern Pakistan are another enclave where white buttons on women's and children's clothing are a major decorative talisman, but here they are combined with white beadwork. In Albania, too, the boleros of the women of the Kruje region that close at the waist with regimented rows of white buttons are augmented by bright beadwork of solar circles, specifically against the evil eye. Such solar motifs of circles and eight-pointed stars decorate the amulet bags of the Chuvash of Russia, which are also filled with small coloured buttons, along with coins, hops and berries.

In all these cases, buttons are used in quantity, though it is often isolated ones that appear more powerful, as on the dresses from Sa'da in Yemen.

BELOW *Plastic buttons alternating with solar motifs on a woman's shawl, Siwa oasis, Egypt.*

OPPOSITE *Protective buttons and beads at the waist of a woman's costume, Kruje, Albania.*

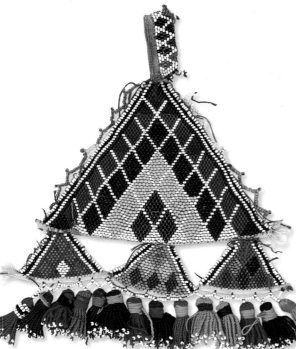

The power of beads functions in a similar way. They can form a necklace, a bracelet, an entire object or pattern, or they can be used singly. One blue bead half-hidden at the centre back of the fringe on a crocheted Turkish shawl has an intense force a string of beads would not have. Equally, two groups of four tiny blue beads on a leather amulet, put round the neck of the goat of a Masai herdsman of Kenya to ensure it finds its way home, focus the evil eye and lead it away from the animal.

The use of beads, single or massed, is of ancient origin, probably already known to Stone Age man. In the Sumerian civilization of the third millennium BC, beads against the evil eye, often decorated with an eye themselves, were recorded as being worn for their protective power, as they were in the Harappan culture of the Indus valley. The bead featuring an eye has remained prevalent throughout the Islamic world.

Through the early civilizations of Western Asia, Egypt and the Mediterranean, beads were not only a status symbol, but were also sewn onto clothing and worn as amulets. In Egypt some represented gods and protected their wearer against specific dangers. Such precise powers will often still be ascribed to a certain bead: beads of black and white agate are a powerful source of general protection for the people of Tibet, while in Bengal, old agate beads protect against dysentery, and, for the traders in salt of the Himalayan region, amulets of strung beads of metal, turquoise and coral are believed to avert sickness on their journeys. In Madagascar, large white 'goat's eye' beads can miraculously bring the wearer things that do not actually exist, and so are deemed particularly magical.

ABOVE *Bedouin beaded tent amulet of triangles, Siwa oasis, Egypt.*

ABOVE RIGHT *Masai amulet of bone and blue beads to stop goats wandering, Kenya.*

BELOW *Beaded necklace with triangle, Albania.*

OPPOSITE *Heavily beaded headdress, Marrakech, Morocco.*

101

The early beads of faience and of lapis, agate, coral, crystal, amethyst and other semi-precious stones, when replaced by glass lost nothing of their apotropaic powers or value. They were used as currency, often replacing cowries, and were an item of trade, especially in North America, where they were unknown to the American Indians before being introduced by Europeans, and so were held to have strong amuletic force.

Beads are worn around the neck or waist, used to decorate animal trappings or, in the case of Indonesia, stitched to weavings and embroideries to attract benevolent spirits and so maintain harmony between man and the heavens. In southern Africa beads cut from ostrich shells decorate amulets made of animal parts.

Of all beads those of blue, whether depicting an eye or simply plain, are today the most widespread, especially in the Mediterranean world and the Middle East, though blue glass beads made in China were even traded from Siberia into the western Canadian Arctic by Alaskan Inuit.

While the blue bead has similar connotations of the sky and sea to turquoise, it can also symbolize the full moon with all its life-giving potency and association with the female. Perhaps for this reason it is a favoured amulet for married women and children. For example, in Albania women's horned headdresses were edged with a broad band of blue beads, while the markets – as in Istanbul and Central Asia – are full of blue bead amulets to be pinned to children's clothes. In the shops of Athens black twisted cord bracelets set with a single blue bead vie with sponges, souvenir postcards and olive oil soap for the attention of the tourists.

TOP LEFT AND RIGHT *Car amulets of a Madonna set on blue glass and of a St Christopher on blue glass with four 'eye' beads, Greece.*

ABOVE *Miniature Koran, heart-shaped blue glass eye, miniature knife and three twisted strings of blue beads enclosing balls of tinfoil, sold on a safety pin in Prizren market, Kosovo.*

RIGHT *Grave with three blue inserts at Bukhauddin Nakhshbandi Mausoleum, Bukhara, Uzbekistan.*

If not in the form of a bead, blue in itself is a dynamic colour, both lucky and cursed: it has cooling, almost therapeutic powers, but also holds an aura of melancholy. In Ethiopia Amharic girls receive a blue cotton cord at baptism, which they wear round their neck with a silver cross; in Europe the bride wears 'something blue'; the Virgin Mary is always robed in blue. A more unusual application was the blue glass horn hung outside houses of ill repute in Naples, against witches and the evil eye.

The epitome of the dynamism of blue is, of course, indigo. The complexity and secrecy of the dyeing process, and the mystical way in which the dyed cloth suddenly changes to blue on contact with the air, all conspire to surround indigo with ritual and superstition. Indigo cloth is considered magical in places as far apart as Indonesia, the Middle East and West Africa, and clothes made of it ward off evil spirits. Even a narrow band inserted above the hem of dresses from Hauran in Syria is enough to protect the bride from the evil eye.

Though the colour blue in indigo cloth, in piercing eye, in glass bead, or in the sea and air captured in a lapis or turquoise stone, has the strongest possible amuletic power, its great rival, especially in Europe, is red.

ABOVE *Indigo insertion in the cuff of a woman's shift, Hauran, Syria.*

RIGHT *Tuareg man in an indigo robe, wearing a turquoise leather purse amulet, Sahara, Morocco.*

BELOW *Tuareg neck-purse amulet found in Sahara, Morocco, made of bright turquoise leather from Kano, Nigeria.*

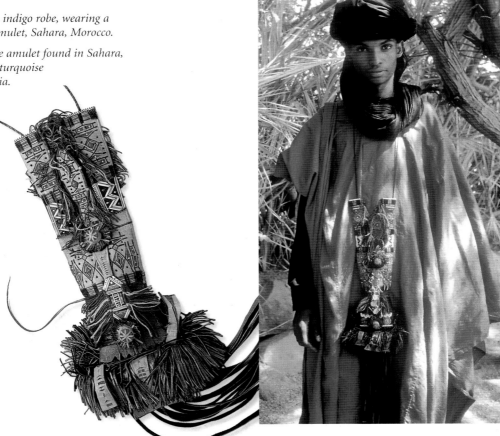

Red, white & black

*I*f the power of blue is harnessed in a single bead or a swathe of indigo cloth, that of red is captured most frequently in a thin thread or a swatch of fabric. The thread may be worked into an embroidery pattern, as in most of the costumes of Eastern Europe or the ritual cloths of Russia and Ukraine, or it may be a garment edging deemed to be effective against witches. It may remain a simple thread tied round the wrist, or a ribbon encircling a Romanian bridal couple at their wedding, used then by the woman to tie her apron on Sundays.

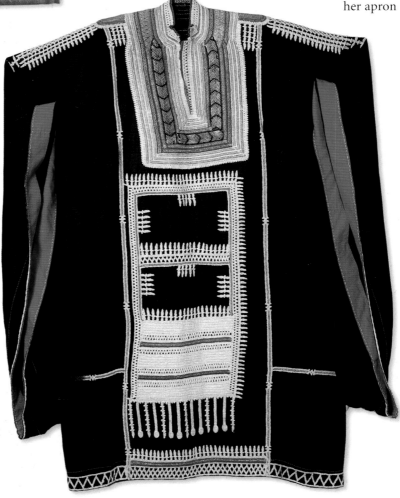

Three colours are basic to the human state: red, white and black. Though interpretations of their symbolism may vary, white traditionally denotes purity and recalls the potency of human milk and semen, while black, associated with excreta and earth – and thus chthonic creatures – denotes decay. It is with such associations that black and white are used in amulets.

Red is the most vibrant, the most exhilarating of colours: it is the blood of life and of sacrifice and the most potent force against demons, witches, wizards, sorcerers and, as ever, the evil eye. Red confronts the forces of darkness with the blaze of the sun and of life. Sacred sites are painted with red ochre, the windows and doors of Welsh cottages are outlined in red to keep demons away, thresholds are decorated with red rags – the entrance of the Bedouin tent as that of the Mongolian yurt. Archaic marking in red survives in the red cross-stitch initials on dowry textiles and on cradle linen.

Just as the king of the Benin of Nigeria required his chiefs to wear red court dress to protect him from evil spirits, so Ceausescu decreed that all embroidery on Romanian costume should be red, even in areas like Nasaud where traditionally only brown and blue beads were used.

In fact, simply edging a garment in red has amuletic power enough, and there are many early examples, like the linen shift of Pazyryk dating from around the fourth century BC, with red thread couched on all its seams, and at wrist and neck.

Red thread alone sufficed to protect. By the late fourth century amulets of red thread had already provoked the distaste of St John Chrysostom, Patriarch of Constantinople and reputed the greatest orator of the Church, who scathingly condemned so many minor vices that the Empress Eudocia

TOP *Red devil amulet collected by Frederick Thomas Elworthy, c. 1890–1905, Paris, France.*

ABOVE *Red rag reinforcing a padlock guard, Bukhara, Uzbekistan.*

RIGHT *Entrance to a temple, India.*

OPPOSITE ABOVE *Embroidered white linen marriage shirt marked with the word 'friendship' in red thread, Portugal.*

OPPOSITE BELOW *Red edging to the sleeves of a woman's dress, Bajil, Yemen.*

ABOVE *Red rags on a festival mask, Russia.*

BELOW *Red tassel on a horse's harness, Shkoder, Albania.*

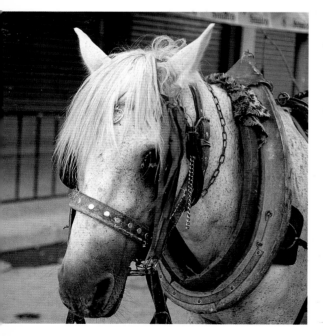

had him banished. Against red thread he was, however, powerless. It is to this day tied round babies' wrists, necks, legs, round the arm of a mother in labour, and over the door of her room. It is twisted together with white to hang medallions, flowers, or whatever takes the fancy, from the trees of Greece and Bulgaria. Though the objects chosen may vary, the colour of the thread is constant. In Russia red thread is tied onto anyone in a transitional phase of life – a child, a fiancé or bride, or the newly deceased. A modern Indian politician wears red thread round his wrist at all times. In Macedonia red woollen thread is tied through a baby girl's ear lobes until she is old enough to wear earrings, or it wraps a sprig of basil against the evil eye.

Red pompoms and tassels can be equally effective, hung, as in Sicily, on windows, doors, railings and gates, or, in most of Eastern Europe and the Mediterranean, on donkeys' and horses' harnesses, tails, ears, or on the shafts of their carts. In Tibet it is the yaks involved in ploughing who sport fluffy red tassels above their heads, perhaps the dyed tails of their fellows.

Red also features in a German recipe of 1732 for an amulet against spells. The worm inside a fallen hazelnut is prised out with its dirt and replaced with an eye feather from a peacock's tail. The nut is then wrapped in red taffeta or a piece of scarlet cloth and worn round the neck. This protects from all harm, but the cord it hangs on must also be of red silk.

The 'red' or 'beautiful' corner of the peasant homes of Eastern Europe and Russia – usually above the table and opposite the stove or door – has become a holy place honouring God, but was originally the revered corner of the ancient Eurasian hunting societies, where protective ancestors lived. Among the traditional objects displayed in it is always a ritual towel embroidered in red, the same as those draped over crosses in the cemetery.

In Japan, red amulets are specifically against smallpox. These can be a red cow with a nodding head, a votive figure of papier mâché wearing a red cloak, or a child's book bound in red covers, sewn with red string and illustrated with red pictures. This book fell into disuse after the introduction of vaccination into Japan in the mid-nineteenth century.

The association of white and black with human body parts, fluids and excreta features more in rituals of superstition than in actual amulets: spitting on a new baby's forehead protects it against the evil eye, stepping in a dog's turd or horse's manure is considered lucky. As for the Copts of Egypt, who are plagued by the *sûflî* – small, underground creatures with vertical eyes, dressed in black, who seek out blood and semen – they must protect themselves by covering a loaf of bread with excrement and semen.

As an amulet, white is found mainly in thread and beads. Zulu babies wear necklaces of white beads, while babies of West Africa wear white cotton thread round their wrists and white beads round waist and neck. In Thailand the white thread used to bind the shroud of the dead is worn as a ring.

Ashes of their dead beloved are worn as an amulet by the people of Kastoria in northern Greece, a town specializing in fur. The beavers of its lake were already hunted to extinction by the nineteenth century, and now

ABOVE *Tekke child's cap of various colours against different evil spirits, decorated with black and white thread and other amulets, Turkmenistan.*

BELOW *Tekke child's cradle hung on black and white 'snake' cords and decorated with multicoloured appliquéd fabrics, Turkmenistan.*

every kind of dead furry animal is fashioned into slippers, key-rings, purses: it is a town with a pall of death.

In South America llama foetuses are dried and buried in each corner of a new building, or incorporated into other amulets. An amulet invoking birth is the caul. Unusual and therefore powerful, it is carefully dried and worn in a medallion, as by seamen, as Charles Dickens describes in *David Copperfield*. Far more common is a piece of umbilical cord, wrapped in cloth and worn round the neck.

In Russia, the Old Believers wore fingernails as an amulet, thinking them useful for climbing out of the grave and up to heaven, while nail parings and hair clippings were always kept, as the whole body had to be there on the Day of Judgment. Nail parings and hair are also useful in black magic, retaining as they do the life-force of the person from whom they were taken.

White and black often protect together: white and black beads are mixed, or black beads are given a white 'eye'. Threads can be mixed, too, as in the magic cord of black and white tapes knotted together with black and white pins, found in a mattress at the house at 43 Strada Mezzodi, Valletta, Malta, in September 1907. Such twisted black and white cord, recalling a local snake, is ubiquitous on children's clothing in Turkmenistan. Here, too, every evil spirit is believed to be offended by a particular colour or smell, so multicoloured patches placate each one.

The protection of black is most often held in black cord worn round the wrist, in a lump of coal, in charcoal, black clothes and kohl on the eyes. And in Crete bat dung is the excreta that is encased as an amulet, symbolizing perhaps the protection of the church tower, or, more probably, mankind's earliest place of refuge, the cave.

Teeth, claws & paws

ABOVE *Copy of an old Native American bear amulet made for tourists, United States.*

BELOW *Stone lion on fountain steps, Venice, Italy.*

St Jerome's guardian lion on a string terrified his fellow monks, as it would evil spirits: animals as amulets must of necessity be an image or a model, rather than real. Lions of stone flank entrance steps, lions and tigers are painted on rickshaws in Bangladesh, on buses in Eritrea, Pakistan and Morocco, and on houses in Japan. The tradition in China of dressing small boys in tiger hats to disguise them was already known in the Song dynasty of the eleventh and twelfth centuries, when tiger heads were fashioned for small boys and warriors to give them strength and protection (see p. 19).

Animals can be jinn in disguise or an actual witch, as the hyena is known to be; they can be inhabited by evil spirits, as in the case of the jackal; they can be people killed by witches and turned into lions, dogs and bush animals, as in Cameroon, or – as for the Ostyaks of Siberia – they can be totemic protector animals like the bear, from whom the family is descended.

As a talismanic device, the animal retains the characteristics of the living creature. Strength, as in the buffalo and horse, is prized. The powerful hippopotamus was early used as an Egyptian amulet, painted on apotropaic wands of around 2800 BC and representing the goddess Tawaret.

It is particularly in body parts – a tooth, a claw, a bone, horn, foot or feather – that animals are used as amulets. Such parts are believed to contain the life-force of the animal and its particular qualities – such as power, speed, cunning, fertility – and to transfer them by magic to the wearer of the amulet. Most body parts are taken from wild animals, while the domestic are the ones protected. Whether the tooth is that of a boar, wolf or crocodile, or the claw that of a bear or eagle, will depend on the local species. The power it imparts to the wearer will be the same.

Animal teeth are among the most common of amulets: the bared teeth of a wild animal are a powerful signal to stay away. The range of teeth considered amuletic is vast, but it is particularly animals whose strength spells danger, such as lions, tigers, leopards, cheetahs and panthers, hyenas, wild dogs, jackals, wolves and bears, that are held in awe. The power of others, in particular the wild boar and pig, is more complex. The ancient rite of the sacrifice of both boar and pig, taken from the Aryans, the pig's ability to prevent mental illness and unravel spells, the recoil before it of both Muslim and Jew – all have imbued it with some sort of sanctity. It is associated with Christianity, but its talismanic powers are far more ancient:

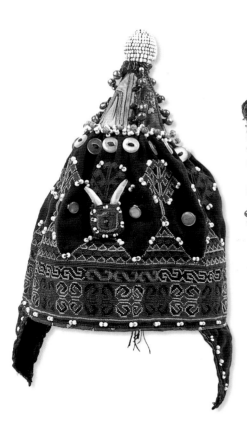

a pig's tooth attached as an amulet has been found on necklaces of the Neolithic period, and of the Gallic and Frankish Bronze Age.

Tekke Turkmen women of Muslim Central Asia wear a pig's tooth wrapped in a cloth triangle hanging from the back of their cloak, believing that all the evil directed at them will be absorbed by the tooth, as belonging to an animal outlawed by Islam. In Morocco pigs and boar are actually jinn, and their teeth are believed to cure disease, and their tusks to pierce the evil eye. Both are laid out for sale on market stalls dealing in magic.

Hedgehog teeth are hung round children's necks in Corsica, against the spirits of the fog, while in Morocco, set in silver, they are sold by jewellers to protect the newborn against the evil eye, and, in their natural state, by traders in magic. Whole hedgehogs – ideal amulets with their defensive spikes – are part of the stock of medicine men.

Teeth of hippos, warthogs, beavers, badgers, marmots, horses, hyenas, deer, caribou – all are talismanic. Even those of fossilized shark or of toadstone are used in Europe and have been found in ancient necropoli in Peru. Beads and bones in the shape of teeth are strung on necklaces in South Africa and Sudan. It is in Africa, too, in parts of Nigeria, Cameroon and Zaire, that the teeth of slain enemies are also worn round the neck. Human teeth as amulets are more often milk teeth, set in a chair as in Norway, or worn as a child's amulet in Germany. In the northern territory of Australia, human and dogs' teeth were carried around together in a netted dilly-bag, while it is recorded that in 1897 someone in Tunbridge Wells, Kent, kept on their person for a considerable time the tip of a human tongue.

Animal claws have the same incisory powers as teeth, those of predators and lesser creatures, such as crabs, lizards and stag beetles, prized alike.

Whole paws, often elaborately mounted in silver, have remarkable magic powers. These are in Algeria and Morocco paws of the porcupine, and in Europe of the mole. The porcupine is, like all animals who dig their home in the domain of underground spirits, a servant of the jinn. Not only its paw but also its quills have devastating powers against the evil eye. It is said in Morocco that any woman hit by a quill will break the dishes she is washing up.

Monkeys' paws, used as amulets in Taiwan, have the added characteristic of resembling human hands, and are therefore linked to all the beliefs concerning hands (see pp. 164–167). The same applies to a mole's paw, already mentioned by Pliny as an amulet. To be effective, the paw must be cut off the living mole, who is then allowed to run away. The paw is usually set on a silver mount and worn as a brooch, but an old man in Wheaton Aston in Staffordshire was known to have kept his in his pocket. It protected him all his life against toothache.

ABOVE *Child's cap with buttons, silver balls and deer's teeth representing horns set in a square amulet on the forehead, Shilkanabad, Palas Valley, northern Pakistan.*

ABOVE RIGHT *Child's cap with a bead topknot, buttons, silver balls and a horn amulet made of deer's teeth on the forehead, Indus Kohistan, northern Pakistan.*

BELOW *Kayan warrior wearing a tiger's upper canine teeth through his ears, Borneo.*

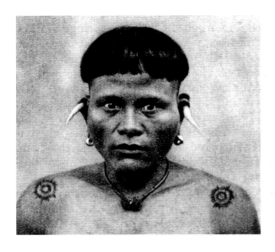

Horns & bones

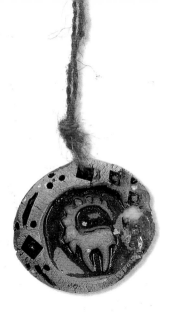

ABOVE *Terracotta ibex, Turkmenistan.*

BELOW *Horns made of wood on the door of a workshop, together with a cross, stones and twigs, Kosmach, Ukraine.*

BELOW RIGHT *Horn amulet hung above a window, Ashkabad, Turkmenistan.*

The forgotten corner of Europe, where the foothills of the Tatra and Carpathians curve through Slovakia and Ukraine before sweeping majestically south to Romania, is a gentle country of apple trees, duck ponds and morning mists. Antlers and horns guard the windows and doors of the small wooden houses, and are painted on their walls like some arcane magic script.

Horns on buildings are found from Sumatra to Senegal, from Afghanistan to Peru and, in the past, from China to Mesopotamia: antlered figures guarded the tombs of the Chinese southern kingdom of Chu in 500 BC; a ram's head centred the pediment of a Han tomb of around 200 BC; while in the civilization of Sumer, probably from around 2500 BC, antlered stags, together with the mythological lion-headed eagle, watched over the temple of Nin-khursag, and a gold bull amulet was found among the treasures of the royal tombs of Ur. One of the earliest amulets of a horned animal known is a gold plaque in the form of a bovine, dating from 4500 BC and found in

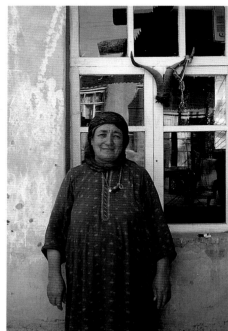

RIGHT *Antlered deer on a restaurant façade, Sigisoara, Romania.*

BELOW *Horn amulet of cloth on a Baluchi spoon bag, southern Pakistan.*

BELOW *Bread oven protected by horn decoration and an old blue jacket, Turkmenistan.*

BELOW RIGHT *Silver horn amulet at the front of a child's cap, Indus Kohistan, northern Pakistan.*

the tombs of Varna in Bulgaria. Holes pierced round its edges show that it was stitched to fabric. Such gold figures are now hung as votive tablets on the icons of churches.

There are several aspects to the significance of horns and antlers. One is the importance of horned animals to the early Palaeolithic hunting societies, another is the power of regeneration, particularly of the antler. There is also the form of a horn, which can be a sharp point capable of piercing evil, especially the evil eye, or a curving version recalling the cosmological symbol of the spiral.

Horns – and horseshoes – are the favourite amulets for the protection of houses, though in Italy from classical times a bull's head guarded buildings

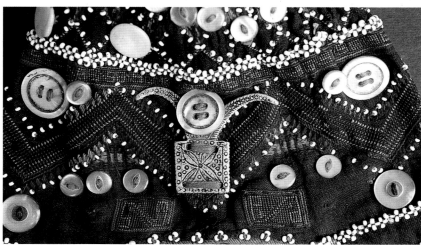

111

FAR RIGHT *San (Bushmen) necklace of beads hung with klipspringer horns, Namibia.*

CENTRE *Horn with two leather Koran containers, seeds and a feather against vampires, Cameroon.*

BELOW *Graves in a men-only cemetery in the Kopet Dag mountains, Turkmenistan. The small fields around the nearby Nokkur village are protected by a ram's skull stuck onto a wooden post.*

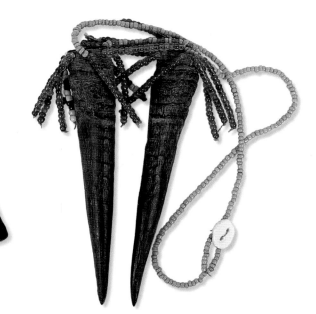

both secular and ecclesiastical, and horns were hung on almost every Neapolitan horse, donkey or mule.

The Uzbeks of Khorezm kept a ram in the courtyard of their house, knowing that the evil eye would be attracted to the horns and so lose its potency. Horns still decorate houses and gravestones in Central Asia.

As with teeth and claws, the animal horn chosen depends on the local species, though rams, bulls and goats are the most common, while for the Shoshone Indians of North America, buffalo horn was the obvious choice. The horns of small antelope such as klipspringer are worn by San (Bushmen) against nosebleeds, and duiker horn by the people of Tanzania to protect from lions. The narwal horn, the basis of the unicorn fable, was used in Europe against epilepsy, worms, pox and plague and, most importantly, because of its phallic form, to increase potency. However, its rarity led to its replacement by other horns, particularly those of cattle, or by deer antlers.

Horns, and even skulls, can also be stuffed with amuletic substances and used as containers, as can fabric, leather and silver. Goats' gallbladders and other magical substances are placed inside horns and worn round the necks of Zulu witch doctors, while a man of the Bamileke tribe of Cameroon wears, and treats with great respect, a horn containing some of his father's remains and earth from his grave.

Horns may be made of other substances, such as pottery or silver, or, in the case of Italy in particular, of coral. Or their shape may be stylized into a decorative pattern: rams' horns are a very common amuletic motif on carpets, felts and embroidered textiles.

Headdresses emulating horns are shown on figurines of gods and goddesses of Sumer dating to between 2000 and 1000 BC, and on stone idols of the Russian steppelands of 1000 BC. While the horned headdresses

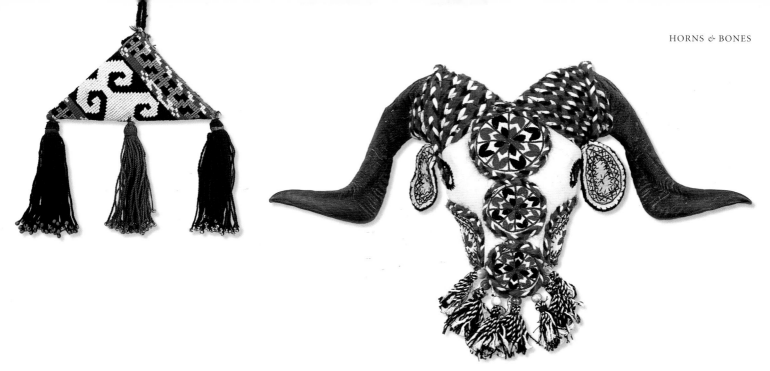

ABOVE *Embroidered triangle with pendants, decorated with a ram's horn motif, Tajikistan.*

ABOVE RIGHT *Goat's skull covered with embroidery, to be hung at the entrance of a Yomut yurt or house, Turkmenistan.*

BELOW *Goat's head amulet for a Tekke yurt, Turkmenistan.*

OVERLEAF *Single-horned cap, Polomka, Slovakia.*

PAGE 115 *Horn over a workshop doorway, Egypt.*

of Eastern Europe, supported by ritually dressed hair, probably have only spiritual significance, those of Central Asia almost certainly serve as amulets. The addition of triangles, silver gewgaws, red buttons, miniature horns and suras from the Koran bound in cloth would be meant to increase their power. The brass bells and English thimbles added to the extraordinary horned headdresses worn by the Bashgal Kafir women of northern Afghanistan until the advent of Islam towards the end of the nineteenth century would have served the same purpose. These headdresses belonged to a culture in which horned animals still denote wealth and social status: carved goats' horns decorate house entrances, and horned skulls of markhor are hung above doorways to show the hunter's skill.

Entire skulls incarnate the spirit of the animal and are placed in every precious field of Khorezm to guard the crops, as was the custom with the Massagetae a thousand years ago. Goats' heads also protect the yurts of Central Asia, those belonging to the Yomut Turkmen often covered with embroidered fabric.

Bleached skulls of horse, ox and sheep were considered efficacious against short-sighted devils in the Balkans and were placed around fields, probably replacing earlier horned animals. Where such skulls were destined for supernatural purposes, the flesh was to be torn from the bones and not cut, much as the linen of the ritualistic shifts of Eastern Europe and the Balkans had to be torn or severed with a stone. In Africa, smaller skulls, such as those of antelope and even monkeys or rodents, are made into personal amulets, often combined with beadwork.

113

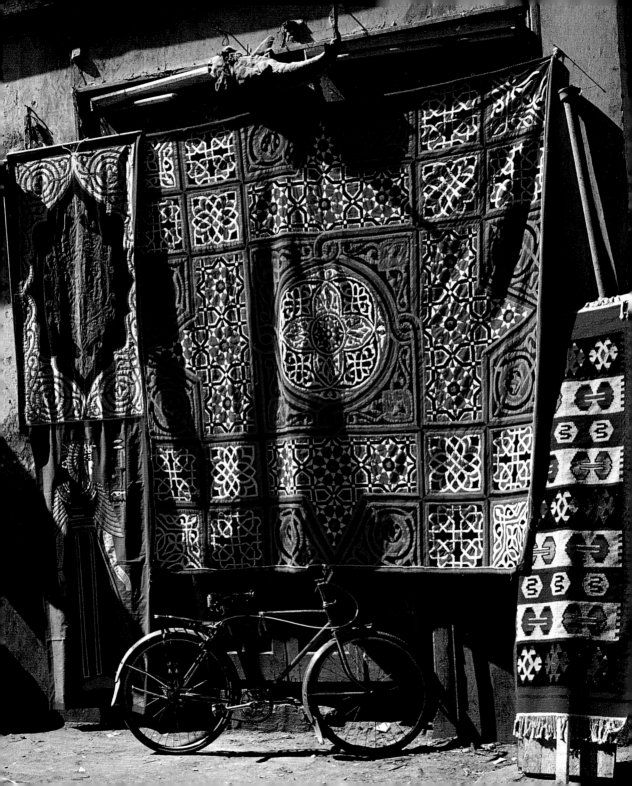

The human skull and skeleton have always been shrouded in mystic power. Skeletal imagery is found all over the world from Palaeolithic times, and in the Neolithic culture of the Swiss lakes, roundels of human skull were perforated and used as amulets. In nineteenth-century England it was common practice to ask church vicars for pieces of human skull to grind as medicine against fits. Today in Cameroon the dead are buried sitting up so that, after decay, it is easy to retrieve the skull. With great ceremony food is shared between the skull and the villagers, and the ancestors are invoked for protection.

Human bones are made into necklaces in the Andaman islands, worn in memory of dead friends and relatives, and to ward off sickness, while in Tibet they are formed into flutes, played to keep away evil spirits. Some of the musical instruments of the Maori are also made of human bones.

Bone amulets can be inscribed, too. In Algeria, a sheep's scapula will carry an incantation against scorpions, while in Myanmar human skull bones are incised with magic squares and scripts.

Domestic animals are also provided with pendants of bone: in India, cattle are so protected from the evil eye, while for the Masai of Kenya such pendants ensure their animals will find their way home.

As with teeth and claws, bones as amulets depend on local species: in England sheep's bones were used against cramp, in Syria the vertebrae of wolf against whooping or 'wolf' cough, in Australia marsupial jaw bones were made into necklaces, and in South Africa and Morocco a whole tortoiseshell was protective, while in the Arctic regions amulets were carved out of whalebone. For the Naga, it is the jaw bone of a dog that they hang from the door lintel – the dog spirit barks when evil spirits approach. Even the beaks and bones of birds serve their purpose: from those of the cassowary, the Arawe tribe of New Britain make a dagger that protects the wearer from attacks of spirits when walking about at night.

BELOW *Ancestor figure with a human skull, kept at home for protection and advice, Irian, western New Guinea.*

BELOW RIGHT *Bone pendant with a carved reindeer and a cross on the back, Finland.*

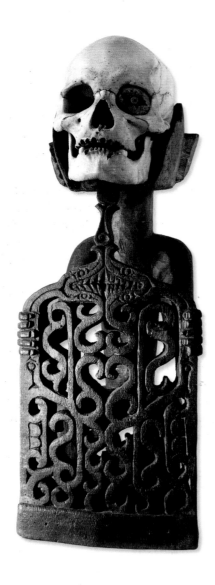

Birds, feathers & hair

ABOVE *Kori bustard's foot set with ostrich shell beads as an amulet for the San (Bushmen) people, Namibia.*

BELOW *Painted Easter eggs, Moravia, Czech Republic.*

Few sounds that carry across the open veld of southern Africa are as eerie as the whistle of a lone train at night, save perhaps the deep resonant call of the kori bustard during the breeding season. This large bird strides over the dry thornland, swinging its neck and head, and flying only when threatened. Its foot, set with beads of ostrich shell, is a Bushmen amulet.

Feet are but one body part holding the talismanic power of birds. Vultures' heads, falcons' talons, beaks of maribou stork and puffin, bills of great auk and loon – one of the leaders of the Sky World – are others. Birds are almost everywhere considered part of the spirit realm, a link between man and the heavens. In Slavic belief, witches and also girls who died before bearing children turned into birds. The long sleeves of the girls' gowns, whirling as they danced, became birds' wings, and their unused fertility was transferred to fields, animals and people.

Because of their association with fertility and life, eggs are considered amuletic. The painted Easter eggs of Ukraine and other parts of Eastern Europe protected domestic animals and the family home, in particular from lightning and fire, while in Romania empty shells were hung from trees, and broken pieces of shell thrown on water so that the good spirits of the dead would protect the world.

In many parts of Africa, and also in Yemen, an egg broken on the edge of a compound or on the threshold of a house repels the evil eye.

The particular character of some birds defines their amuletic role. The crow, an unpleasant black bird with a shrill call, is used in magic. In Japan its wing will save garden crops being eaten by hares, while in Morocco its gall protects against eye disease and stops hair going grey. But in Morocco it is particularly the hoopoe with its regal crown that serves for magic. Its dried entrails are placed in the shops of Tangiers against theft, while its tongue saves milk and butter from witchcraft. Its eye protects against the evil eye, and its blood is used as magic ink for writing amulets.

RIGHT *North American Indian turquoise necklace with eagle pendant, United States.*

BELOW *Paired doves and snakes were always embroidered on the cloaks of the married Catholic women of Shkoder, when it was known as Scutari, a hundred years ago, Albania.*

BELOW RIGHT *Court robe embroidered with a phoenix, China. The oriental phoenix is a symbol of the female, and a charm against misfortune.*

One bird – apart from the owl – is outstanding in the realm of magic, and that is the eagle. King of birds, it is a symbol of victory and of power, particularly for the North American Indian, whose warriors used eagles' feathers as amulets and to symbolize valour. In Morocco amulets written with an eagle's feather save soldiers from enemy bullets and make them shoot better, while its claws hung round the neck protect their leaders. In Russia its eyes, feathers and feet are all used as amulets, and parings from its claws have the same power as fingernails to scrape one's way out of the grave on the Day of Judgment.

General bird shapes can also be amulets, like the jewels of Turkmen women, or those decorating the prows of boats in Oceania, often accompanied by a snake or an ancestor with staring eyes. Birds, representing the spirits of the stars, are embroidered on small German amulet bags worn round the neck and enclosing birch bark. In China it is the oriental phoenix that is a charm against illness and misfortune, while the Indian peacock guarantees fertility.

Both the dove and the cock have long been associated with talismanic power: tiny bronze amulets of doves have been found in prehistoric graves in Bosnia. While the dove now symbolizes peace, the cock was always a solar

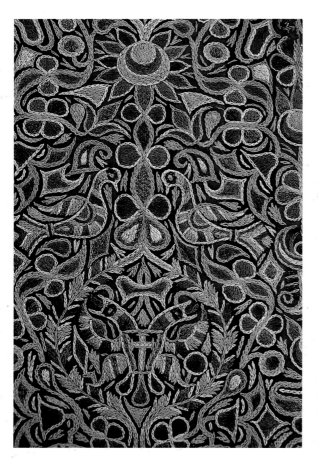

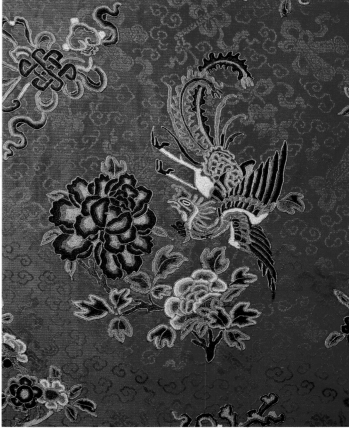

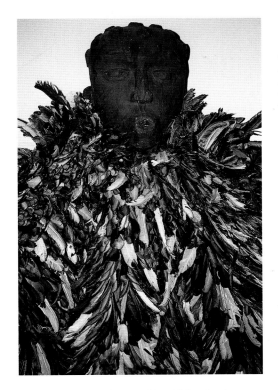

symbol: its crowing chases away the evil spirits of the night and announces the rising of the sun. Wooden cocks and doves top the gables of many houses in Eastern Europe, and are also carved above doorways and on crucifixes and graves.

The humble chicken is the bird most used for divination. In Africa, its feathers are coloured for separate purposes: white ones purify, red (often dyed with madder) are against bad spirits, while black are precious and to be kept. In Zanzibar, feathers from the neck of a black chicken make the wearer invisible.

The Naga set up chicken feathers on a small bamboo stake in a field where a stream is encroaching or the earth is slipping, to scare away the spirits responsible. In France, witches casting spells use chicken bones and feathers tied with black thread, while in Japan, chickens made of clay protect children from nightmares.

A bird's feathers hold its strongest talismanic power. Feathers are fragile filaments that move in the air and are thus contacts with the spirit world. The same is true of threads, grasses and hair.

That hair shares space with the ether is but one of its qualities. It has the power of growth and thus evokes fertility; a woman's hair is seductive and so

ABOVE *Mabu fetish covered in chicken feathers, Cameroon.*

BELOW *Sioux chief with eagle feather headdress, United States.*

OVERLEAF *Animal skins and plants for sale at the stall of a dealer in magical substances, Marrakech, Morocco. Chameleons and tortoises are also normally sold as amulets by such dealers.*

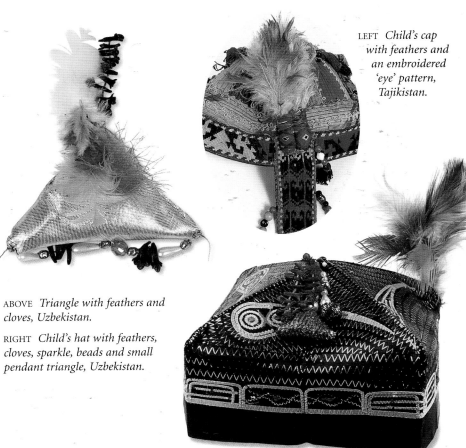

LEFT *Child's cap with feathers and an embroidered 'eye' pattern, Tajikistan.*

ABOVE *Triangle with feathers and cloves, Uzbekistan.*

RIGHT *Child's hat with feathers, cloves, sparkle, beads and small pendant triangle, Uzbekistan.*

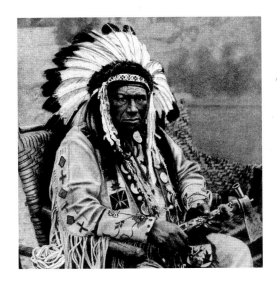

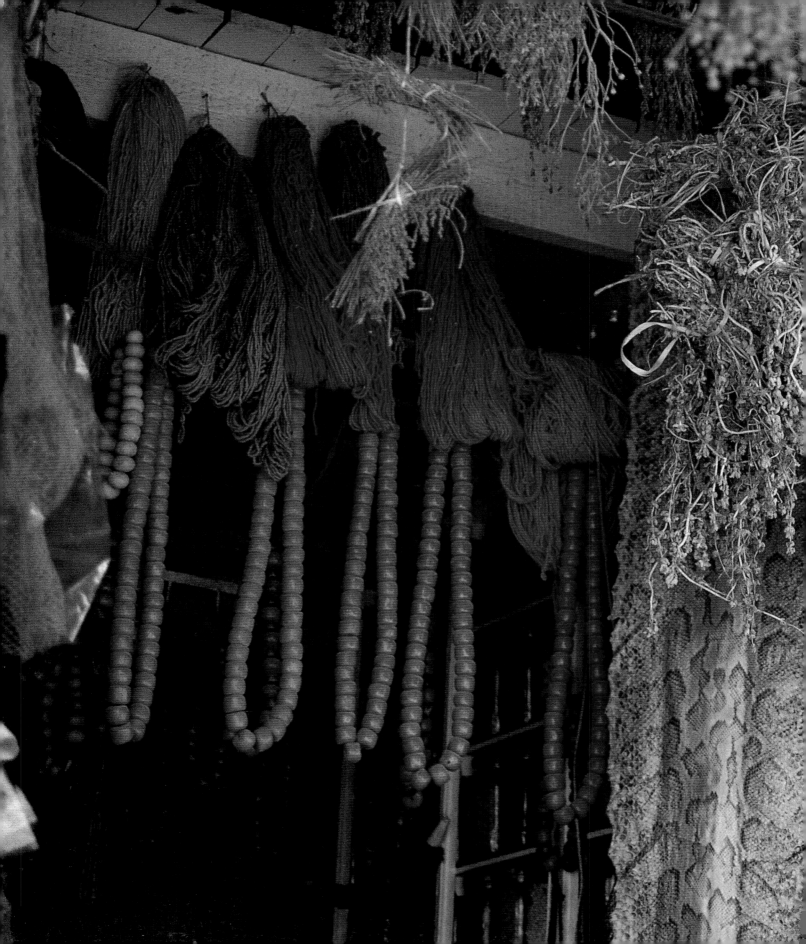

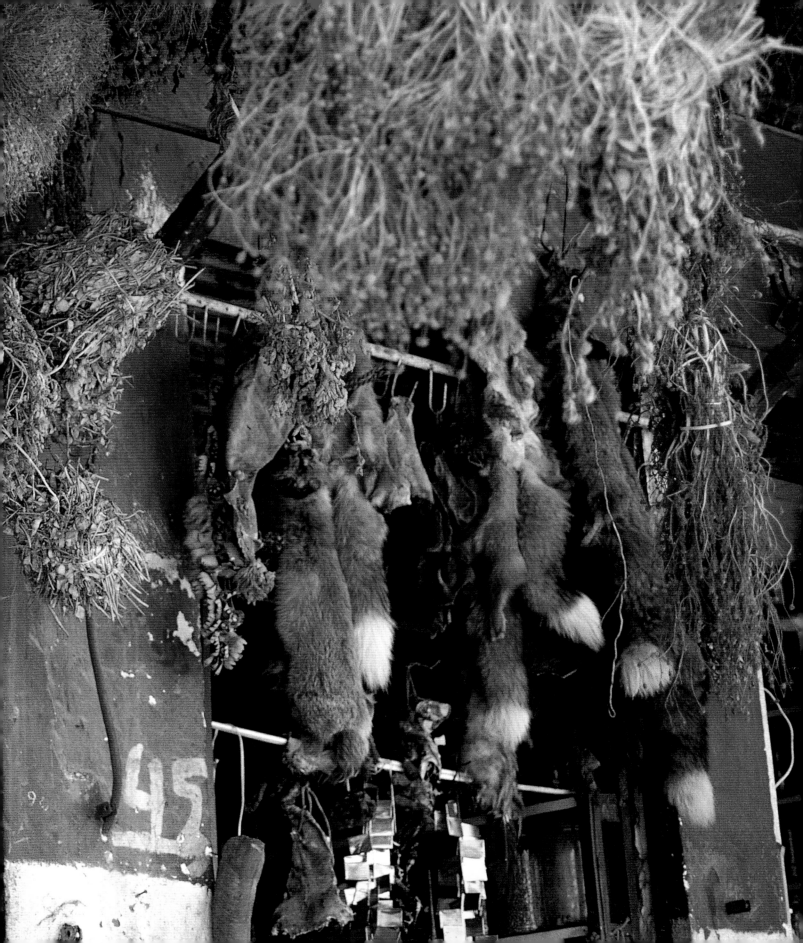

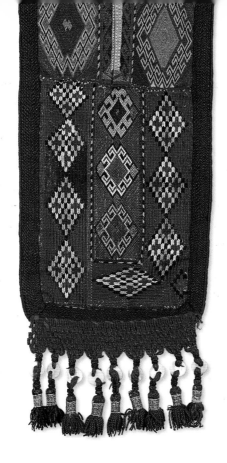

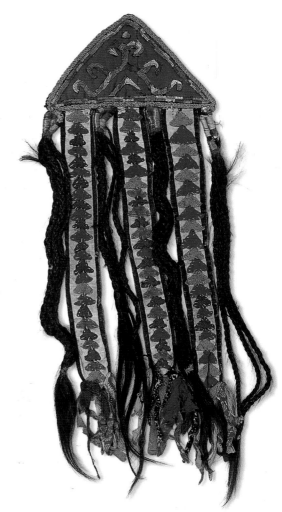

must be covered; hair can be cut and fall into the hands of witches. As hair concentrates the life-force of the person, witches can cast spells with it. Cut hair, nail clippings, scraps of clothing, a woman's name, a photograph, can all be misused in this way.

Loose, unkempt hair is a symbol of the chthonic world and an attribute of witches and sorcerers, while neat hair, particularly plaited, is a symbol of belonging to organized society. Thread sold for plaiting women's hair in Cameroon, made in China and called Ceilingfan, is used for wrapping amulets because of its magical power.

Cut hair serves as an amulet. In Pazyryk tombs it has been found together with nail clippings in special pouches to be worn. This custom is still found in Cameroon where the amulet is not worn but thrown down the latrine, where it attracts all evil spirits and any stray bullets. Bunches of cut hair are stitched on to Turkmen children's clothing, and camel covers used at marriage. The shorter clips are taken from a boy, the longer, sometimes plaited, from a girl, the hair usually being cut at one year old, as earlier will weaken the child.

In both Japan and India the association of hair with fertility involves customs linking women's hair with trees. In Japan an amulet of hair from

OPPOSITE, ABOVE LEFT *Plait cover of a woman's bonnet, Kyrgyzstan.*

OPPOSITE, ABOVE RIGHT *Tekke woman's plait cover of human hair with triangles and rags, Turkmenistan.*

OPPOSITE BELOW *Hair comb and Ceilingfan hair thread made in China, used to dress women's hair and to wrap amulets, Cameroon.*

BELOW *Tekke camel cover for a marriage, with human hair, feathers and fur, Turkmenistan.*

BELOW RIGHT *Totem animal made of fur and dressed as a woman, Siberia, Russia.*

a living woman is hung from a tree to protect it from thieving birds, while in India nails are driven through a woman's hair into a tree to drive out evil spirits.

Of animal hair, that of the horse is the most significant, as the swatch of horsehair or horse's tail marking every holy site in the nomadic regions of Asia shows. The hair is often set on a pole high enough to be seen by distant wanderers across the steppe. The Uzbek women's face-veil, the *chechvan*, is made of black horsehair, which evil spirits are known to run away from. As the veil disguises whether the woman is old or young, the evil eye stays away, but should it approach by mistake it is immediately trapped in the mesh, so that no woman will wear another's veil.

Other animal hair used as an amulet, especially taken from the tail, comes from the goat, dog, cat, fox, zebu, elephant, camel and hyena. In Europe tufts of badger hair were considered particularly efficacious against witches and the evil eye.

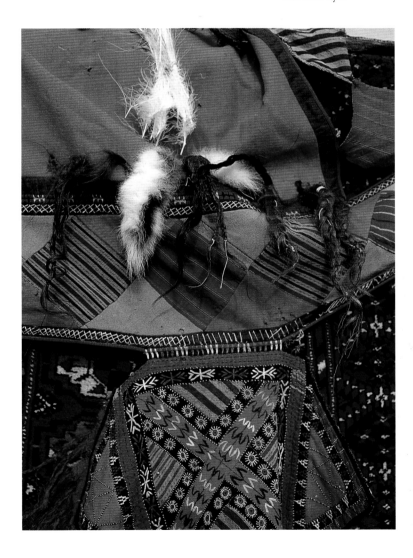

Snakes & fearful creatures

ABOVE *Snakeskin pendant to hold a Coptic scroll, Axum, Ethiopia.*

OPPOSITE, ABOVE LEFT *Detail of the back of a Tekke child's* kurta, *with a snake made of camel- and goat's-wool thread, Turkmenistan.*

OPPOSITE, ABOVE RIGHT *Tekke child's cap decorated with threads of camel hair and black and white cotton, personifying snakes, Turkmenistan. A small piece of wood is stitched over the forehead.*

OPPOSITE, BELOW LEFT *Detail of a Tekke child's* kurta *with two snakes of cotton thread, a cotton triangle and matted human hair, Turkmenistan.*

OPPOSITE, BELOW RIGHT *Tekke baby's harness made of black and white cord representing a snake, decorated with rags, Turkmenistan.*

As birds link man with the spirit world, so snakes, toads and various bizarre creatures remind him of his closeness to the nether regions and waters of the earth. Snakes are one of the most feared, and early snake amulets remain from the second millennium BC, found in the Ferghana valley in Central Asia. Ancient Egypt was one of the earliest homes of serpent worship: the eye goddess in the form of a cobra protected the sun god Amun-Ra, and snakes were guardians of tombs. Today avenues of snakes guard temples in Cambodia.

Stones are another ancient manifestation of snakes. They can be naturally eroded, or worked to resemble a snake. The 'snake-stones' of India are small, black, elliptical and slightly flattened. 'Snake-court' stones are perfectly round and smooth, carried as amulets in Finland, on the basis of the legend that snakes joined in the spring for a court hearing, where the white snake in the centre, acting as judge, spat out these smooth stones to create more snakes. Similar stones were carried in leather pouches by Iron Age man.

Natural objects whose shape is reminiscent of the snake include the seed capsule of the martynia plant of Myanmar – whose twin hooks resemble fangs – and naturally contorted plant roots, some of which can be found in the Hebrides. Actual snake parts used are mainly the skin, which covers the scroll amulets of Ethiopia, or hangs on rafters in Europe to protect the house and ease the pain of a woman in labour. In the Balkans and Hungary, the head served as an amulet: it was a tradition to catch a snake by pinning its head with a forked stick, cutting it off with silver – the sharp edge of a coin would do – and then drying it. It was then enclosed between two silver medallions of St George and blessed by the priest. It protected against all ills, whereas most snake amulets protect only from snakebite, tapeworm, scorpions and witches.

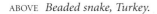

ABOVE *Beaded snake, Turkey.*

RIGHT *Black and white cotton snake to protect a Tekke house, sold in Ashkabad market, Turkmenistan.*

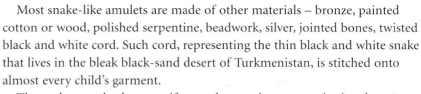

RIGHT *Silvered terracotta disc incised with a snake, on a leather necklace with a blue bead, Thessaloniki, Greece.*

Most snake-like amulets are made of other materials – bronze, painted cotton or wood, polished serpentine, beadwork, silver, jointed bones, twisted black and white cord. Such cord, representing the thin black and white snake that lives in the bleak black-sand desert of Turkmenistan, is stitched onto almost every child's garment.

The snake can also be a motif, carved or cut into protective jewelry or embroidered. The designs around the edges and openings of Ainu clothing – places where demons can easily enter – are often derived from the snake, seen as a deity protecting against illness and helping in childbirth. The spikes terminating the curves and spirals represent snakes' tongues, and protect from evil.

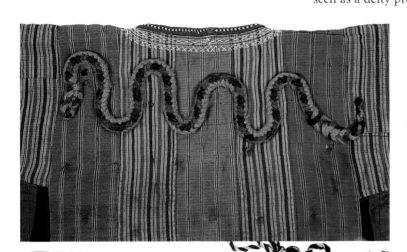

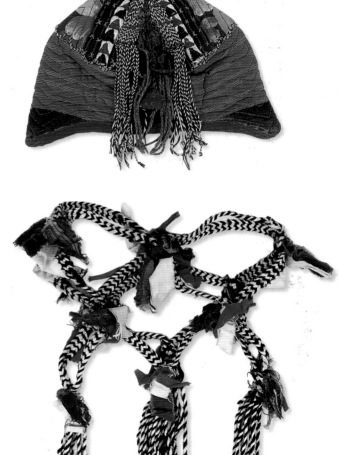

Old men sitting by the mausoleum of Nadjmaddin Kubra, one wearing a snake amulet round his neck, Kunya Urgench, Turkmenistan.

ABOVE *Berber baby's bracelets of black beads with a plastic scorpion and a hand of Fatima, Sahara, Morocco.*

ABOVE RIGHT *The dragon and other animals of the Chinese year, including the snake, are embroidered on women's robes, China.*

RIGHT *Traditional lucky worms carved in glazed wood, Finland.*

The serpent is often combined with elephant, dragon or human to form a mythical creature. The amulet pendants of Russia have a Christian motif on one side and on the other a human/snake motif or a serpent or Gorgon. The legend of Medusa, and the snakes created all over Africa from the blood that dripped from her head, still enters the realm of amulets.

The snake can be a goddess, but can also be evil, a manifestation of the jinn, harbouring poison for witches' potions. Scorpions evoke the same duality and arouse the same fear. Most other bizarre creatures are the objects of phobias and curiosity because of their various habits and characteristics, and serve as amulets on the basis of fighting like with like. Apart from snakes, those most feared for their bites or stings are wasps (believed to harbour the evil eye), bees, hornets, spiders and especially scorpions.

In Egypt of the thirteenth century BC, the scorpion goddess Serqet protected against scorpion bites, while makers of amulets were known as scorpion charmers. Such people are still used to clear areas of venomous reptiles and insects. Though Islam condemns magic as a diabolical intervention, it is believed the Prophet himself allows spells against scorpions on condition that such spells are couched in comprehensible language and include the sacred name of Allah. Still in Morocco spells are placed in each room of a house to stop scorpions coming in, or coloured dishes painted with scorpions are hung at the entrance. Just drawings of scorpions not only protect mosques from scorpions but also from rats. The farmer caste of Bonsali Mahajan from Kathiawar in India have scorpions embroidered on their marriage scarves to protect them from the snake goddess.

Unpleasant creatures of the earth – snails, beetles, cockroaches, ants – are often thought to be metamorphoses of jinn, and are used to protect or cure from disease, for example the snail sewn into a bag, worn round the neck for nine days and then thrown on to the fire as an antidote for fever. A black slug impaled on a thorn was considered a cure for warts in Oxfordshire. Worms appear in Arctic America where women picking berries wear an ivory amulet of a worm-man to protect them from a fearful creature

hiding in the tall marsh grasses and taking on the form of a man, a huge worm or a caterpillar. As amulets for children, caterpillars are mostly chosen in the form of cocoons.

The centipede is cut into pieces in Cameroon, placed in a leaf with other objects, including 'noodles' intended to resemble it, and then hung in a house to keep out thieves. To protect their feet from centipede bites, the Miao people of south-west China embroider centipedes on the soles of their slippers.

The grasshopper or cricket was an ancient Greek amulet against the evil eye, and is still a wall amulet in Portugal, while for the Han Chinese the life-cycle of the cicada suggested the transformation from an entombed or imprisoned body to a winged free spirit, and its body parts were stylized in jade.

In Oceania, the praying mantis is the symbol of the headhunter, as it devours its mate in intercourse. These insects are fashioned as the handles of a drum to protect its good sound, believed to be the voice of ancestors.

Lizards bask in intense sun and quickly regrow their tails if snapped off. This imbues them with an aura of privilege and magic, and destines them to become an ingredient of spells. Already in the Graeco-Egyptian world lizards and honey were mixed in spells, and in the year 2002 Egyptian customs officials seized seven thousand mummified lizards from a Syrian who intended to mix them with honey to make an aphrodisiac.

ABOVE *American Indian beaded lizard containing a girl's umbilical cord, United States.*

BELOW *Miao slippers embroidered with centipedes to protect against those creatures, south-west China.*

Particularly in Morocco a piece of dried lizard worn as an amulet around the neck protects against snake bites. The lizard is also a potent defence against leprosy. For the Plains Indians of North America, a baby's umbilical cord is placed in a beaded container in the shape of a lizard or turtle, and hung from the cradle.

The chameleon's ability to change colour and to swivel its eyes makes it a bewildering creature and a perfect amulet for wary thieves on the lookout and anxious to become invisible. Many amulets are made of its head (wrapped in rag in Algeria), its skin and its dried body.

The spider is less common as an amulet, though put in a nutshell and hung round the neck it will save from fever and whooping cough. Considered harmful and possessed by the evil eye in many places, in Cameroon it is the intermediary between men and God, spinning as it does a web in thin air, while for the tribes living in the Mississippi basin in around AD 1000, the spider was a sun symbol.

Water & the moon

ABOVE *Embroidered stylized toads on a woman's shift from Eastern Europe or the Balkans.*

BELOW *Toadstone (a fossilized tooth of a fish), set in a silver amulet of a toad, Alpine region, possibly Salzburg, 17th–18th century.*

Some exotic creatures are associated with water. Though the crocodile is the most powerful, only its teeth are used as an amulet, even if emulated in bamboo, like those hung over the lintels of living rooms in Assam.

The frog is the commonest amulet, along with its fellow amphibian, the toad. As frogs appear when it rains, they are ascribed magical power over rain gods. A bronze drum from the region of Vietnam, dating from around 3000 BC, is decorated with frogs, probably to invoke such gods, while frog pendants of such materials as amber, coral and metal are worn in many parts of the world against witchcraft and the evil eye, or to give strength to children. In New Zealand twisted frog-like figures of steatite are worn by the Maori, while in Central Asia similar figure-of-eight brooches represent frogs, part of a pre-Islamic cult of water.

The frog itself was an amulet both for the fishermen of Finland and for the children of England, when it was dried and put in a small bag to be worn round the neck. In Morocco, the frog is yet another animal sold by dealers in articles of magic, salted and dried or cut into pieces to make an amulet. Though in some places the frog and toad are interchangeable in their talismanic function, here the toad is a fearful creature, bringing sterility rather than beneficial rain.

The toad is nocturnal, venomous, an associate of witches and the devil. It represents sexual lust and the dark side of female sexuality. This connection with female sex and the uterus dates from at least the Neolithic, when in the east and central Balkans the fertility goddess was depicted as a toad. Its resemblance to a birthing female and also to the human foetus led to the belief that the toad caused pregnancy, even that it floated around in the uterus – a belief still remaining among some southern European peasantry and in, for example, Cameroon, where among the Beti women this creature is called an *evu*.

Toads of terracotta, bronze, ivory and amber have been found in Etruscan, Greek and Roman graves and sanctuaries, while versions in wax, iron, silver and wood are still used in Austria and Bavaria as ex-votos against barrenness. Dried toad hangs in houses to protect from all evil, and in South Africa stops birds eating the crops.

ABOVE *Jewish silver amulet of a salamander, believed powerful against leprosy, Essaouira, Morocco.*

BELOW *Fish and a hand of Fatima embroidered in gold on a woman's jacket, Moknine, Tunisia.*

A creature almost as diabolical as the toad is the salamander, thought to be able to survive fire. In ancient Berber belief it protects from leprosy and helps foresee the future.

The strange, delicate beauty of the seahorse would attract the evil eye and divert it from the object coveted. In southern Italy, seahorses were a common household amulet, hung on a ribbon, tied with red thread, or decorated with bells and a crowned female deity. They also protected cab horses in Naples, and were sometimes pinned over a woman's breast. In China, they were dried and lacquered, and enclosed in basketry as a cure for venereal disease.

Other unusual sea creatures used as amulets were phosphorescent fish hung on doors in Zanzibar against evil spirits and wizards, and in the Philippines pearl oyster shells tied outside houses, while in England a fossil sea urchin was placed on an outside window sill to keep the devil out.

The most highly symbolic amulet of the sea and water is the fish. It is perceived as an enviable creature, moving with complete freedom through the water. Its symbolism thus has elements of the phallic, but its habitat associates it too with the mother goddess and lunar deities. Moreover, living in water, it cannot be reached by the evil eye. The fish is also a prolific bearer of eggs and so represents fertility. It is a symbol of Christianity, predating the cross and linked with baptism and resurrection. In Abruzzi, fish made of pasta were sold specifically outside churches to protect children from the evil eye. On the north-west coast of America, fish – salmon in particular – were a source of food, essential to life. Here, amulets from 500 BC depict the abstracted ribs and vertebrae of fish.

Association with fertility also makes the fish a major amulet in Tunisia, particularly as a motif woven and embroidered on marriage garments. A Berber tradition, which perhaps survives from the Punic era, involves placing a fish on the threshold when the bride enters her home. In the Orient, too, the fish promises abundant offspring. Fish made of cloth are hung outside a house in China on the birth of a boy, while in Manchuria fish carved in soapstone are worn on a tobacco pouch hung at the waist.

If water is the abode of fish and curious marine life, it is also that of spirits and gods, both benign and evil, particularly in the holy wells of the British Isles. Ancient water worship endows these almost mystical sites with powers of healing. Pins are stuck into a wound or wart, then bent and thrown into the well. Trees planted nearby are hung with rags or their barks impaled with nails, coins, buttons or pins. These offerings by pilgrims are touched by others, or taken away and kept as amulets.

Associated with water is, of course, the moon. It has always had an aura of mystery: it also waxes and wanes; it controls the tides and the menstruation of women, and so has power over water and fertility. Amulets of envelopes containing 'important things of the moon and water' were sold at the Buddhist temple of Zenkoji on Honshu Island, Japan, while the amulets of Morocco linked to water, the moon and fertility are silver pendants in the form of a spiral.

Silver moon amulets were already known in the Chalcolithic culture, and crescent moon amulets are still common in the Balkans and southern Europe, especially for horses and draught animals. Moon symbols can also be combined with designs of a frog or toad. The crescent was an ancient device, later adopted by Islam, as well as by the Navajo in the form of a silver amulet. Through the ages the crescent has been a charm to bring fertility to crops, herds and families, as the waxing moon was always associated with power and growth, while the waning moon brought decline and destruction.

ABOVE *Hand of Fatima in silver with sun and moon patterns of stone, Morocco.*

RIGHT *Moon amulet decorated with sundry objects and the Creator holding a wine glass, a depiction influenced by local missionaries, Nancowry, Nicobar islands.*

OPPOSITE *Fish, together with Ganesh, painted above a doorway, India.*

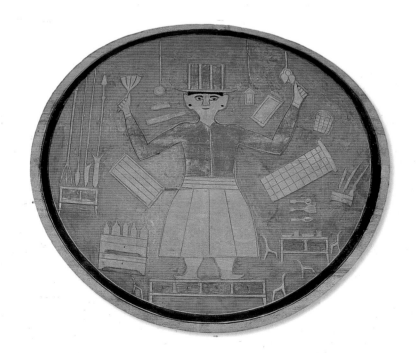

BELOW LEFT *Gun cover with solar motifs (the same motifs are used as a wooden cattle amulet, see p. 39), Palas Valley, northern Pakistan.*

BELOW CENTRE *Brass cattle amulet with a solar pattern, Orissa, India.*

BELOW RIGHT *Detail of a solar motif on a child's cap, and a wooden cattle amulet of the same pattern (see also p. 39), Indus Kohistan, northern Pakistan.*

OPPOSITE, CLOCKWISE FROM TOP LEFT *Solar motifs over a street fountain, Razgrad, Bulgaria; horseshoe on the door of an outside privy (such places were known to be haunted by evil spirits), Oxfordshire, England; solar motifs on a doorway, Sibiel, Romania; solar motifs painted on a house, Cameroon.*

The version of the crescent as an old horseshoe nailed over doors of houses, barns, stables, even village privies, is one of the most familiar amulets in almost every part of the world. The horseshoe can be hung either way up, though it is sometimes thought that luck will run out if it is open at the bottom. Horseshoes can be imitated in various metals, or even by joining two boars' tusks together, but the ordinary shoe has the merit of combining its shape with the potency of iron, a metal loathed by evil spirits. The best horseshoes are those found on the ground, preferably still with their iron nails as these can be hammered into the door 'to nail down demons'.

The lunar crescent as an amulet is often depicted together with the sun – as in Yemen and on graves in northern Albania – or with a star, which is in fact a rayed sun. In Bosnia, this was a prehistoric bronze ornament, and it has survived as a silver earring design and as a tattoo.

The rayed sun is but one solar symbol used as an amulet: swastikas, whorls, rosettes, four- or eight-pointed stars, circles enclosing crosses, axes, apples, lotus flowers, the Egyptian scarab, cocks are others. Solar amulets of bronze hang on cattle in Orissa, and ones of wood in Afghanistan and the Indus valley, where gun covers and children's helmets are embroidered with exactly the same pattern of a circle incised with lines forming a cross. Solar motifs are painted on houses, embroidered on clothes, traced in the earth.

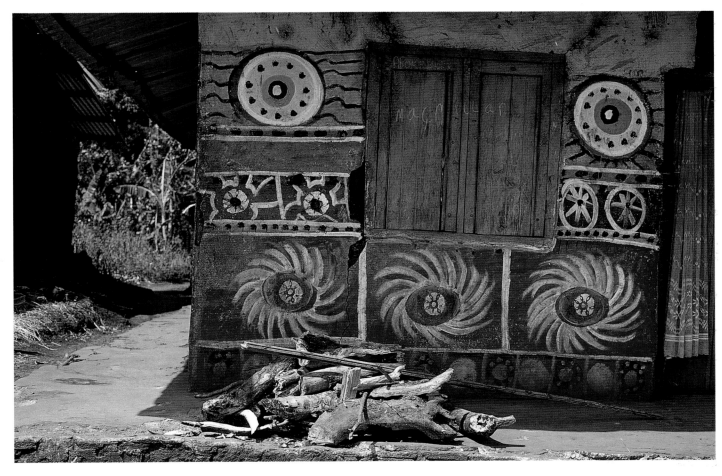

Salt, garlic, incense & plants

As the Aral Sea dries and shrinks, salt creeps over the soil like pus escaping from a wound, encrusted around the edges, scabbed between tufts of rose-pink saltbush. The wind lifts eddies of salt, toxic with traces of nuclear fallout from an abandoned Soviet experimental station, and swirls it into the homes and lungs of the few people trapped there with nowhere to go. Babies are born deformed, disease is rife, there is a suspicion of lingering anthrax spore. To protect their children from the evil spirits responsible, mothers make embroidered amulets, hanging them with bright tassels. They fill them with salt.

Salt is hated by evil spirits. It is a purifier, and protects from decay. Before modern methods of preserving food, salt was essential for survival, and therefore powerful. Until the late fifteenth century new babies in France were salted until baptism to fend off the devil, and still by the end of the nineteenth century sea salt was mixed with sand and hung round the child's neck – too many grains for the devil to count before the child was baptized.

In contrast, in Abruzzi precisely three grains were required, together with three of pepper, three of wheat and a painted figure of St Antony of Padua. This was against all evil.

Bread itself is more frequent as an amuletic power than grains of wheat. Essential to life, like salt, bread also has sacred connotations in its symbolic role in Communion. It is signed with the cross before cutting, as evil spirits are known to use food to harm their enemies.

Food that shrivels was considered amuletic, in the belief that it absorbed illness as it shrank. Potatoes, preferably stolen, were hidden in a pocket, where they soaked up the ill effects of rheumatism and sciatica. Mr Henry Hopkins, keeper of the Roebuck Inn at Leighton Buzzard, carried one in his coat pocket for eight or nine years before donating it to the Pitt Rivers museum in Oxford on 7 December 1894.

Horse chestnuts were kept in pockets against gout and bone disease, while onions absorbed all germs. Hung over house and stable doors, onions also kept witches away.

Many amulets attack evil spirits with pungent smells, and garlic is one of the strongest. Garlic was used by the ancient Romans against vampires, and is still crushed and spread outside windows and doors in Romania, or twisted into plaits on French ceilings, fixed onto Turkish fishing boats, tied

OPPOSITE, ABOVE LEFT *Ceramic garlic head and blue 'eye' bead, Greece.*

OPPOSITE, ABOVE RIGHT *Child's amulet filled with salt, Aral Sea, Karakalpakstan.*

OPPOSITE CENTRE *Wooden stamp to mark holy bread, Apollonia, Albania.*

OPPOSITE BELOW *Bread placed on a weaver's loom, Russia.*

RIGHT *Velvet triangle hung on a cord with cloves and filled with seeds or thorns, made to protect the author on her travels, Olymbos, Karpathos island, Greece.*

FAR RIGHT *Berber amulet of pompoms and spice, Siwa oasis, Egypt.*

BELOW *Yao boy wearing a cap with a blue bag containing a cardamom pod, Taphin village, northern Vietnam.*

RIGHT *Car amulet of cloves and bright tassels, Makran, southern Pakistan.*

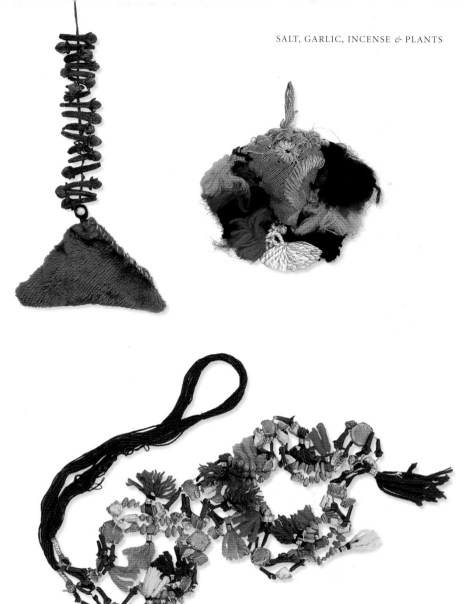

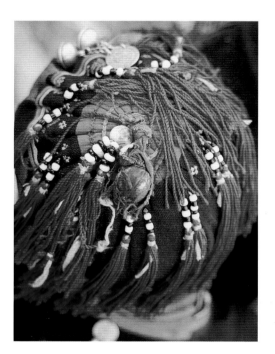

to the tail of domestic animals and, in Albania, hung round the necks of children on red ribbon, especially on or around Shrove Tuesday when witches are most active. All over India garlic is placed at thresholds, with chillis and lemons, to keep out evil spirits. In Germany the name alone – *Knoblauch* – was enough to frighten spirits. In Greece, bulbs of garlic made of white ceramic are hung in houses or cars.

Cloves are equally repellent to evil spirits. Often combined with saffron and musk, they are a threat to jinn and anathema to witches. Leeks played the same role in Germany, as do chillis still in Central Asia. Embroidered on Uzbek caps, chillis are associated with fertility and protect against the evil eye. For the same reason, women weavers hang them on their looms.

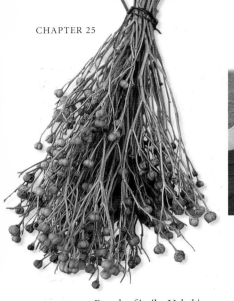

ABOVE *Bunch of* isrik, *Uzbekistan.*

ABOVE, CENTRE AND RIGHT *Garlic, lime, coal and red rags hung over shop doorways, Jodhpur, India.*

BELOW *Plant hung on a pillar to protect a house, Khiva, Uzbekistan.*

Cardamom is the spice that repels evil for the brides of Sind in Pakistan, who centre the flowers of their marriage shawls with a cardamom pod.

In Morocco, it is sulphur that keeps away evil, while in Russia amulets against death consist of pieces of sulphur, coal and salt.

Almost everywhere, the pungency of burning incense is certain to drive away all that bodes ill. Not only is incense associated with the Church, but also with the purifying power of fire, and even the smoke itself confuses the spirits. In 1665 incense was used to burn out the plague, but to little avail – the winter frost was more effective. Its burning can be accompanied by incantations, or, in Lebanon for example, by the addition of other ingredients, such as salt, garlic, onion and spices. Here, it is babies who are fumigated, but in Yemen it is the women's clothes. In Russia houses are protected from evil by incense burned in the holy corner, while in Japan burning incense disperses the evil spirits of storms threatening ships.

Not just frankincense and myrrh, but other strong-smelling gums, spices and plants can be burnt, such as the seeds of rue or, in Africa, plum, and in Central Asia, a plant known locally as *isrik* or *chirak*. This is dried and hung in bunches outside the house or, in Uzbekistan, burnt in small dishes, which gypsies walk round markets selling.

Plants are the stars of folklore. To deny entry to witches, fairies and sundry malefactors, the average cottage door would present an impenetrable barricade of greenery, some plants chosen for evergreen strength, some for powerful aroma, some with lingering memories of ancient legends, others for their tangle of tiny leaves, each of which, like grains of salt or sand, would have to be counted before the intruder could gain access. The sessile thistle, nailed to doorways in Piedmont, France, Germany and Spain to keep witches away, had the added advantage of acting as a barometer, its flower closing when rain was due.

The roof, meanwhile, would be covered in various twigs and flowers against lightning, from hawthorn to alpine rose, from hazel to marsh marigold.

RIGHT *Front of a woman's shift with small triangles of fabric containing herbs, and others cut from mother-of-pearl, together with brass sequins from Sana'a souk, Yemen.*

BELOW *Spice pockets at the neck of a marriage dress to protect the bride as she leaves for her new home, Thano Bula Khan, Sind, Pakistan.*

BELOW RIGHT, CLOCKWISE FROM TOP LEFT *Berber amulets from Morocco: sulphur encased in leather and decorated with feathers; sulphur encased in dyed leather with wool embroidery; sulphur encased in black and red plastic, stitched on to a black wool hand of Fatima.*

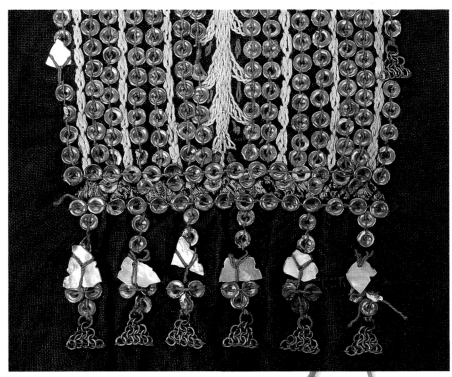

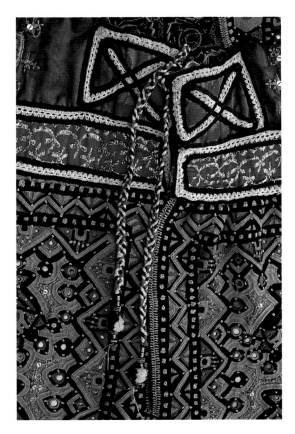

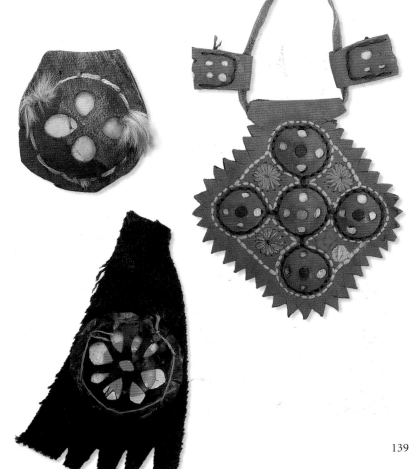

139

Witches themselves tend to use plants that are poisonous or hallucinogenic, whereas those believed to protect are mostly aromatic, such as the rosemary tucked into the black wedding dresses of Catholic brides of Alsace, and the *busuioc* put in water and sprayed over the congregation of Romanian churches, or dried and hung on crossroad crucifixes; or they have medicinal properties as well, such as angelica, against poison and plague and moments of danger. The same plants may be ground and placed in an amulet, or mixed with water to drink as a medicine.

The seeds of many such plants can also be effective against the evil eye. Those of the pungent wild grass known in Uzbek as *sedana* are worn in amulets and scattered on bread.

The aspect of fertility endows evergreens such as rosemary, or the ruta graveolens of Yemen, with special power. Evergreen leaves, such as bay, willow or dogwood, when fashioned into crosses, have the additional benefit of association with the Church, as do the basil and olive leaves of Palm Sunday, and the dried flowers from the Good Friday epitaphios.

Plants gathered at certain witching hours and days have increased potency, or indeed are otherwise useless. St John's Eve is prime time.

To be effective at protecting against demons in Russia, most plants – for example stinging nettles – must be gathered on St John's Eve while a spell is intoned, though in the morning dew of May, by moonlight, or at midnight on New Year's Eve are possible alternatives. The plants must be bound up with a wolf's tooth. Here, as throughout Western Europe, wormwood must be gathered on St John's Eve – and in Ireland singed in St John's Fire before being fixed over houses and barns to keep away fairies. In Corsica the following dawn, the summer solstice, was preferred for gathering all plants, which then had the benefit of solar influences. However, sedum pourpier must be picked at dawn on Ascension Day before being hung at home, while sedum stellatum was sold on the same day at the church door. As for the bunch of fraseen placed over every door in northern Romania to protect house and people, this must be picked on Arminden day, the beginning of the new agricultural year.

OPPOSITE ABOVE *Hallucinogenic seeds of the wiliwili tree, believed to be used by* menehune, *small indigenous people who work at night building fish ponds, roads and temples, Hawaii.*

OPPOSITE, BELOW LEFT *Sprig of leaves over the doorway of the chief's palace, Bandjoun, Cameroon.*

OPPOSITE, BELOW RIGHT Busuioc, *either hung on doors, burnt as incense or soaked in water to be sprinkled over church congregations, Romania.*

BELOW *Fraseen tree growing inside a farmyard, with a dried bunch above the gate, Budesti, Romania.*

In the early sixteenth century, Paracelsus, physician of Einsiedeln, reviving the doctrine of signatures, claimed that plants or parts of them that resembled human organs were powerful amulets, as, for example, a liver-shaped leaf against liver ailments. Another plant he mentioned was the mandrake, whose double root resembles the lower human body, and so is given a male and female spirit. The plant is also believed to scream when dug up. The mandrake has been a magic plant and amulet since antiquity, not only because of its form, but because of its strong narcotic effect and its power to stimulate passion. More prosaically, when placed in the four corners of a house in Russia, it protects against burglars. In Romania, the best day to pick mandrake is on the Friday before Whitsun, first marking the plant with red ribbon. A piece is then often secretly blessed by the priest before it is worn as an amulet under a hat or sewn into clothes.

Other double-rooted plants can be substituted, as was the case with a root of black bryony found in Headington, Oxford, by a labourer who was convinced it had magic powers.

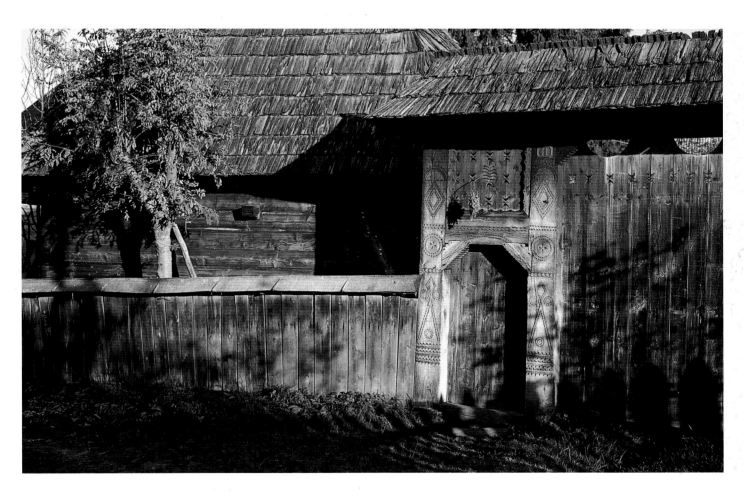

Trees, rags & stitches

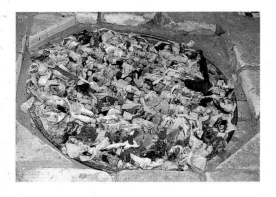

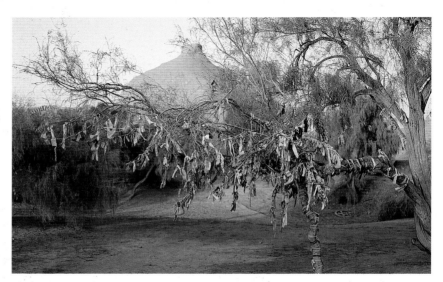

TOP *Tree bark, twigs and a seed pod bound in red rag against vampires, Foumban, Cameroon.*

ABOVE *Coloured rags tied on a drain cover in the mausoleum of Sultan Sanjar, Seljuk ruler of Merv, Merv oasis, southern Turkmenistan.*

BELOW RIGHT *Rags on the saxaul tree beside the mausoleum of Mohammed Ibn Said, Merv oasis, southern Turkmenistan. The rags are placed here by women wishing for a child: a white rag denotes a boy, a coloured one a girl.*

BELOW *Baby's cap with a piece of* ekurkik – *a parasitic growth on mulberry trees that is used as an amulet against whooping cough, Turkmenistan.*

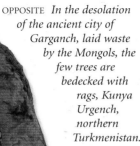

OPPOSITE *In the desolation of the ancient city of Garganch, laid waste by the Mongols, the few trees are bedecked with rags, Kunya Urgench, northern Turkmenistan.*

Where the Mongols razed the ancient oasis cities of Central Asia, holy sites are marked by a tree bedecked with rags, such as the Forty Mullahs' Hill of Kunya Urgench in Turkmenistan, littered with bones and skulls believed to be the remains of its massacred inhabitants. A spindly tree below the hill is almost obliterated by rags, and surrounded by women hanging up more, as prayers for conception, white in the hope of a boy, coloured for a girl.

The tree is a powerful symbol, its roots in the underworld, its branches in the sky, its annual life-cycle associating it with fertility. The custom of hanging ritual cloths or tying rags on trees, still found in much of Europe, the Middle East and Central Asia, can be a relic of tree worship or it can also be a way of transferring disease, which a rag of old clothing will have absorbed.

It is believed worldwide that trees have spirits embodying their fertility and power of regrowth that can be transferred to flocks, fields and women. These spirits are harnessed as amulets in their twigs, branches, leaves and fruit, even in mistletoe and other parasitic growths such as that on mulberry trees. A fruit kernel of the issingan, the king's tree of Cameroon, set with a human tooth and carried as a key ring, protects from witches, while a double walnut or double almond averted the evil eye in Italy. In Britain, two hazel

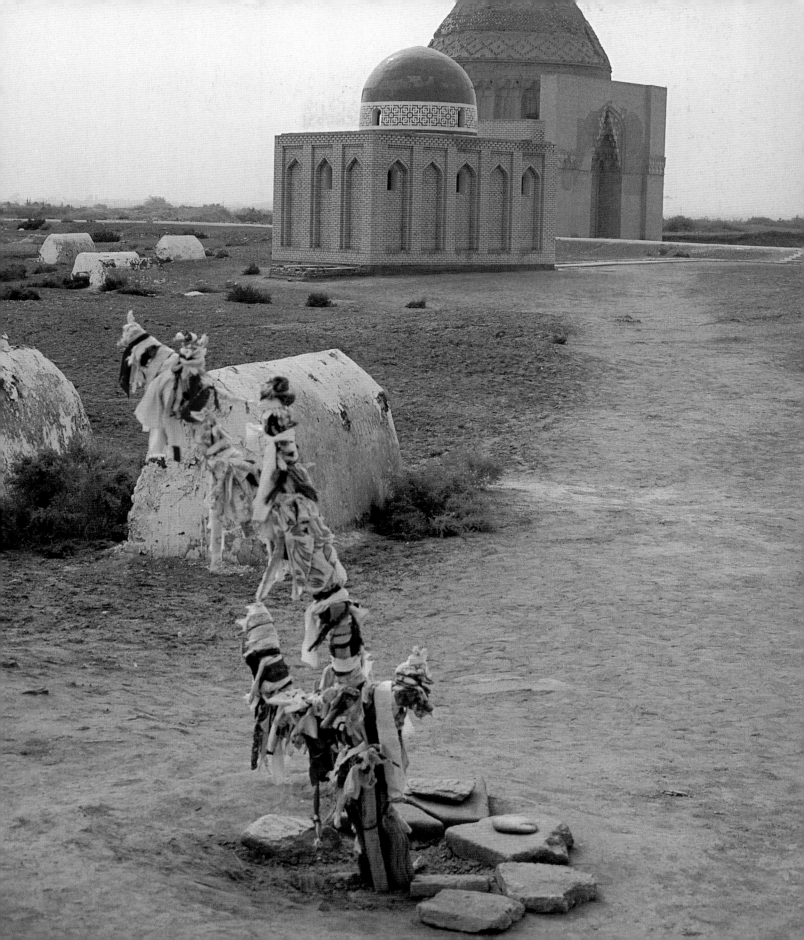

ABOVE *The braided edging of a woman's* chapan, *in quilted ikat with Russian print lining, to keep away evil spirits, Khiva, Uzbekistan.*

ABOVE RIGHT *Braided edging of an ikat coat (as with the adjacent* chapan, *not appliquéd but made directly on the garment), Samarkand, Uzbekistan.*

BELOW *Tekke woman's cloak, or* chyrpy, *embroidered with sharp pointed amulets, Turkmenistan.*

BELOW RIGHT *Magical double ikat ceremonial cloth, known as a* gerinsing, *Tenganan, Bali.*

twigs twisted into a cross and covered with blessed wax from Candlemas will capture evil spirits, while in Russia a piece of birch bark is hung in the house. Tree bark is also used in Africa, either ground into an amulet or combined with twigs and red rag against thieves or vampires. It is recorded that in August 1866 a piece of bark and two knotted leaves were given after many ceremonies and incantations to a Mr R. B. N. Walker, previous to his attempt to ascend the Upper Ogowe, as a most powerful charm to safeguard him.

Many trees are sacred, such as the hazel, hawthorn, oak, ash and yew of Celtic lore, and branches in lofts or at doorways or windows will protect a house against lightning and witches. Rowan is the strongest deterrent to

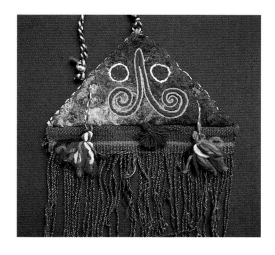

ABOVE *Tekke felt yurt amulet embroidered with ram's horns, Turkmenistan.*

BELOW *Both the scarf round this Tai Daeng shaman's shoulders and the rectangle placed on top of her head cloth will protect her as well as help her speak to the spirits, Laos.*

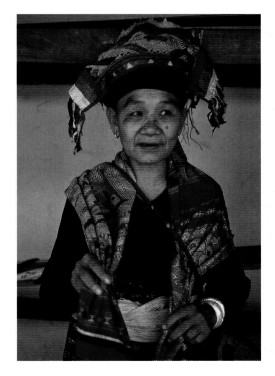

witches, fairies and the evil eye, while a walking stick of elder will protect any traveller against wild animals and highway robbers.

The power of the tree remains in wood: 'Touch wud' is inscribed on the back of an English amulet, a small ball of wood carved as a face with green glass eyes and limbs of metal. Amulets can be wooden beads, carved pendants or even, in France, wood blocks for stamping cheese that prevent the evil eye from spoiling it.

Wood can be chosen for various qualities. It can be fragrant, such as sandalwood, or red in colour, such as the *bayarka* chosen in Central Asia, or the *camor* of Cameroon mixed with white chalk to ward off evil. It can be wood taken from temples, or old bridges that have afforded safe passage to others, as in Japan. It can also be burnt, incorporating the added power of fire in the form of charcoal, or as ashes rubbed on cattle stalls.

For the Slavs living in northern forests, it is wood that separates the inner space belonging to man – defined by the wooden fence and house – from the outer space of the natural world. Trees belong to the natural world, while wood, fabric and clothes are controlled by man and can therefore be used as ritual objects to link the two worlds, not only by hanging fabric on trees, but also on fences, wayside crosses and gravestones. The fabric can be newly woven and embroidered – usually in red with motifs of the goddess – or it can be rags from old clothing. As such rags carry the smell and essence of a person, in Africa they are used as amulets. In northern Europe they bring with them the inner meaning of the clothes worn through the human life-cycle: the white chemise stitched with red for the newborn, the decorated symbolic belt and apron, the ornate marriage costume, the subdued clothing of the old.

The realm of dress and textile is rich in talismanic power. Clothes can have an amuletic function in themselves, protecting parts of the body vulnerable to evil, or their decoration can form an amulet by its positioning, its colour or its pattern. The braid edgings of Afghan coats, specifically against the evil eye, the abrupt colour changes in a Syrian dress from Saraqib, the tiny triangular herb-filled bags stitched on the front of a Yemeni shift, the fish woven into a Tunisian marriage shawl, are but a few tokens of protective devices that might easily be dismissed as the merely decorative or slightly bizarre.

It is perhaps with textiles that the definition of an amulet as something that protects comes under closest scrutiny. To describe a meteorite or a lion's tooth hanging round the neck as an amulet brooks no challenge. But a meticulously embroidered, vaguely dagger-like motif on a Turkmen women's cloak, or patterns such as ram's horns on rugs and felts? Their purpose is the same, their presence as deliberate. Such patterns belong to the repertoire of uneducated women and can often date back thousands of years, their origin unknown, but their function as an amulet established.

There are many aspects of textiles, not just pattern, that are protective, such as thread itself. For the Berber, wool is considered a gift from heaven

that overcomes evil spirits, while the cloths of South East Asia not only carry images believed to ward off harm, but are woven in thread ascribed the same potency. In Turkmenistan camel wool has magic powers and can only be used in men's clothing and in amulets.

The role of garments themselves as amulets lies particularly with headgear, belts and aprons. The caps of Eastern Europe, the animal headdresses of the children of south-west China, the hats of the rulers of Zaire and north-western Angola – even tall headdresses in general, which link the human and spiritual worlds – all protect from evil. Belts and girdles, such as the goat wool strip ghurm wrapped round the hips of Yemeni men, protect the source of life, as do the front and back aprons of Eastern Europe. A Mordvinian girl would put on a string back apron at betrothal, to protect her from evil spirits and preserve her fertility, and would remove it on the birth of her first child. The bridal shawl offered the same protection and hope of fertility.

It is particularly in the embroidered chemise of Eastern Europe that most mysticism resides. The red stitching that dominates all costume is deemed a powerful deterrent to witches, while the 'river' patterns on the sleeves and bodices of Romanian blouses hold the same magic power as the fast-flowing rivers that run through the villages.

The edgings of garments, and embroidery on seams, round pockets and over breasts, prevent disease-carrying spirits from reaching the body. Borders of tassels that are not just a natural outcome of the weaving technique, edges of bunched rags on Turkmen baby shifts, the red fringes on the dresses of Macedonia and the Bahariya oasis of Egypt, seduce the evil eye by their

Tall hats of the Bamileke, Bafut, Cameroon. The ruler, the Fon, wears the highest of all at his palace festival, changing between yellow, blue and red as events progress.

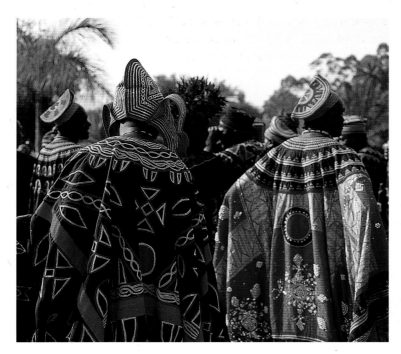

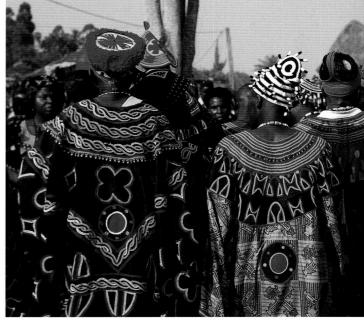

ABOVE *Tekke yurt amulet of appliquéd triangles to greet and protect guests, Turkmenistan.*

BELOW *Detail of the back of a Soninké man's robe, Mali. Amulets are often embroidered on the boubous of West Africa.*

BELOW *Achal Tekke baby's 'bib', or kerlik, with protective rags, symbols and triangles, Turkmenistan.*

movement and beauty. Bright rags also border Turkmen camel covers used at marriage, and the festive doorway hangings of India: such edgings confuse the evil eye and divert it from bride, child and ceremony. Tufts of wool and colourful pompoms fulfil the same purpose.

Confusion is an effective weapon against whatever the local demons are. Pockets out of alignment or simply false, a gap in decoration or small irregular details, sudden changes in colour and complicated dense patterning, all serve to perplex. The closer the patterning, the less space is left for the evil eye. Pattern, though, can be equally as powerful as a single motif when it is a symbol or represents a precise object. Though the *suzani* embroideries of Uzbekistan appear to be floral, much of their pattern, especially on those from Pskent, is astral, and isolated protective patterns include a knife, a candle, a chilli or almond, and frequent representations of the triangular amulet with three tassels.

Such motifs do not represent amulets, but are in themselves amulets. They include, for example, the eight-pointed star, tree of life, goddess, cross, hand, labyrinth, eye, toad and magic square. On the dresses of Palestine rows of appliquéd triangles protect, on those of Syria and Yemen insertions of indigo, or a patchwork of bright or ikat fabric inside the hem or sleeve, flash a warning to spirits.

Amulets in carpets, felts and weavings vary with region. The most common in the carpets of Central Asia is the triangle, sometimes with three pendants, more often with several that form a comb-like projection. In the felts of the Kirghiz it is the ram's horn motif, particularly as a repeat edging pattern. In the rugs and weavings of Morocco the diamond and double triangle protect against the evil eye, as does the hand, often obscured in various patterns based on five. The brocaded silk belts of Fes always have a hand woven into their ends. In the rugs of Ouarzazate the colour black itself keeps away the evil eye, as well as owls and devils.

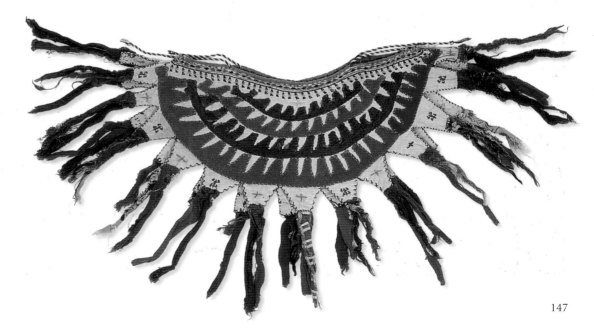

Tangles & triangles

*I*f threads can be woven, stitched or coloured in ways to cause offence to evil spirits, so can they be knotted, twisted and tangled to trap them by perplexity.

Tying thread into a knot has an element of witchcraft about it, and the idea of the magic knot is universal, recorded in Mesopotamia and in the Graeco-Roman world, where the Hercules knot was a design of amuletic jewelry. Knotted creepers are hung over doors in Thailand to trap wandering spirits and keep them out of the house, while in Zaire it is a knotted cord that ensnares them.

Other amulets can be added to knotted cord for multiple effect. A cowrie shell and feathers tied to a cow's tail are carried in Ghana to aid courtship, binding the beloved by sympathetic magic. In Albania, the cord is black and the knots three, while scissors, a wool-carding comb and some berries are added. This hangs on doorposts, not only to protect the house, but generously to prevent witches and evil spirits from bringing harm to the world in general.

A knot can also close a strip of fabric into the purity of a circle, so that the scarf tied round the head of a Japanese woman ensures her safety from evil.

Knots can also be made in sequence, forming netting. Pieces of fishing net are a common ingredient of the fabric amulets of Greece, stuffed with various magic ingredients, while netted belts, such as the women's ones of the Peloponnese, protect them during pregnancy and childbirth. A covering of netted thread encloses amulets of cowrie shells or fossilized stones in Thailand.

The patterns appliquéd and embroidered around the neck, sleeves and hem of the garments of the Ainu in Japan derive from tied ropes and fishing nets, and confuse evil spirits into staying away, while net patterns, with thorns and eyes, guard the most vulnerable spot, the base of the neck opening.

The netted hoops of the North American Indians, known as 'dream catchers', are believed to catch evil spirits and evil dreams, as they lose their way and die. Feathers help guide the good dreams and ensnare the bad.

Threads can be twisted in other ways. They can form the lace collars and cuffs of European dress which traditionally divided

OPPOSITE *Triangles hung on a tree in the enclosed courtyard of a shrine, Thano Bula Khan, southern Pakistan.*

BELOW *Labyrinth, a replica of a prehistoric cave drawing, first found by the composer Sibelius at Vitträsk, Kirkkonummi, Finland.*

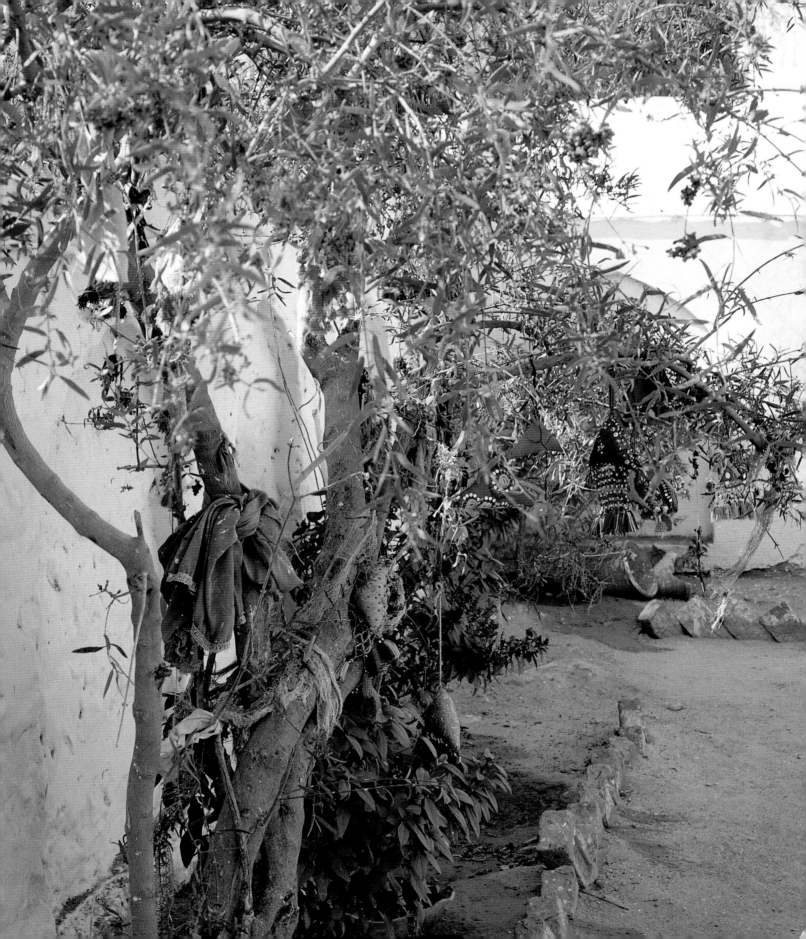

ABOVE *Goddess figures with triangular skirts on the hems of women's shifts, Kruje, Albania.*

BELOW *Triangle on a loom, Kunya Urgench, northern Turkmenistan.*

the concealed parts of the body from the exposed. They can be worked in herringbone stitch, known in German as 'witches' stitch', and used particularly in red and white for the clothes of children, brides and women in childbirth. They can be snipped into clippings, tangled inextricably together and put inside witch balls, where, attracted by the shiny ball, both witches and the evil eye will be ensnared.

The black horsehair face-veils of Uzbek women are also a trap for the evil eye, while witches flee from the horsehair. The veils are made only by gypsies – who also make horsehair sieves – and are worked vertically from a circular frame in a complex structure of detached buttonhole stitch. The veil, *chechvan* or *chasm band* – which means 'go away, eye' – not only keeps the evil eye from the woman, but is placed over the cradle of a newborn child to protect it. A protest movement by women in the 1920s, the *khudjum*, ended the wearing of these veils, but in fundamentalist areas they can be seen again.

The Uzbeks also pin wasps' nests by the door of shops and houses, where the intricate mesh confounds the evil eye, a power of confusion shared in some parts of the world by basketwork.

Weaving itself is considered a dangerous activity, as a product of culture and not nature. Because weaving reflects the movement of life, inverting the direction on the loom can break a spell cast on a sick child, for example. Jinn are known to take over the loom at night and spoil the weave, so many looms are hung with amulets – chillis, sparkly objects and, especially in Central Asia, the *dogha*, a fabric triangle hung with three tassels. In Morocco the shuttle itself is used as an amulet, hung on cows' horns.

Amulets in the form of triangles are ubiquitous. Various devices boost their power, including pendant tassels, coins, or embroidery of significant patterns such as rams' horns or goddess figures. They can hang from a belt, or a loom, or a purse. They can be made of fabric or silver, cornelian, beads or chick peas. They can protect a yurt, a house, a child, a donkey.

Triangles represent the age-old concept of three. Of heaven, earth and the underworld; of father, mother, child; of the Trinities of almost every ancient religion, including the Christian Father, Son and Holy Ghost.

The triangle also symbolizes female fertility, though sometimes the upwardly pointing can represent the male, and the downward the female. The triangle can form the skirt of the fertility goddess, or can be a geometric transformation of the eye. Two joined together can make a rhombus or the Star of David, while a row of triangles as a chevron or zigzag is a symbol of water and the snake. This pattern, usually as a fabric appliqué, forms an amuletic border not only on the dresses of Palestine, but also the caps of men in the mountain villages of Galicia. Appliquéd fabric triangles are a feature of the costume of the Akha hill tribes of Thailand, whose villages are guarded by sacred gates and wooden posts supporting huge triangles of wood and painted zigzags against 'hawks and wildcats, leopards and tigers, illness and plague, leprosy and epilepsy, vampires and weretigers, and all other bad and wicked things'.

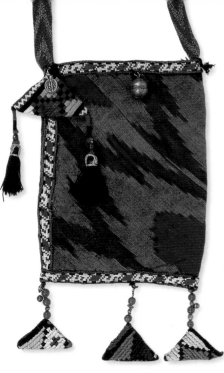

LEFT *Ikat bag with triangles and silver, Uzbekistan.*

ABOVE *Triangle and tassels, Tajikistan.*

RIGHT *Triangle with goddess motif and tassels, Karakalpakstan.*

RIGHT *Triangle of corn and rags hung over the door of a complex of interconnecting houses, Harran, eastern Turkey.*

BELOW *Triangle with a coin, to be pinned on an object such as the bag above, Uzbekistan.*

BELOW *Interior of an old man's troglodyte house, hung with mainly triangular amulets, Merv, Turkmenistan.*

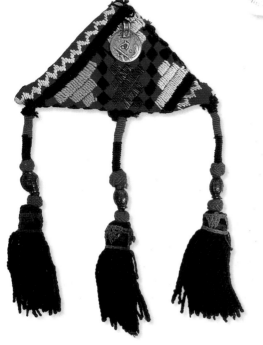

BELOW *Back of an Akha man's jacket, Thailand. Triangles are a common motif on Akha clothing and wooden triangles are among the carvings placed at village entrances to keep away evil spirits.*

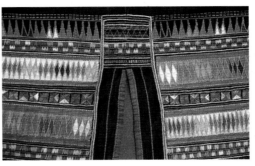

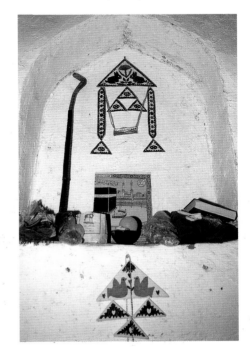

151

ABOVE *Triangular amulet with pendants hanging over the entrance to the breakfast room in a small guest-house in Mary, Turkmenistan.*

BELOW *Silver triangles on a woman's shift, Indus Kohistan, Palas Valley, northern Pakistan.*

BELOW RIGHT *Prayer enclosed in black fabric, made to protect the author on her travels, sold with the warning, 'Don't take the desert road to Siwa', Bahariya oasis, Egypt.*

Triangular amulets made for men – or for lone travellers who would normally be male – are of plain fabric crudely stitched, while women's are in the form of jewelry. Earrings of both silver and gold, hung with three pendants, were worn from the third century AD in Central Asia, and today highly decorated silver triangles are one of the most common forms of jewelry throughout the Muslim world.

The contents of the triangle can range from the garlic, umbilical cord and bits of fishing net of the Greek island of Karpathos to the paper inscription more common elsewhere. The Catholics of Albania wear leather amulet cases that are 'triangular, holding such Latin texts as they can get the priest to write for them. These, too, are bound to the horns of cattle and the manes of horses, to prevent the latter from being spirit-ridden at night by *oras* or devils.'

More often the amulet contains a prayer by a mullah, or a sura from the Koran. Almost no person, building or car can be seen in Central Asia without an embroidered triangle. For the Muslim Tungan people of Kyrgyzstan, it is made for a child by its grandmother or an old woman. The baby is kept out of sight in a covered cradle to protect it from the evil eye and demons until the age of one, from which time the duty of protection is taken over by the amulet. It is kept all the person's life and worn again when there is any threat of danger or illness. On death it can be passed on to a new child.

An oil technologist in the city of Almaty in Kazakhstan explained that his mother had made his amulet and he had worn it all his life. It protected him from the evil eye and also from bears, wolves, leopards and tigers – animals not actually seen in Almaty – and also from illness, though this seemed less important. It contained, he thought, a sura or a prayer but, of course, it could not be opened.

Some, when opened, can be found to contain nothing at all. The triangle in itself is powerful enough. It has sharp points.

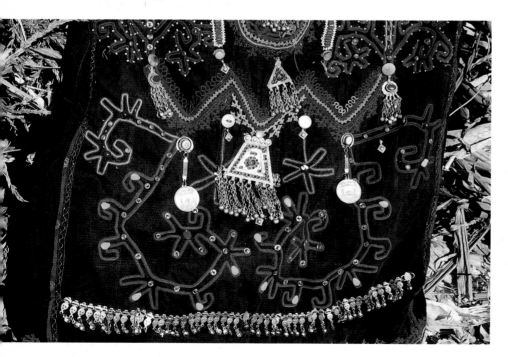

Needles, iron & bells

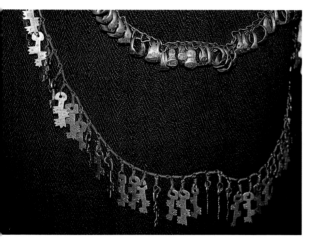

*B*rocade triangles, new pins, porcupine quills, pointed shoes – anything sharp terrifies demons and puts the evil eye to flight for fear of being pierced.

Childbirth is a particularly unclean business, when evil spirits hover, and sharp objects are here the best defence for mother and baby. In the old rural homes of Slovakia – where twenty or thirty people would share one room, and concepts of hygiene were not understood – mother and baby would be spared from sickness by being hidden behind the *kutnice*, a curtain pierced with needles and embroidered with irregular spiky patterns. Here, protected by knives, garlic, herbs and an axe, they would spend forty days. In Bulgaria the new mother would have a needle threaded with red stuck into her shirt, and garlic and blue beads hung round her neck. Turkmen protect babies with broken needles stitched to their caps, while women wear silver triangles enclosing pieces of needle with sand from the cemetery. On the walls of their homes they hang a fabric amulet stuck with a needle.

In Romania it is keys that are considered protective in childbirth, and in the Padureni area the keys hung on the magic belt of the women open the world of the living to the child, while miniature tools are intended to express the hope of a boy. The Romanian word for 'key' is also used to describe the protective stitching in alternating colours that decorate garment seams.

ABOVE *Chain hung with metal keys, rings, phalluses and miniature tools, worn over a married woman's apron, Padureni region, Romania.*

RIGHT *Tekke baby's cap with rags, each colour against a different evil, Turkmenistan. The tassel includes a broken needle.*

FAR RIGHT *House amulet of a triangle pierced by a needle, Bukhara, Uzbekistan.*

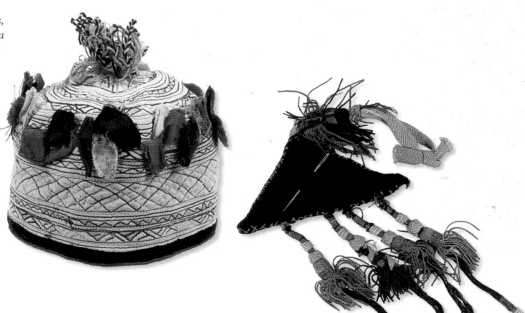

Keys, invented by the bronzesmith Theodore of Samos in the sixth century BC, always had quasi-magical powers – travellers in medieval France, for example, branded them on their horse or donkey for safety on the road – but though their symbolism is usually masculine and relates to opening, they can also express closing, thus keeping out evil spirits and averting spells. This symbolism is enhanced by the padlock, also worn as an amulet. In Shanghai a child would wear a silver padlock round its neck to prevent its spirit being stolen, while the Ashanti add a European padlock to an amulet of knotted cord, two small horns, a seed, a tuft of porcupine tail and bits of leopard skin. In Madagascar it is three padlock keys that are included in a necklace of twisted roots and other amuletic devices.

Knives are put on houses in Indonesia, hung on babies' amulets in Albania, used by shamans to fight evil spirits, and thrust into the milk of sick ewes in Romania to kill the spells cast on them. Knives are an amuletic embroidery pattern on the suzanis of the Uzbek, as well as on the 'eight-knives' men's robes of northern Nigeria.

Knives, together with scissors, were put in babies' cradles in Eastern Europe, and also in America, while Serbian women wore scissors on a silver chain. In Madagascar scissors were known to slice all evil spirits in advance of their arrival and were worn as a pendant, blades upright and handle sheathed in fine beadwork.

Nails were already a Greek and Roman defence against pestilence, and are still a powerful amulet, especially when taken from a horse's shoe.

The sharpness so devastating to demons can be found not only in needles and blades, but also in virtually anything spiky. Thorny plants and thistles are hung on the top of buildings under construction and placed around

ABOVE *Iron tools at the apex of a Bedouin tent, Tunisia.*

BELOW *Plant against the evil eye protecting a blacksmith's workshop, Roumsiki, Cameroon.*

BELOW RIGHT *Spiked fence protecting a smallholding, Kizhi, Russia.*

RIGHT *A feature of many Uzbek buildings is the wooden beams that formed part of the construction being left visible. Spikes like these at the top of buildings are specifically against the evil eye, Khiva, Uzbekistan.*

BELOW *Woman wearing a calabash, with a metal stick through her nose, Toubour, northern Nigeria/Cameroon.*

BELOW RIGHT *Spikes on a missile against vampires decorated with red seeds, on sale in the market, Foumban, Cameroon.*

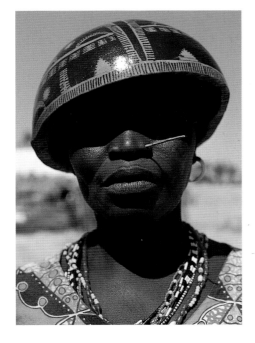

fields of millet against witchcraft. Porcupine quills are used to the same effect, as are hedgehogs – even the entire animal, an essential attribute of any witch doctor. Such thorns and spikes were worked in embroidery, as on the cloaks of Turkmen women, or in weaving and tattoos, as in the Middle East. Spikes on jewelry, as on silver Berber bracelets, kept the evil eye at bay, and those on anklets protected too from underground devils.

Evil spirits that wander in the sky are kept away from Thai temples by the sharp defensive barbs, *jaofao*, that decorate their roofs.

Even shoes have played a role. In Mesopotamia from around 1500 BC, bronze amulets were shaped as a boot with an upturned toe, and in Poland

RIGHT *Tekke silver amulet representing a bow and arrows, stitched to the back of a girl's* kurta *to persuade the spirits to make sure the next child is a boy, Turkmenistan.*

BELOW *Bishârîn man armed with an amulet and a sword, Nubia, Egypt.*

BELOW RIGHT *San demon chaser, consisting of a quiver of wood and skin, arrows and a bow, South Africa. The arrows are shot onto the ground, forcing devils away in the direction each arrow faces.*

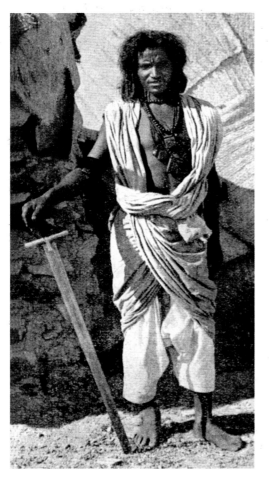

and Holland in the mid-fifteenth century, it was the pointed shoe that was a defence against witchery. The power of sharp arrows and weapons is also transferred to amulets: in the steppes of southern Russia, a female warrior was buried in about the fourth century BC with a bronze arrowhead hung round her neck in a leather bag. Arrows ward off evil spirits and, by throwing them on the ground, the Bushmen of Namibia scare away demons. The Japanese even make arrows by inserting paper charms against insects and lightning into cleft sticks and placing them in fields. In the Arab world it is arrowheads of flint, agate or cornelian that are worn round the neck, while the Turkmen choose a silver bow to stitch onto a girl's cap or *kurta* in the hope that the next child will be a boy.

Weapons such as swords, daggers and spears are used as amulets both in North Africa and in the Orient. In China swords hang above the bed against evil, while in Indonesia a sword intended for use in headhunting was protected by amulets – a bottle of oil, a shell, a red rag, white tassel and blue beads. The dagger of Indonesia, the *kris*, is a magic object, of which the blade is the most important part. On this the smith will forge the pattern of a figure, depicting its soul, while the blade itself, straight or curly, represents a resting or active cosmic snake.

In India weapon amulets were in the form of models – in Assam as a spear hung over doorways, and elsewhere as a miniature bow, spear, axe and gun, placed with offerings of flesh and grain by village paths to protect the dead, or worn as a necklace on an iron chain. Such necklaces of miniature iron implements were also worn by Algerian children, and ones of cord hung with iron fetters by Nigerian babies.

The concept of the magic power of sharpness is usually allied with iron. Ghosts, jinn, witches, demons, all manner of evil creatures fear iron, whose magic is associated with magnetism and with blacksmiths.

ABOVE *17th- or 18th-century iron votive figures in the shape of the so-called 'Leonardische Tiere', Austria. St Leonard helped women in childbirth and also protected against fire and illness.*

BELOW *Necklace of miniature iron weapons, India.*

The mysterious ability of the blacksmith to work iron with bellows and anvil imbues him with powers of the occult, and in many societies he is a feared and ostracised man.

Already mentioned by Pliny, the aversion of spirits to iron is almost universal, and still current. In India a five-year-old bridegroom, garlanded in flowers and rupees, holds iron rods to ward off evil spirits, while other children have iron rings round their feet to frighten ghosts. Iron anklets are worn, too, by Egyptian children, but to protect the next child from any malignant spirit within the mother. The Tuareg hang their specially erected nuptial tents with swords and daggers of iron. The bridal couple stay in the tent for several days to avoid evil spirits and the dead leaving their tombs to attack them, though such spirits are known to be afraid of iron.

The Kissi people of Guinea, northern Liberia and Sierra Leone used twisted iron sticks, flattened at the ends, for protection and money until the mid-1920s. They were known as Kissi Pennies.

The clothing of the women and children of Indus Kohistan in Pakistan is edged with non-functional metal zips and bands of metal discs and chain.

Powers ascribed to iron apply often to brass and bronze, and much amuletic jewelry of Asia and Africa is made of these metals. In Europe, too, a bronze amulet of animal form for a woman's neck, dating from 1100 to 500 BC, was found in Albania. Brass and bronze-plated wooden figures are placed on the tombs of Koto chiefs of Gabon as reliquary figures to guard their remains from evil spirits. They are depicted not as men, but as half-man, half-weapon.

When metal and weaponry against evil spirits are augmented by noise, the spirits have little chance. The report of gunpowder will destroy them entirely. The Yemenis fire shots during marriage processions; the Turkmen fire as the tribe leaves camp.

A ceremony featured in *The National Geographic Magazine* of 1928, entitled 'Many Demons Face Destruction', shows a group of lamas in north-western China assembled around a cauldron of burning oil. 'By incantations all manner of evil spirits and demons of bad luck have been coerced to enter the triangular paper suspended above the cauldron.' The newly elected lama stands ready to throw a bowl of explosives into the fire, once it leaps to twenty feet (6 m) in the air, so destroying the demons. A Tibetan will carry an amulet of explosives, a lighter, and an iron blade to pierce the spirits, hung on a belt in a leather pochette decorated by a solar motif. In many countries simply firing a gun is known to chase away demons.

Bells were considered magical in Ancient Egypt and have been used against the evil eye since Roman times. They can be set in children's rattles, stitched on clothing, hung on necklaces. While always associated with metal, in Europe they also recall the power of the Church. Church towers rise into the domain of clouds and demons, and the ringing of bells is thus anathema to evil spirits. Bells against the evil eye were found in the ruins of Santa Fe in Argentina, a practice introduced by the Spanish. But bells are also worn as amulets in countries where there are no church bells, such as India, Turkmenistan, Siberia and China, as well as the Ivory Coast, where they summonsed the vigilant spirits of the dead in defence against evil. Bells are a significant accoutrement of the shaman, adding sound to ritual dancing.

Not just bells, but anything that tinkles, jingles, clinks, or even rustles like silk, frightens the evil eye. Pebbles inserted in the silver anklets of the Berber, pistachio shells round a Turkmen child's shift, bits of chain hanging from a Bulgarian bride's hairpins, all are effective: even today's patio wind-chimes were once demon-dispelling amulets.

RIGHT *Yurt amulet hung with bells, Turkmenistan.*

BELOW *Men's robes, Bafut, Cameroon. The twin bells of Cameroon are tapped to frighten away evil spirits, and are a common embroidery motif on men's robes.*

BELOW RIGHT *Shaman in a costume hung with bells, Siberia, Russia.*

OPPOSITE *Bells over a holy niche, Bishnoi village, near Jodhpur, Rajasthan, India.*

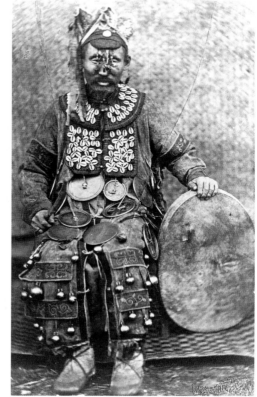

Numbers & letters

ABOVE *Old woman's collection of seven amulets, always kept at the ready, Ndop, Cameroon.*

BELOW *Kurdish knitted slippers with prominently five-fingered 'hands', Turkey.*

The weaponry and assaults a poor old woman from Ndop in Cameroon would be most likely to encounter, when she left her little hut, numbered seven – guns, knives, spears, cutlasses, sticks, fire and unnatural disaster. Against them she wore a twist of white calico round her waist, covered in red dust and tied with seven knots, to protect her from each of these threats. Guns were the one she most expected to encounter, and this amulet would ensure that she was 300 feet (100 m) away before she was fired at. It was one of her seven amulets for various eventualities – from getting rid of witches to the unwelcome attentions of a man – that she kept in a cardboard box when not in use. In contrast, in Romania nine knots tied in a belt, stuck with nine needles and placed under the threshold of a house, would attract a desirable man.

Numbers seem a gift from the gods. From notches on Palaeolithic bones to higher mathematics, the concept of fixing quantity in a linear sequence took humanity thousands of years of abstract reasoning. Numbers are magical, and almost always those that relate to amulets are integral to their power: three tassels, five lines, seven pompoms, nine knots, too many grains of salt or sand for a witch to count.

In general it is odd numbers that have the greatest amuletic power. Triangles with three tassels are an extremely common amulet, while depictions of the number five – representing the five tenets of Islam and the hand – are found throughout the Muslim world, most frequently in the form of the hand of Fatima as a pendant. In Calabria six and seven were the numbers in thrall to witches, so an eight or nine painted over the doorway would surely overpower them.

Numbers, or letters, forming magic squares are ancient amulets. Numerical ones can be either four vertical, diagonal and horizontal lines of four digits, each adding up to thirty-two or seventy-two, or a square of threes, each line totalling fifteen – this against smallpox. As such squares embodied holy order and harmony, they could be harnessed to restore that equilibrium.

Though the magic square is usually written on paper or cloth, folded several times and placed in a leather casing to be worn next to the skin, it also features as an embroidered pattern on the front of men's robes from Liberia.

Defining speech by writing is no less magical than recording quantity by numbers. Sometimes the power of the amulet comes not so much from what the words say, or purport to say, but from the power of writing itself, a gift, like numbers, from the gods. Egyptian hieroglyphs were considered of heavenly origin: already in the thirteenth century BC texts from the Egyptian Book of the Dead guaranteed the resurrection of the dead and protected them from being eaten by worms. In India Sanskrit script also came from the gods, while in the Islamic world the Koran is the writing of Allah.

Japanese and Chinese characters are forceful in themselves as amulets. Write down those for 'tiger', 'sun', 'moon', 'dragon', for example, and their essence is captured. Even a number of visiting cards strung or pasted together have, by their writing alone, the power to protect from burglars and thieves. A paper amulet bearing the character for 'earth' written in red and held as the traveller crosses a river is doubly protective: red is anathema to evil spirits and deceives them into thinking the man is on firm ground and unassailable.

Obscurity and mysticism cloud the use of script in amulets. From cabbalistic sources, from alchemy and astronomy, come written versions of arcane spells and incantations. Favourite magical formulae were the neatly patterned triangle of ABRACADABRA, and the harmonious square formed by SATOR. Though of much earlier origin, ABRACADABRA was a plague amulet, first mentioned by the Roman physician Quintus Serenus Sammonicus. By removing a letter each day until only the A at the apex remained, the sufferer would be divested of disease. Similarly, the magic square SATOR, a mirror image reading the same from back to front and top to bottom and thus representing harmony, was written down, stitched into a bag and hung round the neck of a potential plague victim.

Many texts relate to established religions. From Christianity magic formulae, unbearable to the eyes and ears of demons, play on the names of Jesus, Mary and the saints. The letters G, M and B carved on lintels in southern Alsace,

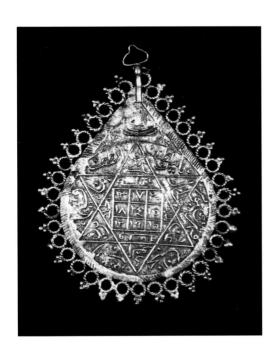

ABOVE *Gold pendant inscribed with magic numbers and a Koranic prayer, Algeria.*

RIGHT *Two sides of a Bornu Hausa amulet, perhaps recording a pilgrimage to Mecca. The pattern on one side is also embroidered on Mahgreb robes.*

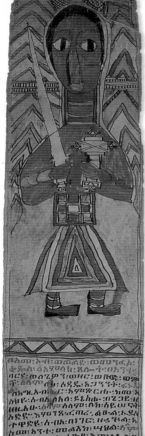

Switzerland and Germany stood for the magic names of the three wise men, Gaspard, Melchior and Balthazar, and were deemed to protect the house. Other Christian amulets were cryptic messages in Latin or German, garbled invocations in Ancient Greek to St Basil and St John Chrysostom, Patriarch of Constantinople. The first words of the Gospel of St John – 'In the beginning was the Word, and the Word was with God, and the Word was God' – have been worn as an amulet since the time of the Apostles.

Jewish amulets are based on a belief in the power of the written names of God and quotes from the Old Testament, such expressions of devotion threatening evil and the evil eye. The writing is usually encased in leather, as this protected against contamination of the holy scripts inside, or it could be engraved on silver or carved on bone.

Most Buddhist magical texts are inscribed on prayer flags, such as those of Tibet invoking the protection of the five Buddhas of meditation of the cardinal points and the centre. Though amulets are often white cloths hung from bridges and trees by rivers, magic diagrams with inscriptions in Pali

ABOVE *Coptic scroll of paintings of saints and incantations written in the ecclesiastical language Ge'ez on sheep's skin to protect women from sickness, Ethiopia. The saints are depicted in red ink made from red stone crushed with red flowers. The black ink of the script was made from the charcoal that collects under the cooking pot, allowed to ferment. The scroll is encased in snakeskin to hang round the neck (see p. 124).*

ABOVE LEFT *Jewish pendant carved in bone to be worn or hung on a wall against the evil eye.*

RIGHT *Powerful Taungyo talismanic waistcoat to protect a man travelling or working in the forest from evil spirits, Myanmar. The front (above) is decorated with grids and squares filled with astrological symbols. On the back (below) are illustrations of Buddha and monks, and auspicious numbers.*

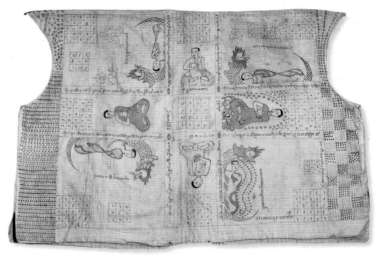

ABOVE *Coat of a warrior, hung with leather amulets containing either magical formulae or suras from the Koran, Mali.*

BELOW *Old lady with necklace of Koranic writing encased in leather, Ashkabad, Turkmenistan.*

BELOW RIGHT *Bowl engraved with suras, holding five silver coins, Bukhara, Uzbekistan.*

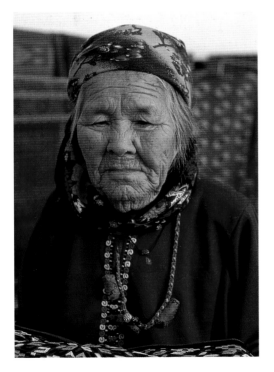

(the language of the sacred texts of southern Buddhism) have been found buried in foundation stones in Mandalay.

Magical numbers and letters on cloths and clothing are often associated with chiefs, or with hunting and war. Warriors' tunics can be entirely covered by inscriptions – even with the complete text of the Koran – or magical formulae can be enclosed in leather amulets hung over the garment, as with the tunics of Mali. Thai waistcoats were printed with designs, diagrams and inscriptions in Khom, while for Korean military government officials of the Choson dynasty, cotton jackets were hung with iron platelets to protect against arrows, and were stamped on front and back with Buddhist and Taoist scripts in the form of stylized Sanskrit and Chinese graphs.

By far the most common texts in amulets are from the Koran, or garbled versions thereof, often consisting of a few loops and dots vaguely resembling Arabic script. The paper is folded several times and then sewn into leather to be worn next to the skin or on clothing, or to be hung in houses or on horses and camels.

As an inscription in an amulet, Mr Routledge's 'bad beasts do not harm me' (see p. 8) is rare in its direct request, matched only by the two favourite suras from the Koran used in amulets. The 113th requests refuge from 'the evil of an envier when he envies', clearly aimed at the evil eye, and from 'the women who spit on knots', that is, practise witchcraft. The 114th and last sura seeks protection from the devil, the 'slinking whisperer' who whispers in the hearts of men and slinks away at the name of God.

Texts can also decorate bowls, like the brass 'silver water' ones of Uzbekistan, where forty suras are engraved on the inside. Five silver coins are added and water poured in. When this is thrown away, the evil eye leaves with it. Similar bowls were known in the Levant from the first century AD, where the protective spell was in Amharic and the bowl was buried upside down to trap demons. In South Vietnam the bowls were of terracotta, decorated with magic characters and containing magic papers, protecting sick children while they slept.

Many inscriptions of numbers and letters, from whatever source, are simply gibberish, the work of illiterate mullahs, marabouts, wise women, rural priests and medicine men.

Hands & crosses

North-east of Lake Titicaca, in the high Andean valleys of Bolivia, six villages are home to the Kallawaya, itinerant medicine men whose traditions date back to pre-Inca times. In these villages human excrement is burnt to chase away evil spirits, instruction is given in natural medicine, white magic and sometimes even black magic. The villages are also a hive of industry, producing amulets which the Kallawaya trade over much of South America. Wandering in their beautifully woven shawls – for weaving is a local tradition, harbouring much the same magical qualities as their medicines – they sell amulets made of a soft alabaster. While some can be bought by anyone, many are only to be sold to the married, or the celibate, or the widowed.

Kallawaya amulets are often in the form of a hand – in which case whatever is held in the palm imparts a different power – or they depict triangles with horns, or couples in coitus. Oiling such amulets in llama fat gives them their first magic power, which further oiling is needed to reinforce.

The Kallawaya repertoire of patterns and shapes of amulets embraces almost every conceivable concept of protection, but most common of all is the hand. While the vast majority of hand amulets worldwide relate to the hand of Fatima and Islam, the Kallawaya choice of the hand clearly has its origin in non-religious, animistic beliefs. The raised hand, palm out, is a primeval, instinctive reaction of any human being to an attack. The hand is probably the oldest and most immediately recognizable physical and symbolic weapon of defence.

Many other powers lie in the hand: raised in supplication and benediction, grasping others in seal of friendship or alliance, or holding the tools of intellectual and artistic expression. Hand amulets are found in Egyptian, Etruscan and Phoenician graves, and in the tombs of Scythian nomads. The hand with spread fingers was also a potent motif on most pre-historic rock paintings, though whether it then had any amuletic function is impossible to say.

The hand, as a symbol and amulet today, has been taken over particularly by Islam. The hand of Fatima, embroidered, woven, or made in silver and hung as a pendant, is one of the most common amulets throughout the Muslim world. Its fingers can pierce the evil eye.

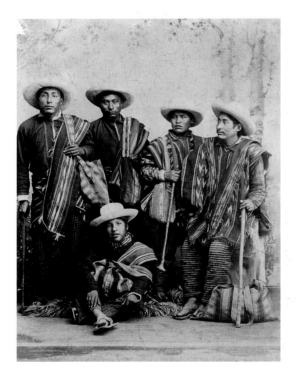

A group of itinerant Kallawaya medicine men and amulet makers, La Paz, Bolivia.

ABOVE RIGHT *Hands painted around a doorway, Rabat, Morocco. The base of the house wall is coloured blue for protection.*

BELOW *Doorknocker in the form of a hand, Marrakech, Morocco.*

BELOW RIGHT *Imprint of two right hands stamped on the wall of a house, Cairo, Egypt.*

The hand is also a popular Jewish amulet, while in Italy it is found in the obscene version of the *mano in fica*, or as a doorknocker protecting the house. The imprint of a hand stamped on walls to ward off ill fortune is common in the Mediterranean region, where for example in Egypt it is made by steeping the hand in the blood of a newly slaughtered sheep or goat, and slapping it on the wall. In Japan the imprint is in ink and keeps away robbers, or alternatively zigzag strips of folded white paper placed over houses represent the benevolent hands of the gods.

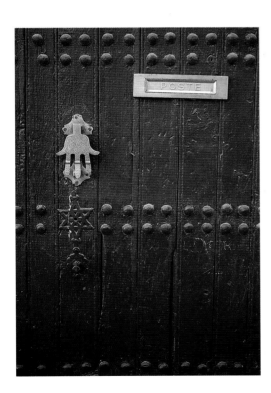

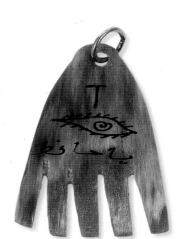

ABOVE *Hand of Fatima made of plastic and shell, Morocco.*

RIGHT *Hand of Fatima and eye, made of horn, with the initial of the person it is to protect, Morocco.*

FAR RIGHT *Jewish hand amulet with a bent thumb, similar to the Arab hand of Fatima, Essaouira, Morocco.*

BELOW *Jewish parchment wall hanging to protect a family and women in childbirth. The dense wording contains mystical meaning.*

BELOW RIGHT *Hazara prayer cloth embroidered with a hand of Fatima, Afghanistan.*

In Europe the 'hand of glory' rendered assailants motionless. This was a hand cut from a man hung from the gibbet. It was soaked in tallow, and a wick placed in each finger, while the moon was waxing and not waning. Thieves were known to acquire such a hand and place it on the kitchen table of the household they intended to rob. It would ensure that the inhabitants would be still as if dead, and unable to stir a finger against them.

The foot, along with footprints and shoes, also had amuletic powers and could avert the evil eye, drive out ghosts and protect from spells. Foot symbols from the Neolithic, footprints of Vishnu, shoe fetishes, all are variations on this theme.

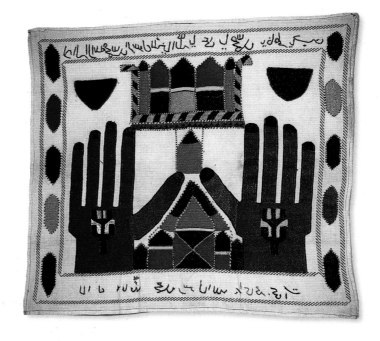

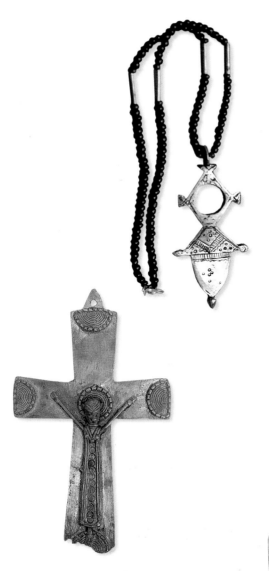

If, when established religions begrudgingly took cognizance of pagan amulets, Islam annexed the hand as a symbol, Christianity took the cross.

Tracing a cross on an object cuts it and sacrifices it; crossing oneself asks for protection; crossing another takes away their influence; crossroads are the domain of evil spirits but also disperse them by disorientation, just as the arms of a cross push evil to the points of the compass. Our perception of the cross is not just as a sacred symbol – though it is known that a clear symptom of possession by spirits is an aversion to it – but also as a depiction of conflicting forces. The left bar is passive, the right active, the base matter, the top spirit. It captures and disseminates good and evil forces, and can assume various forms: the Egyptian *ankh*, principle of the life-force; the Southern Cross, a universal protector in the Arab world; the T-shape of Scandinavia, representing the hammer of Thor; the double-armed Cross of Lorraine or Caravaca, effective against the plague, and the crucifix, both deeply Christian symbols.

The positioning and application of the cross is diverse. Often it carries associations with the Church, though that the cross can be considered an amulet in the Christian context is debatable: God protects, not a symbol. However, a beleaguered Christian household in a society of Muslims or animists certainly believes that the cross they have placed on their roof, or painted over their door, acts as an amulet. Likewise, a crucifix made by the local blacksmith – well known to possess magic powers – will be hung on their wall to protect them. And a Bosnian Christian woman, living among Muslims, announces her faith by appliquéing a protective cross of red fabric on her marriage shift and shawl.

TOP *Berber silver amulet of the Southern Cross, Morocco.*

ABOVE *Brass crucifix for a Christian house in a Muslim community, made by the local blacksmith, northern Nigeria.*

RIGHT *Marriage costume with crosses declaring that the bride belongs to the Orthodox faith, Livno region, Bosnia.*

OVERLEAF *Offerings made to a cross specially erected at Easter for protection and prosperity, Olymbos, Karpathos island, Greece.*

167

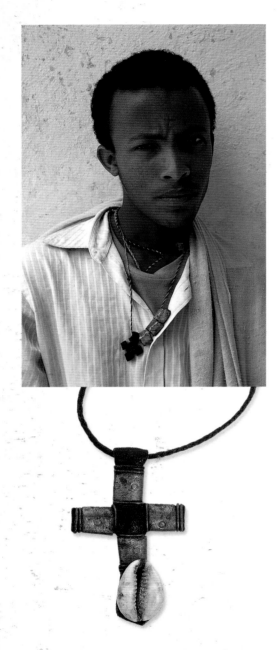

In the Apennines a plain cross of wood, with a string of olives attached, would be taken into church on Palm Sunday and then set up in the fields on Ascension Day to keep off hail. In New Mexico a cross of sticks and juniper would be taken to Santa Cruz to be blessed by the Catholic priest and then placed in a wheatfield to promote the crop. In the village of Olymbos on the Greek island of Karpathos, a cross is set up in the cemetery at Easter, and offerings are made to it. It was on Easter Sunday, too, in the Balkans, that a cross was made from the bones of the last pig eaten by the villagers and hung on the door of the church, trapping witches within. Crosses there would be stood in fields, planted on hills, scratched or painted on doors and set on the gables of roofs, while in Latvia they were not only painted on houses but also on beds, and woven into belts. The cross is still marked on holy bread, on hot cross buns.

But the place of predilection for crosses is the crossroad or wayside. In many Catholic countries crosses and saints are erected to protect passers-by at those points where malign influences congregate. In Romania wooden structures at crossroads, *troitsa*, enclosing a crucifix and often decorated with birds and hung with amuletic branches, safeguard the old woman trudging by in shawl and felted leggings, while along the village street she will cross herself at every house as she walks by the wooden crucifix erected by the garden wall for the sole purpose of extending blessings and protection to those who pass.

Most amuletic crosses are worn round the neck as pendants, some as simple crosses, others as crucifixes. In the fifteenth century Emperor Zara Ya'Gob of Ethiopia imposed a law requiring all Christians to wear a pendant cross but, in most of the Christian world, wearing a cross is a purely personal decision and may mean little. In 1948 the French church authorities tried to stop Scouts and Guides wearing a metal ring and crucifix on their belts, but to no avail.

The cross is also worn as an amulet outside the Christian world. For the Zoroastrians it is a sun symbol, while for the North American Indians it is equated with the dragonfly, which is associated with thunder. Crosses of the Saharan Tuareg were powerful amulets passed from father to son, and used to buy cattle, cloth and food in times of need.

Still the cross is overwhelmingly Christian, and even more powerful than the blessings and perceived safeguard of a plethora of Christian saints.

TOP *Cross of Axum worn by a young man from Tigray, Ethiopia.*

ABOVE *Woodabe leather cross, wrapped with brass and decorated with a cowrie, Nigeria.*

OPPOSITE *Wayside crucifix to protect passers-by, Budesti, Romania.*

Saints and the Church

'Whenever I went down with malaria,' wrote Alberti Denti di Pirajno in Eritrea, 'Tabhatu, a widow of a certain age, a Coptic turned Catholic who looked after me, filled my bed with pictures of saints and sacred talismen: I would awake, exhausted and soaked with sweat, to find St Ignatius on my stomach, St Cecilia the Martyr under my arm, and the Holy Family on my chest.'

Though the idea of confronting evil forces with saints, deities, angels and supposed celestial beings is both pagan and Christian, it is particularly in the Catholic church that saints – or depictions of them – bring the power of God to save infants from convulsions, men from demoniac temptations, women from a curse on childbirth, crops from hail and thieves, and people in general from apoplexy, strokes and the evil eye.

Though medallions of St Christopher to save travellers from the perils of the road are perhaps best known, it is probably St Antony of Padua who is the most important saint corralled into amuletic use. Pendants of his image, hung between the horns of cattle, preserved them from witchcraft, while a prolific number of card amulets of his portrait were sold opposite the cathedral of Padua.

Certain saints have a specific power, such as St Roch who, from his own sufferings and help to victims, gained a holy strength to protect people from the plague. Other saints have a smaller part to play. In France the figure of St Joseph in a tin case, given by priests to young people and sewn in the corner of their aprons, kept them from evil and heresy. Notre Dame de Lourdes, the Virgin Mary in general – often depicted in the form of a heart – and a number of minor saints fulfilled the roles expected of them.

Such minor saints were adopted with enthusiasm among the descendants of slaves in Central and South America, where the image of Christ on the cross, thin, wounded, helpless, had little appeal, whereas St Michael slaying the dragon offered a much easier fusion with their own local gods. Most of these came from Africa as, though the slaves shipped to the Caribbean and South America lost all their possessions, they kept their gods and spirits. Their African beliefs became voodoo in Haiti, Winti in Suriname and Candomblé in Brazil.

The amulets of Central and South America in general – and Mexico in particular – are a kitsch medley of sparkle, Christian saints, garlic, plastic Buddhas, pasta, crosses, hearts, horseshoes and red and black seeds, sold in shops. In contrast, lacking such availability of exotic materials from elsewhere, the amulets of the Indian tribes of Peru, Bolivia and Amazonia are made of feathers, white clay, bark, wood, shells, raffia and red cloth, and relate to specific rites of passage, such as menstruation.

ABOVE *Catholic amulet of a Madonna surrounded by kitsch sparkle to hang in a house, Mexico.*

BELOW RIGHT *Catholic folding pocket amulet of plastic with miniature saints, a Madonna and a small metal disc hung on blue beads inscribed with an M and a cross, Mexico.*

OPPOSITE ABOVE *Windows and doorways in the small town of Orlat are guarded by images of the Madonna and Child, the Pascal Lamb and free interpretations of angels, Romania.*

OPPOSITE, BELOW LEFT *Madonna, hung on the rear-view mirror of a taxi, Albania.*

OPPOSITE, BELOW RIGHT *Madonna and saints at a wayside shrine, Korça, Albania.*

ABOVE *House amulet made of an old tin lid, depicting Shiva, India.*

BELOW *Shiva depicted on an appliqué cloth, India.*

BELOW RIGHT *The lame Li Tie-Guai, one of the Eight Taoist Immortals, China. Silver models of the Immortals are made as amulets for children.*

The role played by Christian saints in amuletic protection is shared by the holy men of other religions. In Hinduism it is particularly Vishnu who is favoured. His footprints, his embodiment as an ammonite, his face painted on the lid of an old tin – still bearing the instructions 'Cut Here', 'Replace Firmly' – along with that of Shiva, protected the house from evil. Ganesh, though often installed as a guardian deity on the outskirts of villages, or embroidered above doorways, is much rarer as an amulet in himself.

Buddhist and Shinto amulets of Japan less often show the deity involved, but when they do, as for example those depicting the god Daikoku, he is machine-embroidered in gold and placed in a clear plastic wallet hung on a white cord. He protects against traffic accidents.

The Taoist Immortals of China can be embroidered or formed in silver as tiny amulets to sew in a child's hat. Though each has a specific function and its own attribute, as amulets for children or the house they seem to be used indiscriminately.

Holy men and saints are but one manifestation of the protective power of the Church. Bells are another (see p. 158), as are a variety of trappings such as candle wax, trodden soil, scraps of blessed cloth and missionary zeal.

One specific amulet of the Catholic Church was the scapulary, two small pieces of a monk's habit stitched together and hung from the shoulder. Introduced by the Carmelites in the thirteenth century and approved by a succession of popes, this amulet could also be stuffed with the usual defences of plants gathered on St John's Eve, prayers, olive leaves blessed on Palm Sunday and wax from church candles. The stitching of the scapulary was, of course, in red thread.

Earth taken from the holy ground of the church was not just a custom of Christianity – extending even to bat dung. Sweepings of the Kaaba at Mecca were also made into amulets and hung in mosques and houses, while sand taken from the tomb of a venerated marabout of Morocco was sewn with suras from the Koran in small leather sachets and hung round the neck. Dirt deposited by worshippers' shoes and swept from Shinto shrines was sold in packets, not only to transfer the holiness of the site to the wearer, but also by sympathetic magic to attract similar large numbers of people to the seller's shop.

Though the Christian Church attempted to outlaw amulets, beginning with the Council of Laodicea in the second half of the fourth century which prohibited ecclesiastics from making amulets under penalty of excommunication, to St Caesarius's canons of the early sixth century against amulets, and then the declarations of the Leptiner Council of AD 743 that crosses and holy relics should be worn instead of amulets, it was to no avail. People took, and still take, amulets to church to be blessed or left on the altar or at the threshold for forty days, to absorb the holy power of the church.

In the year 2001 there was a boom in exorcism in Italy, when half a million people, believing themselves to be possessed by the devil and finding amulets ineffective, turned to an exorcist to expel their evil spirits during the Catholic Holy Year. A number of such exorcisms have been conducted by Pope John Paul II in recent years. Commenting on one that took place in 2002, Father Gabriele Amorth, President of the International Association of Exorcists, stated that the only possible weapons against evil are the cross and holy water. And extra virgin olive oil.

Triangular brocade amulet left on the altar of the village Orthodox church for forty days to be empowered, Olymbos, Karpathos island, Greece.

Postscript

Dr Barnabas's hut stood amid banana palms and clumps of aloe vera, reached by local bus and a walk through grassfields. It was a simple affair of sun-dried mud bricks, the gaps between them stuffed with feathers and plastic bags. The floor was of beaten red earth, the roof of tin. Piles of leaves, and ingredients for his medicines, lay outside, but no amulet hung at the door. Instead it was protected by a shiny new padlock and a ring of keys dangling with a miniature Guinness bottle.

Dr Barnabas was a tousled man of glistening ebony and demented eyes, dressed in a puffy baby-blue anorak. He was registered witch doctor No. 0338, according to the notice on his wall. I was his first European customer, though six white men had once come in a Land Cruiser. As he had recently been dealing with a woman suffering from 'overflowing menses' – his hand waved generally in the direction where this would appear, were he a woman – he couldn't possibly let them in. They would inevitably be stricken with chronic gonorrhoea. They left without demur.

He was very reluctant to make me an amulet to protect me on my travels and, of course, if he did so it would be secret. He would forgo the normal charge of two roosters, observing that I had come empty-handed, but would

Dr Barnabas's hut, Bali, Cameroon.

require 'heavy money', 25,000 or 10,000 francs. The difference in quality of the amulet that these amounts would procure seemed to be ill-defined, so I opted for the more downmarket version, which was still over sixteen dollars.

The commission agreed, Dr Barnabas went outside, leaving me sitting alone on a little bamboo stool. His stock-in-trade lay in a dusty, rusty heap on the earth before me, crawling with spiders. I observed a monkey skull, *World Famous Dr Ramas Oil It Works Wonders*, metal traps, bells, cowries, *Good Luck Soap Highly Spiritual* (in bright pink paper), coins from British West Africa, Federation of Nigeria, and old French francs, *Original 999 Lord Krishna Puja 10 Dhoop Sticks* (in a lurid green pack), animal horns, iron fetters and chains, and other unidentifiable accoutrements.

Dr Barnabas returned. He had nipped down to the village to buy a red candle, as no ritual was possible without it. He began. He jabbed two metal stakes into the ground and placed a white cloth between them, adding two small torn rags on top. Round each side he placed a curved leaf. These, he explained, shrink in the sun so you can use them to clamp your enemy by the ankles. The name of the plant I understood to be 'tie-you'. He carefully set down on the cloth an old rusty padlock, a selection of coins and the joss sticks, encircling the entire arrangement – which had begun to look like an altar – with a heavy chain. He then lit the red candle and rang a bell in his ear. This, he explained, 'sends the clouds away and moves you out of danger'. He then placed the monkey skull on the cloth – a monkey that had killed people by witchcraft – and unwrapped a bundle of palm leaves. They held a dried-out poisonous snake. He placed some of the powder from the snake and from the skull on to the two small rags, and then began adding bits of squashed leaves, and anything that came to hand, sealing each ingredient with wax from the burning candle.

ABOVE *Interior of Dr Barnabas's hut.*

RIGHT *Dr Barnabas's materials.*

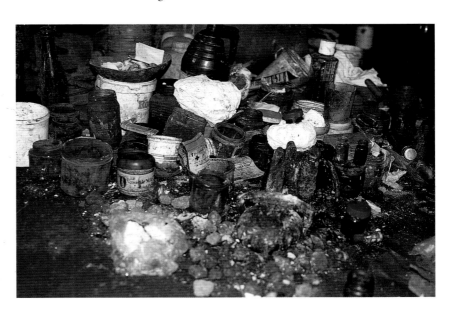

177

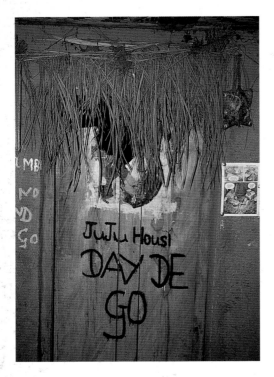

ABOVE *Juju witch doctor's hut, Babungo, Cameroon.*

BELOW LEFT *Dr Barnabas's amulet wrapped with thread for dressing women's hair, made to protect the author on her travels, Bali, Cameroon.*

BELOW RIGHT *Incantations wrapped in paper, tied with thread used to dress women's hair, and with chicken feathers added, made by the juju witch doctor to protect the author on her travels, Babungo, Cameroon.*

OPPOSITE *Carvings on the doorway of the juju witch doctor's hut, Babungo, Cameroon.*

'Show me your chest,' he suddenly ordered. I must have looked alarmed for he asked, 'Are you OK?' and opted just to dab a blob of grease at the open neck of my shirt. It was tiger fat, he said. 'You have tigers here?' I was somewhat incredulous. 'Yes. Up country in the reserve. And many in Foumban. In the zoo.' Only later did I discover that leopards are called tigers in Cameroon, and that the small town of Foumban has no zoo.

At this stage, warming to his task, he clamped my feet in iron fetters and chained my ankles. 'Are you OK?' he repeated, placing some fiery powder on my tongue. He burnt a chicken feather and added it to the little waxen heap on the rags, along with the same fiery powder and some seeds. He then folded the rags into a square and wrapped it tightly with the black thread used by women to plait their hair, and considered magic. 'Ceilingfan. Made in China,' I noted – though it was difficult to get hold of, now that women just go to the hairdresser, Dr Barnabas commented.

He then burned the small package in a piece of scrap metal until it was sizzling in a pool of red wax. He placed it on a stone covered in corroded gunge that lay by three knives stuck in the earth. He leant the burning red candle on the knives, declared the amulet ready, and placed the warm, pungent, trussed bundle in my hand. After a pause for dramatic effect, he freed my ankles from the chains that bound them and my feet from their iron fetters, and began his incantation: 'You will walk the land, and you will be safe. You will fly over the world, and you will not fall down. You will be caught in the depths of the sea, and you will escape. You will lie down and make love, and you will not get the sickness.'

As AIDS decimates the population of Africa, many for their defence have only their faith in witch doctors and amulets.

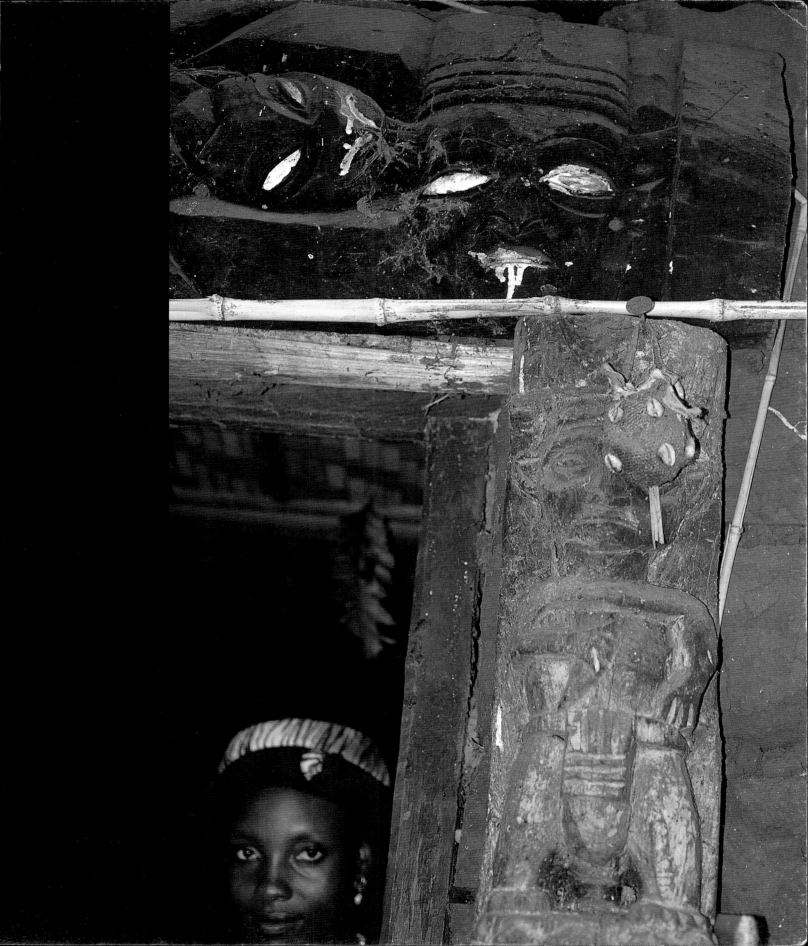

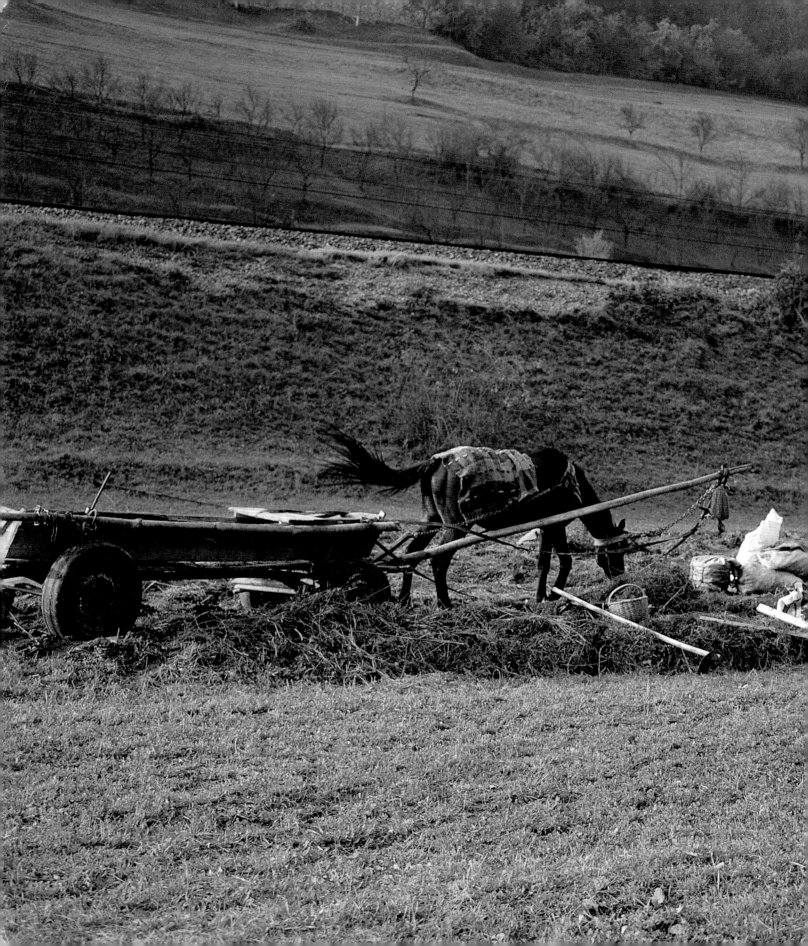

The red tassel worn by almost all horses is put on the shaft of its cart while horse and owner take a break, Maramures, Romania.

Acknowledgments

There is a logical progression from studying the amuletic function of embroidery to studying the power of amulets themselves, a progression that has taken me most of my lifetime to follow. The role of superstition in embroidery – the motifs originating from pagan and religious symbolism, the protective strength of decorative stitching around edges and seams where evil spirits are most likely to enter the body and cause disease, the overwhelming force of red – is described in my book *Embroidered Textiles*. This aspect of embroidery is merely part of a much wider concept of magical defence against calamities beyond human understanding.

A gradual intrusion of amulets and magic into my research into embroidery traditions in many parts of the world led, not to the abandonment of one in favour of the other, but to a dual interest where I found no conflict. However, the balance of my information on either one or the other varies in that my earlier journeys concentrated on embroidery and I observed less of amulets; by the later ones amulets had taken a stronger hold.

Knowledge built up over the years emanates from journeys through the Indian subcontinent, the Middle East, North and South Africa, Central America, Eastern Europe and, most particularly, Central Asia, which I have come to know intimately over the last ten years. More intensive study relates to East Africa and the Horn of Africa, Egypt, Greece and Albania. Many of my journeys are described in *The Afghan Amulet*, *The Golden Horde* and *The Linen Goddess*.

Final specific research has been in Romania, chosen as a rather isolated, traditional area of Europe, and Cameroon, chosen as a significant region of great ethnic diversity.

I have ignored the 'New Age' faith in crystals, feeling it a Western craze with slim affiliation to the profundity and fervour of the primeval fears and incomprehension that are the basis of amulets.

Finally, unable to wander the whole world, though keen to do so, I have found the collections and staff of various museums valuable sources of information, for which I am truly grateful. These include, in particular: the Pitt Rivers Museum in Oxford, also the Ashmolean Museum; the Ethnographic Department of the British Museum, London; the Bankfield Museum, Halifax; the Tropenmuseum, Amsterdam; the Musée des Arts et Traditions Populaires, the Musée des Arts d'Afrique et d'Océanie and the

Musée de l'Homme, all in Paris and all now closed, some of their collections transferred to the new Musée des Arts Premiers, Quai Branly; the Museum der Kulturen and the Pharmazie Historisches Museum, both in Basel; the Kuopio Museum, Finland; the South African Cultural History Museum, Cape Town; the Textile Museum of Canada and the Bata Shoe Museum, both in Toronto; the National Historical Museum, Tirana, Albania; the National Archaeological Museum, Athens; and the Russian Ethnographic Museum, St Petersburg.

Most of my information on contemporary amulets has been gleaned from snippets in the national press.

Passages quoted in the text are from the following sources: p. 18 Edith Durham, *Some Tribal Origins, Laws and Customs of the Balkans*; p. 38 Frederick Thomas Elworthy, *The Evil Eye*; p. 48 W. H. Ingrams, *Zanzibar: Its History and its People*; p. 54 Lionel Bonnemère, *Amulettes et Talismans* (sadly the amulet described on p. 50 has vanished from the Musée National des Arts et Traditions Populaires, Paris); p. 57 Pitt Rivers Museum, Oxford, Acc. No. 1923.67.5 letter dated 3 December 1937 from E. H. Hunt to Henry Balfour; p. 58 Pitt Rivers Museum, Oxford, Acc. No. 1884.56.88, Accession Book entry VII; p. 72 Pitt Rivers Museum, Oxford, Acc. No. 1965.3.216, Accession Book entry XVIII; p. 76 Pitt Rivers Museum, Oxford, Acc. No. 1897.28.1, Accession Book entry H. Matheson Esq.; p. 87 personal letter from H. Woodward to H. Hawkins, now in the possession of Dr Richard Fortey, Natural History Museum, London; p. 91 Tadeusz Skorupski, *Tibetan Amulets*; p. 150 Paul and Elaine Lewis, *Peoples of the Golden Triangle*; p. 152 Edith Durham, op cit. I am indebted to those authors concerned.

I must also gratefully acknowledge my indebtedness to those men of enthusiasm who have preceded me. In particular the donors of amulets to the Pitt Rivers Museum, Oxford, who recorded with their acquisitions and donations such details as 'Monsieur Leonard became very well-known in Regents Park' and 'I was obliged to saw the image into three or four pieces in order to pack it'. Then many colonial administrators, such as Dr Hunt, who prepared the gung-ho Union Jack amulet for his old laundrywoman (see p. 57) and took the trouble to note down exactly how it was made and to be used. Also Louis Girault, French ethnographer, who devoted twenty years of his life to researching the Kallawaya of the Andes, before dying of a heart attack in La Paz at an early age. And such men as Lionel Bonnemère, who, more than a hundred years ago, left notebooks filled with thick calligraphic swirls recording every detail of every amulet he came across and acquired.

Their infectious enthusiasm has carried over the centuries and been an inspiration. It forgives my excitement at the sight of a 'wolf's toe' in Samarkand market, a string of garlic on a stable door in Romania, a CD dangling from a taxi's rear view mirror in Albania. And the collection of potent exotica I brought home.

Bibliography

Carol Andrews: *Amulets of Ancient Egypt*, London 1994

Margaret Baker: *Discovering the Folklore of Plants*, Princes Risborough 2001

Jenny Balfour-Paul: *Indigo*, London 1998

Nigel Barley: *The Innocent Anthropologist*, London 1985

Lionel Bonnemère, ed. B. Guichard: *Amulettes et Talismans, La Collection Lionel Bonnemère*, Réunion des Musées Nationaux, Paris 1991

France Borel: *The Splendor of Ethnic Jewelry*, New York 1994

Dominique Camus: *La Sorcellerie en France Aujourd'hui*, Rennes 2001

Robert Chenciner: *Madder Red*, London 2000

Ralph T. Coe: *Sacred Circles*, exhib. cat., Hayward Gallery, London 1976

Mary F. Connors: *Lao Textiles and Traditions*, Singapore 1996

Frank Cushing: *Zuni Fetishes*, Tucson 1966

Lois Sher Dubin: *North American Indian Jewelry and Adornment*, New York 1999

Alan Dundes, ed.: *The Evil Eye: A Folklore Casebook*, New York and London 1981

Edith Durham: *Some Tribal Origins, Laws and Customs of the Balkans*, London 1929

T. T. Dyer: *The Little Book of Ancient Charms*, 1878, English Folklore, reprint Penzance 1997

Frederick Thomas Elworthy: *The Evil Eye*, London 1895, reprint New York 1958

Angela Fisher: *Africa Adorned*, London 1984

Bernhard Gardi: *Boubou c'est Chic*, Basel 2000

William Gill: *The River of Golden Sand*, London 1880

Marija Gimbutas: *The Goddesses and Gods of Old Europe*, London 1982

Louis Girault: *Textiles Boliviens*, Paris 1969

——: *Kallaway: Guérisseurs Itinérants des Andes*, Paris 1984

André Goldenberg: *Bestiaire de la Culture Populaire Musulmane et Juive au Maroc*, Aix-en-Provence 2000

Agustín Zapata Gollán: *Supersticiones y Amuletos*, Santa Fé, Argentina 1977

Denis Guedj: *Numbers: The Universal Language*, Paris 1996, London 1998

Pat Hickman: *Innerskins Outerskins: Gut and Fishskin*, San Francisco 1987

W. L. Hildburgh: *Japanese Popular Magic Connected with Agriculture and Trade*, London 1913

——: *Some Japanese Minor Magical or Religious Practices Connected with Travelling*, London 1916

James Hornell: *Survival of the Use of Oculi in Modern Boats*, Journal of the Royal Anthropological Institute, Vol. LIII, pp. 289–321, 1923

——: *Boat Oculi Survivals: Additional Records*, Journal of the Royal Anthropological Institute, Vol. LXVIII, pp. 339–348, 1938

W. H. Ingrams: *Zanzibar: Its History and its People*, London 1931, 1967

J. Wilfred Jackson: *The Use of Cowry Shells for the Purposes of Currency, Amulets and Charms: Memoirs and Proceedings of the Manchester Literary and Philosophical Society*, Vol. 60, Part III, Session 1915–1916

J. C. H. King: *Thunderbird and Lightning*, London 1982

Ruth Kirk: *Zuni Fetishism*, Albuquerque 1943, 1988

Harry Koll and Udo Hirsch: *Kultkelim: Ausgewählte Anatolische Flachgewebe*, Aachen 1999

Mark Kurlansky: *Salt: A World History*, London 2002

Olga Lysenko: *Fabric: Ritual: Man*, St Petersburg 1992

Christina Martin: *Holy Wells in the British Isles*, Powys 2000

James A. Montgomery: *Some Early Amulets from Palestine*, Journal of the American Oriental Society, 31, pp. 272–281, 1910–1911

Ted Morgan: *Somerset Maugham*, London 1980

Ester Muchawsky-Schnapper: *The Yemenites: Two Thousand Years of Jewish Culture*, Israel Museum, Jerusalem 2000

Roccu Multedo: *Le Folklore Magique de la Corse*, Nice 1982

Edmund O'Donovan: *The Merv Oasis*, London 1882

I. Opie and Tatun, *A Dictionary of Superstition*, Oxford 1989

Roselyne Pachet: *Les Plantes: Mythes et Symboles en Afrique du Nord*, Montreuil 1999

A. Pignol: *Costume et Parure dans le Monde Arabe*, Paris 1987

Geraldine Pinch: *Magic in Ancient Egypt*, London 1994

Alberto Denti di Pirajno (The Duke of Pirajno): *A Cure for Serpents: An Italian Doctor in North Africa*, transl. Kathleen Naylor, London 1955, 1985

Denise Pop-Câmpeanu: *Se Vêtir: quand, pourquoi, comment,* Freiburg 1984

J. H. Probst-Biraben: *La Main de Fatima et ses Antécedents Symboliques, Revue Anthropologique* 43, pp. 370–375, 1933

——: *Les Talismans Contre le Mauvais Oeil, Revue Anthropologique* 46, pp. 171–180, 1936

Francis Ramirez and Christian Rolot: *Tapis et Tissages du Maroc,* Paris 1995

Dorothy Jean Ray: *Eskimo Art: Tradition and Innovation in North Alaska,* Seattle 1977

——: *Eskimo Art: Tradition and Innovation in South Alaska,* Seattle 1981

H. Reinisch and W. Stanzer: *Berber: Tribal Carpets and Weavings from Morocco,* Graz 1991

Marian Rodee and James Ostler: *The Fetish Carvers of Zuni,* Albuquerque 1990

W. Scoresby Routledge and Kathleen Routledge: *With a Prehistoric People: The Akikuyu of British East Africa,* London 1910

Sergei I. Rudenko: *Frozen Tombs of Siberia,* transl. M. W. Thompson, London 1970

W. F. Ryan: *The Bathhouse at Midnight: A Historical Survey of Magic and Divination in Russia,* Stroud 1999

Viktor Sarianidi: *The Zoroastrian Problem, Bactria and Margiana, Turkmenistan,* Centro Studi Ricerche Ligabue, Venice 1996

——: *Margush,* Ashkabad 2002

Simone Widauer Scheidegger: *Amulett, Wohl & Sein,* pp. 221–240, Basel 1996

T. Schrire: *Hebrew Amulets,* London 1986

S. Seligmann: *Der Böse Blick und Verwandtes,* Berlin 1910

Tadeusz Skorupski: *Tibetan Amulets,* Bangkok 1983

François Thierry: *Amulettes de Chine et du Vietnam,* Paris 1987

Jon Thompson: *Carpets: From the Tents, Cottages and Workshops of Asia,* London 1993

Mary Tkachuk, Marie Kishchuk and Alice Nicholaichuk: *Pysanka: Icon of the Universe,* Saskatoon 1977

E. B. Tylor: *Notes on the Modern Survival of Ancient Amulets Against the Evil Eye,* Journal of the Royal Anthropological Institute 19, pp. 54–56, 1890

——: *Exhibition of Charms and Amulets,* Papers and Transactions of the International Folklore Congress 1891, pp. 387–393, 1892

Gérard Viaud: *Magie et Coutumes Populaires chez les Coptes d'Egypte,* Sisteron 1978

Jeanne-Françoise Vincent: *Femmes Beti entre Deux Mondes,* Paris 2001

A. J. B. Wace: *Grotesques and the Evil Eye,* Annual of the British School at Athens, no. X, 1903–1904

Linda Welters, ed.: *Folk Dress in Europe and Anatolia: Beliefs about Protection and Fertility,* Oxford and New York 1999

Arthur Woodward: *A Brief History of Navajo Silversmithing,* Flagstaff 1971

Picture credits

Collection Girault No. 72.1287 493. Photo J. Oster
Below right: Treasury of the Ethnographic Museum, St Petersburg
90 Photo Charles and Patricia Aithie

Chapter 17 Silver & sparkle
91 Left: from Sir John Hammerton, *Peoples of All Nations*
 Right: photo Paul Harris
92 Below right: Treasury of the Ethnographic Museum, St Petersburg. All other photos Charles and Patricia Aithie
93 All photos Charles and Patricia Aithie
94 Private collection
95 Top left and centre: photos Charles and Patricia Aithie
 Top right: private collection
 Below left: from Sir John Hammerton, *Peoples of All Nations*. Photo Holmes & Co., Peshawar
 Below centre and right: Treasury of the Ethnographic Museum, St Petersburg
96 Above: from Sir John Hammerton, *Peoples of All Nations*. Photo L. G. Popoff
97 Treasury of the Ethnographic Museum, St Petersburg

Chapter 18 Buttons, beads & blue
98 Collection Joyce Doel. Photo Dudley Moss
100 Private collection
101 All photos Charles and Patricia Aithie
102 Top and centre: photos Charles and Patricia Aithie
103 Above and below left: photos Charles and Patricia Aithie
 Below right: photo Paul Harris

Chapter 19 Red, white & black
104 Above: private collection
105 Top: Pitt Rivers Museum, University of Oxford, Acc. No. 1968.13.51. Photo Charles and Patricia Aithie
106 Above: Paraskeva Collection, St Petersburg
107 Above: collection and photo Jenny Parry
 Below: Ethnographic Museum, Mary, Turkmenistan

Chapter 20 Teeth, claws & paws
108 Above: photo Charles and Patricia Aithie
109 Top left and right: photos Charles and Patricia Aithie
 Below: from Sir John Hammerton, *Peoples of All Nations*

Chapter 21 Horns & bones
110 Above: photo Charles and Patricia Aithie
111 Top left: Gordon Reece Gallery, London
 Below left: photo Dee Court
112 Top left and right: photos Charles and Patricia Aithie
 Below: photo David Richardson
113 Top left and right: photos Charles and Patricia Aithie
 Below: Ethnographic Museum, Mary, Turkmenistan
116 Left: Musée de l'Homme, Paris, No. C60-36-493. Photo Musée de l'Homme
 Right: photo Charles and Patricia Aithie

Chapter 22 Birds, feathers & hair
117 Above: photo Charles and Patricia Aithie
118 Above: photo Charles and Patricia Aithie
 Below right: photo Dudley Moss

119 Below left: from Sir John Hammerton, *Peoples of All Nations*. Photo Hudson's Bay Company
 Below right: photos Charles and Patricia Aithie
122 All photos Charles and Patricia Aithie
123 Right: Paraskeva Collection, St Petersburg

Chapter 23 Snakes & fearful creatures
124 All photos Charles and Patricia Aithie
125 Below right: private collection. All photos Charles and Patricia Aithie
128 Top left and below left: photos Charles and Patricia Aithie
129 Above: Pitt Rivers Museum, University of Oxford, Acc. No. 1934.64.29. Photo Daisy Cantalamessa-Carboni
 Below: photo Charles and Patricia Aithie

Chapter 24 Water & the moon
130 Below: Collection Dreyfus-Best, Switzerland. Photo Beatriz Chadour-Sampson
131 Above: photo Charles and Patricia Aithie
 Below: photo Dudley Moss
132 Below: Pitt Rivers Museum, University of Oxford, Acc. No. 1887.11.82. Both photos Charles and Patricia Aithie
134 All photos Charles and Patricia Aithie

Chapter 25 Salt, garlic, incense & plants
136 Top right, top left and centre: photos Charles and Patricia Aithie
137 Top left, top right and below right: photos Charles and Patricia Aithie
 Below left: photo Mary F. Connors
139 Above and below right: photos Charles and Patricia Aithie
140 Above: Collection Pamela Watts. Photo Charles and Patricia Aithie

Chapter 26 Trees, rags & stitches
142 Top and below left: photos Charles and Patricia Aithie
144 Top left and right: photos Charles and Patricia Aithie
 Below right: Pitt Rivers Museum, University of Oxford, Acc. No. 1953.2.17. Photo Charles and Patricia Aithie
145 Above: photo Charles and Patricia Aithie
 Below: photo Mary F. Connors
147 All photos Charles and Patricia Aithie

Chapter 27 Tangles & triangles
148 Photo Charles and Patricia Aithie
151 Top left, top centre, top right, centre, and below left: photos Charles and Patricia Aithie
 Below right: photo David Richardson
152 Below right: photo Charles and Patricia Aithie

Chapter 28 Needles, iron & bells
153 Below left and right: photos Charles and Patricia Aithie
156 Top and below right: photos Charles and Patricia Aithie
 Below left: from Sir John Hammerton, *Peoples of All Nations*. Photo Donald McLeish
157 Above: Pharmazie-Historisches Museum der Universität Basel. Photo Daniel Kriemler
 Below: Pitt Rivers Museum, University of Oxford, Acc. No. PRIV.124. Photo Charles and Patricia Aithie
158 Above: The Turkmen Gallery, London
 Below right: Musée de l'Homme, Paris, No. CG3 4342 173. Photo Musée de l'Homme

Chapter 29 Numbers & letters
161 Above: Musée National des Arts d'Afrique et d'Océanie, Paris, No. 68.5.75. Photo André Chuzeville
 Below: Musée National des Arts d'Afrique et d'Océanie, Paris, No. 1962.1577. Photos Armand Emont
162 Top: photo Charles and Patricia Aithie
 Centre left: private collection
 Centre right and below right: The Richardson Collection. Photo David Richardson
163 Above: private collection
 Below right: photo Charles and Patricia Aithie

Chapter 30 Hands & crosses
164 Musée de l'Homme, Paris, No. D68.176.623. Photo Louis Girault
166 Top left, centre and right: photos Charles and Patricia Aithie
 Below left: private collection
 Below right: from the Collection of The Textile Museum of Canada, no. T04.2.1
167 Top and centre: photos Charles and Patricia Aithie
 Below: Musée de l'Homme, Paris, No. D55.830 (1-5). Photo Musée de l'Homme
170 Below: photo Charles and Patricia Aithie

Chapter 31 Saints and the Church
172 Below left: photo Charles and Patricia Aithie
173 Both photos Charles and Patricia Aithie
174 Above: Musée de l'Homme, Paris, No. 979.27.68

Postscript
178 Below left and right: photos Charles and Patricia Aithie

All other photographs are by the author.

Unless otherwise stated, the items photographed are in the author's collection.

Index page numbers in *italics* refer to illustrations

Index

About the Authors

Dirk Boelman has been designing and drawing patterns since the early 1980s, when the resurgence in the popularity of scroll sawing began. He has produced thousands of patterns that have appeared in countless books, magazines, and other publications. Dirk publishes a newsletter *Scroll Saw Chatter,* and sells patterns and supplies through his own mail-order catalog.

Dirk's ancestors were woodworkers, carpenters, and boatbuilders. An artitst in several mediums, he had an earlier career as a graphic artist in the advertising and commercial printing industry. Dubbing himself as "The Art Factory," he considers himself very fortunate to have made a business from his love to draw, paint, design, and create. It brings him great pleasure to share his artistic skills to help others experience the pride and satisfaction of creating beauty with their own hands.

Patrick Spielman lives surrounded by a hardwood forest in the famous tourist area of Door County in northeast Wisconsin. After college he taught high school and vocational woodworking for 27 years. Patrick left the classroom more than 10 years ago, but he continues to teach and share ideas and designs through his published works. He serves as a technical consultant and designer for a major tool manufacturer and enjoys lending his knowledge of woodworking to promote talent and activites of other artisans.

He has written more than 60 woodworking books. One of Patrick's proudest accomplishments is his book, *The Router Handbook,* which sold more than 1.5 million copies worldwide. His updated version, *The New Router Handbook,* was selected the best how-to book of 1994 by the National Association of Home and Workshop writers.